JIMMY ERNST

JIMMY ERNST

TEXT BY **DONALD KUSPIT**

INTRODUCTION BY **KURT VONNEGUT**

WITH CONTRIBUTIONS BY **LOUIS SIMPSON, LOUISE SVENDSON, SONDRA GAIR,** *AND* **JIMMY ERNST**

COORDINATING EDITOR **PHYLLIS BRAFF**

HUDSON HILLS PRESS NEW YORK

First Edition

© 2000 by Ernst Art Limited Partnership.

Published in the United States by Hudson Hills Press, Inc., 1133 Broadway,
Suite 1301, New York, NY 10010-8001.

Distributed in the United States, its territories and possessions, and Canada by
National Book Network.

Editor and Publisher: Paul Anbinder

Manuscript Editor: Virginia Wageman
Proofreader: Lydia Edwards
Indexer: Karla J. Knight
Designer: Marcus Ratliff
Composition: Amy Pyle

Manufactured in Japan by Toppan Printing Company.

Library of Congress Cataloguing-in-Publication Data

Kuspit, Donald B. (Donald Burton), 1935–
 Jimmy Ernst / text by Donald Kuspit ; introduction by Kurt Vonnegut with
 contributions by Louis Simpson . . . [et al.].—1st ed.
 p. cm.
 Includes bibliographical references and index.
ISBN 1-55595-191-0 (cloth : alk. paper)
 1. Ernst, Jimmy, 1920—Criticism and interpretation. 2. Ernst, Jimmy,
 1920—Interviews. I. Ernst, Jimmy, 1920– II. Title.
ND237.E7 K87 2000
759.13—dc21
 00-40910

CONTENTS

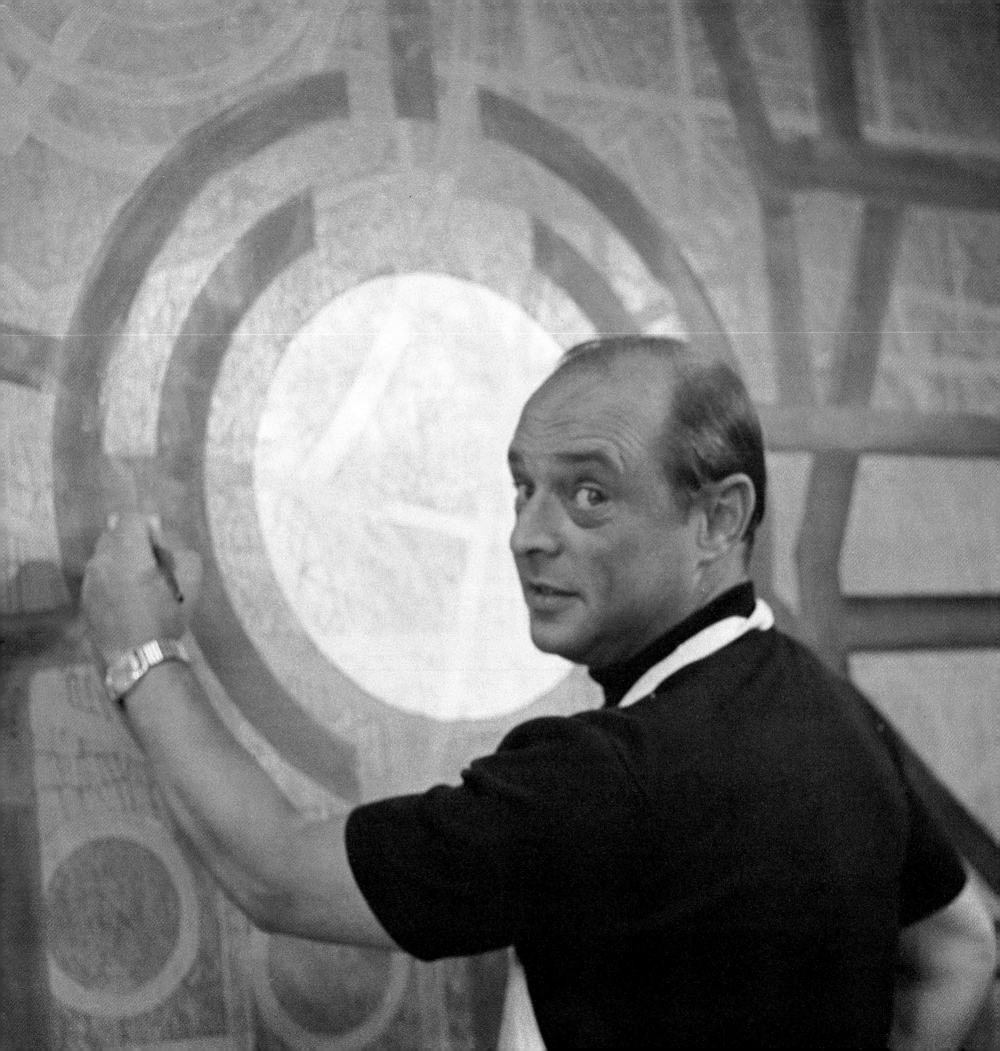

A TRIBUTE TO JIMMY ERNST *KURT VONNEGUT*

Fifteen years have gone by since I wrote the words below—for a memorial service at the American Academy and Institute of Arts and Letters, New York. Sorrow was harrowingly fresh then. Quiet elation that such a good person was once among us, and that he gave us so many enchanting gifts before he left us, is the mood today.

THIS IS ABOUT Jimmy Ernst, born in 1920 in Germany—our dear friend the painter and writer, who was killed instantly by a stroke on February 6, 1984. He was at the peak of his powers, and of his happiness, too, by all outward signs. His stunning autobiography had just been published. In two days he expected to attend the opening of a show here in New York City of his most courageous and personal and successful paintings.

I will say a word about his father. Max Ernst was surely the most famous artist in any field to sire a member of the American Academy and Institute of Arts and Letters. To reverse that equation: Jimmy Ernst is the only son of a great artist, that I can think of anyway, who reached for greatness in the selfsame art. It was as though there had never been a Sigmund Freud.

Conrad Aiken told me one time that sons will indeed compete with capable fathers, but only at those fathers' weakest points. Aiken's father fancied himself a renaissance man, a physician and scholar and athlete and poet and so on. And Aiken himself became a poet because his father's poetry was so bad.

Jimmy Ernst was surely not the only American artist whose mother was suffocated by cyanide in a German gas chamber. The Holocaust is a bond between immigrants to this country, including those who did so much to make this city the art capital of the world. I am not entitled to say what his best painting was, although I have my favorite—a triptych, black on black, executed so meticulously that the paint might have been laid on by a jeweler using a magnifying glass. I will dare to say that his spiritual masterpiece was to live without hating anyone—to forgive no one, since there was no one to forgive.

He elected to work without drawing on this quite customary source of creative energy, and I will name it again: hate.

The painter James Brooks wrote a letter to me about Jimmy—in longhand, in pen and ink, which included a phrase that so efficiently describes the ghost of Jimmy which should now live on in our heads that I will save it for the end. It was at the very top of the letter.

Toward the bottom of the letter, Brooks celebrated Jimmy's famous helpfulness to other painters—his obvious enjoyment of their work, his bringing them together with institutions that would show their work, and on and on. He also placed him in the perspective of very short-term art history, saying: "At the time Jimmy came to New York from Europe, the abstract-expressionist movement was ripening—which added to any difficulties he might be having in adjustment. The Americans couldn't easily accept his highly detailed, closely finished work, since they were then glorying in the invention of large, free-flowing shapes with little attention to detail." There ends the quotation.

He did not change, of course, and at the time of his death was widely admired not only by Abstract Expressionists, but by painters of every kind.

I will now tell you the phrase at the top of James Brooks's letter. "I think first," said Brooks, "of a deliberately unprotected psyche."

Again: "I think first of a deliberately unprotected psyche."

Again: "I think first of a deliberately unprotected psyche."

Again: "I think first of a deliberately unprotected psyche."

Jimmy Ernst in his New Canaan, Connecticut, studio, 1965

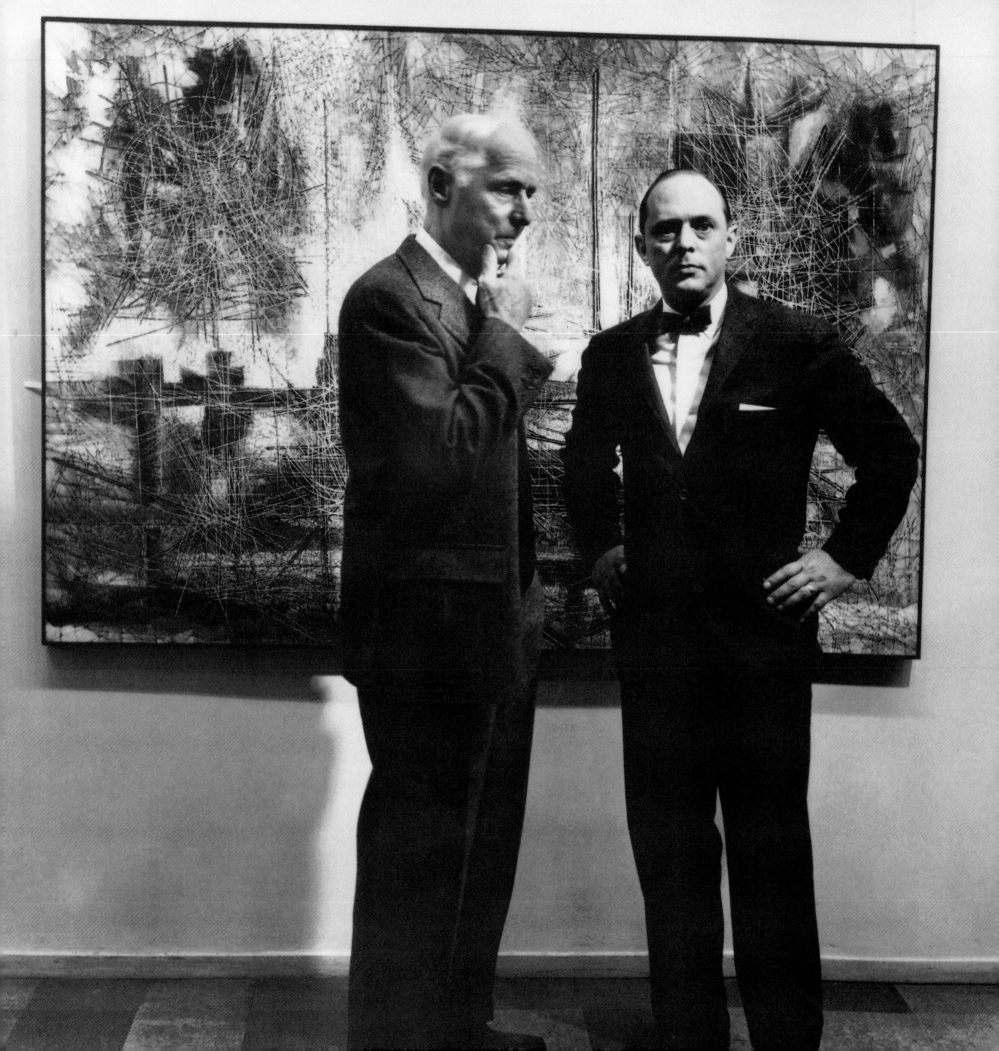

JIMMY ERNST

ART AND LIFE

BY DONALD KUSPIT

Does anybody ... ever escape his internalized folk and learn to deal with the cast of his adult life on his own terms?

—Erik H. Erikson, "On 'Psycho-Historical' Evidence"[1]

Tradition is much more than memory....
It has a clear, a single, a solid form,
That of the son who bears upon his back
The father that he loves, and bears him from
The ruins of the past, out of nothing left,
Made noble by the honor he receives,
As if in a golden cloud. The son restores
The father. He hides his ancient blue beneath
His own bright red. But he bears him out of love,
His life made double by his father's life,
Ascending the humane.

—Wallace Stevens, "Tradition"[2]

Bill [Baziotes] tried to put his finger on the larger issue of'mean-ingful art." That, he felt, could occur only within groups who shared a totally common experience. Or in a time, perhaps like the Renaissance, when the artist's subject matter ran fairly parallel to a predominant belief.

—Jimmy Ernst, A Not-So-Still Life[3]

FATHER AND SON

JIMMY ERNST'S life and art are inseparable from that of his famous, multitalented father, the Surrealist artist Max Ernst. And yet to achieve his identity and integrity, as he did, after much inner turmoil and external difficulty, Jimmy had to separate and differentiate himself from his father. This was complicated by the fact that his father had abandoned Jimmy and his mother when he was a child—a premature separation that was overcome only later in life when there was a reconciliation of sorts between father and son, but never to the extent that Jimmy laid his ambivalence about Max to rest, however much he came to understand Max and his ruthless vanity and pursuit of his art.

The struggle of Jimmy's art, then, is a struggle with Max's art and person, and while the identity Jimmy achieved was initially that of a Surrealist painter—as such early works as *The Flying Dutchman*, 1942 (page 37), show—traces of Surrealism remain visible in his art to the end of his life. He eventually achieved an art that, I believe, superseded his father's, which was oriented to the unconscious and contemporary European history. In the process Jimmy became a quite different person—more humane, considerate—than his father.

Max's art was essentially an art of disillusionment, premised on his direct experience of World War I and later, more indirectly, of World War II. It was also initially an expression of his ambivalent attitude toward his father, whom he associated with World War I.[4] He was in overt conflict as well as subliminally identified with his father, an amateur realist painter, just as Jimmy later was with him. In becoming a professional Surrealist artist Max at once appropriated, transformed, and transcended his father's realism and identity, just as, I will argue, Jimmy appropriated, transformed, and transcended Max's Surrealism and identity. Max's vision of "the decline of the West" is evident in such works as *Europe after the Rain*, 1940–42, and *The Twentieth Century*, 1955.[5] He

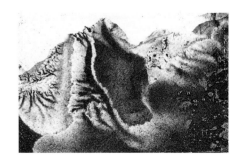

Max Ernst
Cruel Greenery (De cruelles verdures), ca. 1949
Oil on paperboard, 1³⁄₈ × 2¹⁄₄ inches
The Menil Collection, Houston (S-5209)

was acutely aware of the cruelty of life and the conflict between nature—including human nature at its cruelest—and civilization. The vegetation in the 1940–42 and 1955 paintings creeps over everything, as it does in many of Max's works, and in the end there is nothing man-made to be seen.

Cruel Greenery, ca. 1949 (page 11), makes the point succinctly. In it we are immersed in a subhuman world of nature, with no human alternative in sight. Civilization has altogether disappeared, leaving behind no trace. The scene is one of cruel oblivion; not a single relic, not a single memory, of humanity remains from the catastrophe. It is as though humanity had never existed. When human beings do appear in Max's art, they tend to be mythologized, to be at once more and less than human, as in the woman in *La Belle Jardinière*, 1923, and overgrown, encrusted, with nature, as in *Mother and Child, Groupe Mythologique*, 1940–41.[6] Or else they are part of nature, whether animal, as in *The Family Is the Root of the Family*, 1942, or vegetable, as in *Sister Souls*, 1961, or a strange hybrid of both, as in the sculptures *Oedipus I* and *II*, both 1934, and *Capricorn*, 1948.[7] As Hans Sedlmayr writes, this "demoniac transfiguration of man" into natural terms is "the expression of a profound anti-humanism." It involves a "process of dehumanization": a devaluation of the human that begins in "impatience with man," develops into a "cynical view of man," and ends in "hatred for man." Max's art is an exemplary instance of such "Romantic Nihilism," which in seeking to escape "anthropomorphic fetters" ends by "destroying" the human.[8] Max may have been an archaeologist of the unconscious, emulating Sigmund Freud, but what he discovered in it was a human nature as cruel, inhospitable, and raw as nature at its most implacable. Max's art is about being homeless in a cruel, insane world and in the unconscious, where man's inhumanity to man and nature's indifference to man join forces.

My thesis is that Jimmy's art tried to undo Max's pessimistic, malignant vision, offering something more humane and hopeful, less pathological, as an alternative. No doubt this reflected Jimmy's move from Nazi Germany to democratic America. More generally, it reflected the difference between the forward-looking New World and the backward-looking Old World. It is the difference between a world full of hope about the future and a world that lived in the shadow of the past—a world burdened by the sins of the fathers, which their sons were still paying for, with no absolution in sight. Like Max, Jimmy was a visionary in the grand manner, but his

vision is of a benign nature and a potentially peaceful world, of a society in which people share the same beliefs and thus have the basis for a common experience of life. Forming a community of the spirit, they would avoid war, both civil and with other communities—the kind of war Jimmy witnessed and apparently foresaw, as his autobiography, *A Not-So-Still Life,* suggests. Indeed, to use Ferdinand Tönnies's famous distinction, Jimmy was in search of community within society, while Max conveyed the endless war of each against the other, and the endless war within everyone, that prevails in society.[9]

This community, with its "intimate, private, and exclusive living together" and "organic" character,[10] is symbolized in Jimmy's *Southwest Solstice*, 1983 (page 122). The repetition of the shamanistic figures, with their cathedral-like headdress symbolizing their common experience and beliefs, conveys the harmony and unity of their community. It is a sanctuary and home, not simply an idle grouping of people or a crowd of individuals who are indifferent to each other, however much they happen to be together in the same place. The organic connection of Jimmy's figures is further confirmed by the sacramental branch each holds and the green necklace each wears, signifying the tree of life—their consecration to a benign nature. They are necessarily a primitive (Native American) community, for, as Tönnies observed, in modern society community is largely a thing of the past, an anachronistic paradise.[11] The search for community necessarily takes the form of nostalgic regression, for there is no model of it in modernity apart from the classless commune. There is something of the aura of one in *Southwest Solstice*, as the sameness of the figures suggests. Community is a sacred myth in Jimmy's picture, but nonetheless an emotionally real place.

Jimmy viewed "the stoicism and pride of these [Native American] people as a final fortification against a [threatening] alien culture [society]" and thought their pueblos were "unassailable buttresses" that "suggested the ramparts of medieval castles," an important, recurrent association in Jimmy's thinking and art.[12] In a sense, his whole project was to build, in modern abstract form, a shining new image of the impregnable medieval castles and communal cathedrals he had seen as a boy in Germany—symbols of safety and transcendence, that is, safe havens or sanctuaries within an unsafe society. In sharp contrast to this idealism, the ugliness of war with its unresolvable tension and contradiction is visible everywhere, in one form or another, in Max's pictures. In

society, a "mere coexistence of people independent of each other," with a "mechanical structure," war will sooner or later break out; it is always a hidden constant, confirming the dubious, profane character of relationships and lack of shared community and safety in modern society.[13]

Perhaps nowhere is the contrast between Jimmy's vision of life's potential and the potential for genuine community, and Max's vision of the lack of potential for both, clearer than in the difference between Max's *Fragrant Forest*, 1933,[14] and Jimmy's *Southwest Solstice*. In *The Fragrant Forest*, the trees, dramatically at odds—they surge in different directions—look like an abstract, hallucinatory reprise of the realistic fighting figures in a Renaissance scene, for example, by Paolo Uccello or Antonio Pollaiuolo, while the regularity and orderliness of the figures in *Southwest Solstice* convey peace and dignity. In both cases, perspectival space has been dissolved into the primitive pictorial space of the unconscious—the dream space—but the dream that emerges from the unconscious is radically different.[15]

In short, Max's art rages with tragic conflict between all kinds of creatures and the elements of nature itself, as well as within the unconscious, and is full of fragmentation and suffering. Jimmy's art, on the other hand, struggles to articulate an ideal of unity and harmony. It is not self-evident or predetermined or given from the beginning, but hard won. Jimmy's pictures are often as full of fragmentation and signs of collapse—of impending doom under the guise of metamorphosis—as Max's pictures, but they are subsumed, or in the process of being subsumed, in a structure that, however precarious, conveys a sense of wholeness, balance, and hope. Jimmy's art rebuilds what Max's tears apart, often using the same fragments. It is an artful rebuilding and reenvisioning, to new expressive effect, of what has broken down in Max's vision. Jimmy's art struggles to present a civilized alternative to Max's discovery of the emotional barbarians and predators we are underneath our civilized veneer. In a sense, Max's vision is easier to achieve than Jimmy's, for civilization is always breaking down—war is always breaking out and exists within all of us—and is hard to build and rebuild, as Jimmy's pictures indicate.

If one compares the predatory nature of Max's *Cruel Greenery* with Jimmy's *Sea of Grass (Black-on-Black)*, 1982 (page 120), the difference is apparent at once. The sublime unity of the different strata of fertile, growing nature—different textures of water, vegetation, and finally sky harmoniously integrated while maintaining their individuality and distinctness—in Jimmy's picture contrasts starkly with the rapacious, turbulent landscape in Max's. Even greater unity and harmony are achieved in *Sea of Grass—White*, 1983, and in the nearly monochromatic *Sea of Grass—Early Frost*, 1982, where the subtle overallness and luminosity of the painting convey absolute, tranquil harmony. We are dissolved in the light, as it were, and as such are in a kind of gnostic heaven. In Max's case, the same malevolent, voracious nature as appears in *Cruel Greenery*—the same regression to raw vegetation, which consumes everything—is evident in such works as *Painting for Young People*, 1943.[16] In the end, nothing remains in Max's apocalyptic world but a bleak, infertile landscape, such as appears in *Clouds, Sun, and Sea*, 1952.[17] It is a dismal cosmic landscape that is repeated over and over. The whole cosmos is inwardly lifeless for Max, life (especially human life) on earth being a temporary accident. The abandoned earth, with no sign of human presence, sings its "contorted song" (to refer to a 1959–60 landscape of that title by Max).

The point is made even more tellingly by contrasting the coherent, harmonious layers of nature in Jimmy's *Sea of Grass* landscapes with the barely cohesive layers in Max's *Tremblement de Terre*, 1925.[18] In sum, where Max's landscape, like all the landscapes of his *Histoire naturelle* frottage series, signifies "destructive force," as Werner Spies said,[19] Jimmy's landscapes, while equally elemental, are constructive, or rather reconstructive. Jimmy discovers the potential for harmony and wholeness, or goodness, in nature, while Max always looks for the "flaw": his lines of forces are essentially fault lines, signs of weakness (as in emotional fact destructiveness often is),[20] along which nature fragments, finally crumbling into ruin. Indeed, Max shows us a nature always on the verge of ruin. Jimmy restores that same nature to wholeness, showing that it can be full of peace, plenty, and happiness; that it can be positive. Insofar as he does so, his is a "postmodern" vision, that is, the antithesis to the prevailing modern negativity, of which Max Ernst is a major representative.[21]

Perhaps nowhere is Jimmy's ambition to repair—to make whole what has been destroyed—more conspicuous than in such works as *Rimrock*, 1960 (page 76), and *Self-Portrait When Last Seen (Out of the Past)*, 1961 (page 82). In these works fragments are pieced and laced together to form a matrix, which however idiosyncratic and ungrounded, tenuous and incomplete, has the potential for structure, which emerges explicitly in *Another Silence*, 1972 (pages 104–5). Indeed, the blurred line of division latent in

Rimrock becomes the firm, decisive line with which structure is built in *Another Silence*. In Jimmy's pictures the forces of destruction and creation exist simultaneously, the latter modifying the former. In contrast, Max tends to emphasize, with almost orgasmic enthusiasm and self-recognition, the triumph of the destructive over the creative. The latter rarely exists in more than germinal form, as in *The Fascinating Cypress*, 1925, and *The Blind Swimmer*, 1934.[22] Again and again Max depicts a germ cell, whether in the form of the sun or the moon—the positive and negative of the same idea-image—or some other shape, such as that of *Shell Flowers*, 1933,[23] which however eccentric remain hermetically self-enclosed.

Both Max and Jimmy use nature as a metaphor for human nature; Max has a grim, supposedly realistic view of it, Jimmy a more hopeful, idealistic view. The point is that both are equally truthful. Max, for historical and personal reasons, emphasized the destructiveness in life—this was true to his experience of it—and in doing so he was true to himself, that is, to his own amoral destructiveness (particularly evident in his intimate relationships). Jimmy, however, because of his own personal history, emphasized the constructive in life, transcending the destructive German and personal world in which he grew up and overcoming his own destructive tendencies. His insightful autobiography is the story of how he did so. In a sense, Jimmy became a more mature (and moral) human being than Max ever was, if maturity means accomplishing "the immensely important task of integrating the life instincts with the death instincts," which is the most basic ego task—indeed, it "corresponds to the ego," as León Grinberg says.[24] Max never escaped his own death instinct, which is why his works tend to suggest an endangered ego.

Jimmy may have been a well-intentioned humanist,[25] but his humanism is contaminated with a good deal of despair, left over from his relationship with his father. Jimmy's *Icarus*, 1962 (page 83), encodes the relationship's problematic character. It is worth quoting Jimmy's unusual interpretation of the myth at length to understand the special meaning it had and the problem it posed—the fears it communicated—for him:

Icarus' destruction was the result of not having obeyed his father's commands to avoid soaring so high the sun would melt the wax that held his wings together, or so low that moisture from the sea would make them heavy. I did not endear myself to my rigid tutors [who taught him Greek mythology in the

Gymnasium] by agreeing that Icarus was indeed at fault, not for disobedience, but for having, in the first place, unquestionably trusted artificial wings fashioned by his father, Daedalus, whose genius had enabled him to entrap the monster Minotaur on Crete.[26]

Jimmy said that after noting that "only Daedalus would live to tell the tale," for it is a story told from the father's point of view, not the son's, "a strange anger suddenly took possession of me. The ancient dilemma: Should a son make use of wings fashioned by his father? I bolted from the building and delivered myself of a tirade against all painting."[27]

Expecting his mother to understand "the nature of [his] crisis," he found instead that she associated his attitude with that of the Nazis "who want to burn our books, our music, our poetry . . . the paintings, the sculpture, the architecture." She saw in her son's aggressive outburst a harbinger of the "war, a big one, not like any war before," that the Nazis wanted to make. War was on everybody's mind, and she could not help projecting her fear of it onto her suddenly warlike son. It would be, Jimmy wrote, a vicious war that would "kill, once and for all, everything human that had somehow survived after they had beaten it into the dust, and that slowly stood up again and was victorious after all." In other words, it would be a war that would destroy civilization, that would return the world to barbarism. It would be a total catastrophe for humanity. "Pictures [that] survived destruction even in the Thirty Years' War," Jimmy continued, "[that] existed for over five hundred years" will "not be so lucky" in the war Nazi Germany was planning, and "will never be seen again." The story of Icarus is a "disturbing myth," Jimmy's mother—a Jewish woman, Louise Straus-Ernst—acknowledged, but she was more interested in the very disturbed state of Europe.[28]

The threat to civilization meant more to her, no doubt with some justification, than the threat Jimmy felt from his father, which she assumed would pass. Mother and son were close, as the famous photograph made of them in 1928 by August Sander indicates (page 15), but there were larger issues—world historical issues—than the state of Jimmy's mind. Louise was too preoccupied with the Nazi threat to have much understanding of Jimmy's problems and conflict with his father, although she had her own problems and conflict with Max, who betrayed her with another woman, Gala Eluard (who would later become Gala Dalí), and

Lou Straus-Ernst and Jimmy in a 1928 portrait by August Sander, part of the photographer's photo portrait of Germany project

abandoned her in pursuit of artistic glory. Max's cruelty was nothing compared to the Nazis' potential for cruelty. Nonetheless, her remarks were profoundly influential on Jimmy: she came to represent the idea of the humanity of art.

Ultimately, she rather than Max was responsible for Jimmy's finally becoming an artist, after great uncertainty about what career to pursue; he at one time wanted to be a boxer, suggesting his tendency toward "pugnacious autonomy," as the psychoanalyst Gilbert Rose calls it.[29] It was Louise, rather than Max, who had the idea of a human art, of reconciling art and humanity, which alone justified art in Jimmy's mind, no doubt because it permitted him to preserve his own sense of humanity in an inhuman society.

Jimmy's Icarian complex, then, is crucial for understanding the twists and turns of his life and art, but so is the profound humanity of his mother, which became his saving grace, saving him from the Minotaur that his father was. For, psychologically speaking, the Minotaur is the destructive side of Daedalus, who built the labyrinth to contain his own hostility and violence. It was, as Thomas Bulfinch tells us, "an edifice with numberless winding passages and turnings opening into one another, and seeming to have neither beginning nor end, like the river Maeander, which returns on itself, and flows now onward, now backward, in its course to the sea."[30] In other words, it was like Max's art, which constantly shifted stylistic direction, now seeming more realistic in its details, now more abstract. Its impulsive surface, created by Max's famous frottage technique, was especially meandering and dense; it was an obscure labyrinth of marks and gestures that could not be easily followed and frequently led to dead ends—symbolizing, I believe, the emotional dead end of destructiveness Max found himself in—before its violent energy finally dissipated in the sea of the unconscious.

Daedalus was the most skillful artificer of his day, as his invention of flying indicates, and reputedly the inventor of sculpture. According to Bulfinch, he "was so proud of his achievements that he could not bear the idea of a rival."[31] And therein hangs a psychological parable that is extremely important for understanding Jimmy's attitude toward Max, who also could not bear the idea of a rival, as indicated by the fact that he was envious of Pablo Picasso, all the more so when Jimmy told him that it was Picasso's *Guernica*, rather than Max's own painting, that had finally inspired him to become an artist.[32] The threat Jimmy felt from Max was not entirely a fantasy, not only an expression of his anger at

being abandoned by Max, but very real. Jimmy picked up something in Max's unconscious, something that was often explicit in his response to other artists, who were his rivals. As Bulfinch wrote:

> Daedalus's sister had placed her son Perdix under his charge to be taught the mechanical arts. He was an apt scholar and gave striking evidences of ingenuity. Walking on the seashore, he picked up the spine of a fish. Imitating it, he took a piece of iron and notched it on the edge, and thus invented the *saw*. He put two pieces of iron together, connecting them at one end with a rivet, and sharpening the other ends, and made a pair of *compasses*. Daedalus was so envious of his nephew's performances that he took an opportunity, when they were together one day on a high tower, to push him off. But Minerva, who favors ingenuity, saw him falling, and arrested his fate by changing him into a bird called after his name, the Partridge. This bird does not build his nest in the trees, nor take lofty flights, but nestles in the hedges, and mindful of his fall, avoids high places.[33]

Is this story not another version of the myth of Icarus, who, like Perdix, "took flight" from a tower (where he and his father were imprisoned by King Minos)? The ending is happier. I am going to suggest it is Jimmy's "ending," except that Jimmy was always trying to reconstruct, in lofty flights of the imagination, the tower from which he had fallen, or rather off which he had been pushed by his father and the Nazis. Or else he was celebrating his safe landing, as in the *Sea of Grass* pictures, which are essentially images of a nest but with a similar sinister tone. The myth of Icarus is Daedalus's way of "rationalizing" Icarus's death, not the truth, which is that he pushed Icarus off the tower because he was a threat to him—the way Perdix was (Perdix is clearly a surrogate son, or perhaps the son Daedalus had out of incestuous union with his sister)—not because Icarus disobeyed his instructions. Sooner or later Icarus no doubt would go his own way, perhaps outshining his famous father, the way Perdix threatened to outshine Daedalus. In fact, Perdix proved more inventive and insightful—more attuned to nature, and so more able to learn from it—than he was. I am suggesting that the myth of Icarus both ingeniously hides and subtly reflects the reality of Daedalus's death wish to his son—a potential rival and a serious future threat once they made good their escape from the tower—and the fact that he acted on it, murdering his son. His treatment of Perdix shows the truth, while the

myth of Icarus is a dream—Daedalus's own dream (as Jimmy astutely realized)—that obscures the truth in the very act of revealing it. Unexpectedly, it tips Daedalus's emotional hand.

Daedalus reportedly mourned his son and "bitterly lamented his own arts," says Bulfinch,[34] but this piety and regret after the fact only confirm his ambivalence toward Icarus and his sense of superiority. Daedalus undoubtedly had a side that loved his son, as an extension of himself, that loved the son who subserviently followed instructions and had no aspirations of his own (symbolized by his flying toward the sun, no doubt prematurely). But in reality that son lost out to the side that felt threatened by and so hated him, that is, that feared being displaced by him. Love was reinstated, as required by society, after his death, when Icarus was no longer a threat to Daedalus.

Daedalus–Max may have supported Jimmy with good canvases and paint when Jimmy decided to become a painter, but it was because he thought Jimmy was blindly following in his footsteps, as Jimmy's early work suggested, rather than going his own way, showing his own ingenuity and inventiveness. No doubt that came later, when Jimmy finally made his break with his father—inwardly separated from him—but in my opinion Max never really expected it to happen, so full of grandiosity was he.

This break—the serious turning point in their relationship—came about in 1941, when, unexpectedly, Max was put in Jimmy's custody when he arrived in the United States, an enemy alien from the point of view of the Department of Immigration. The ironic story is beautifully told by Jimmy in *A Not-So-Still Life*,[35] but the point is that Jimmy, in becoming in effect his father's guardian—his surrogate parent, as it were, responsible for his good behavior in the United States—became liberated from his father's emotional hold on him. Jimmy "had never seen Max so shaken" as he was in detention in the customs inspection office at La Guardia Marine Air Terminal, where Max had arrived by glamorous seaplane with Peggy Guggenheim and her children. The scene was, as Jimmy writes, "rather funereal" (surreal?), for here was "the great man, my father," "this great artist," forced to go to Ellis Island, where he was regarded with suspicion because he had a German passport. His fate hung in the balance: would he be sent back to Nazi Germany, where he was regarded as a "degenerate" artist and was likely to be incarcerated in a concentration camp, and perhaps liquidated as an enemy of the state, or would he be allowed to remain in the United States, which he knew nothing and cared less about? The comic tale of how Jimmy came to rescue him and vouch for his "good moral character," and Max's disbelief at this turn of events, despite its happy consequence, is secondary to its salient effect on Jimmy. (Once safely in New York, Max held court along with André Breton among the exiled Surrealist painters and intellectuals, haughtily preempting the position of leader, enhanced by his relationship with the wealthy Peggy Guggenheim, who correctly felt that Max never really loved her but used her as a way of escaping occupied France.)

In effect being drafted into playing Aeneas to Max's Anchises, Jimmy was at last able to escape Max's power. Max was hardly the model of a good father, however good he occasionally was to Jimmy (usually materially, as when he bought boxing equipment when Jimmy wanted to be a boxer and canvas and paints when he wanted to be a painter). The escape became complete when Jimmy, with the help of William Baziotes, who became in effect the good father Jimmy never had, moved beyond Surrealism in his work. As he said, "my talent was still being held captive by Surrealist ghosts," by the "literary dos and don'ts" of Surrealism.[36] This ended his "childhood helplessness"[37] and unconscious dependence on Max in more ways than one. Just as Aeneas left Troy to build the new kingdom of Rome, so Jimmy left European Surrealism to help build a new kingdom of American art, which however dependent on European Surrealism—however much Surrealism was its point of departure—was a totally different artistic space. The prophecy inherent in the role reversal that occurred when Max immigrated to the United States was fulfilled when Jimmy became an American artist rather than a parasite on his father's European art and ideas. Ironically, he learned such "nonconformity" from his father, as he noted.[38] But, as he also noted, his "noncompliance" was a revolt against his father's dogmatization of Surrealism. The paradox of Jimmy's life is that he was and was not his father's son.

From the beginning I have been interested in the poetic aspect of the discoveries of man in scientific fields and through this in a reaffirmation in the belief of man's ability to use his scientific discoveries for man's good instead of for man's destruction. I have tried to invent or discover new techniques for the expression of these ideas.... I feel that the intricate design of my canvases has a certain classical quality which gives strength to the sheer poetry of my painting.

—Jimmy Ernst, 1945[1]

But, no question about it, this was jazz, pure improvisation, from some of the strangest instruments I had ever seen.... The tall player of the gut bucket occasionally vocalized with some scat-singing. I found the experience electrifying and could not tear myself away.

—Jimmy Ernst, *A Not-So-Still Life*[2]

Without any deliberate effort I found the content of my paintings shifting toward a more pronounced Abstraction.... For example, certain totally nonfigurative passages on a canvas became strongly reminiscent of the Gothic church-architecture and stained-glass windows of my youth.

—Jimmy Ernst, *A Not-So-Still Life*[3]

PART TWO

BEYOND SURREALISM

IMPROVISING NEW SPIRITUAL FORM

I T IS EASY to think of Jimmy's art as derived from Max's, and there are certainly obvious connections. As Jimmy himself said, he was "a child of Dada and Surrealism."[4] He was "prenatally conditioned," as it were, for "my mother helped to install that notorious [Dada] exhibition in Cologne when she was seven months pregnant with me."[5] Jimmy is the imperial infant who emerges from the primordial world of dinosaurs in a collage that Max made in 1920 to celebrate Jimmy's birth (page 20). On its back Max wrote: "Jimmy. Dadafex minimus le plus grand anti-philosophe du monde." Staring at the spectator, the alert, composed Jimmy is seated half-inside, half-outside the dinosaur world, a symbol at once of the womb and the unconscious—equally monstrous, magical places for Dadaism and Surrealism. The uncanny image states the dilemma that haunted Jimmy's art and life: bred on the primordial thinking of Dadaism and Surrealism, he had to rise above and abandon them to achieve his own identity.

But he could not do so uncritically, otherwise he would remain inwardly bound to them, and to Max. Jimmy defined his art not simply in opposition to Max, but also to indicate the spiritual shortcomings of Surrealism. Jimmy's art when it came into its own was less a gratuitous rebellion against Max—he had a larger cause and higher purpose—than an attempt to repair the spiritual damage Surrealism reflects, indeed luxuriates in. Jimmy struggled to make a spiritual art, a new kind of idealistic, inspirational art appropriate to the modern world. He aimed to undo Surrealism's mockery of spirituality, its degrading and subverting spirituality's ideal of healing expressed through hope for transcendence and/or transformation of the everyday lifeworld as well as self-integration. Indeed, the Surrealist satire of such spiritual aspiration—Surrealist cynicism about the possibility of healing or changing the world and the self for the better—seems to climax in the dispirited, listless, "descendental" atmosphere of Max's late landscapes. Jimmy was not simply

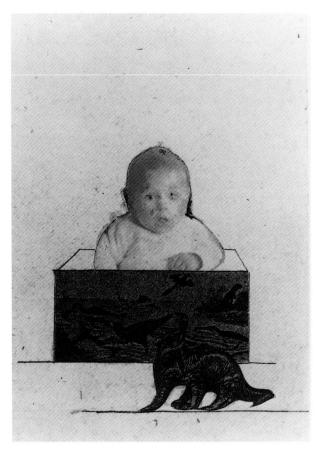

Max Ernst
Dadafex minimus (Jimmy Ernst), 1920
Collage of cutout printed reproductions and
photographs with pencil on paper,
4 ½ × 3 ¼ inches
Jimmy Ernst Family Collection

searching for an alternative to Surrealism, for the next step or "advance" in art. Rather, he was struggling to convey hope and possibility where Surrealism had settled into despair and emptiness, however disguised by mania (whether in the form of Max's excited textures or his general sense of the monstrousness of the world and its creatures, particularly human beings).

Jimmy wanted to show that it was still possible to be spiritual, that spirituality was an authentic option in the monstrous modern world, which "has debased man and trodden him into the mire."[6] Even more crucially, he felt that it was only through spirituality that one could find and be one's true self.[7] To comply to Surrealism meant to falsify the possibilities of one's self, to sell one's self short. In a sense, Jimmy's critique of Surrealism was not unlike that of Sedlmayr and other humanists, who saw in it "a complete obliteration of the difference between the sub-rational and the super-rational," and finally the collapsing of the "upward direction" into the "downward aberration."[8] Jimmy wanted to reinstate the distinction, thus differentiating himself from his Surrealist father and counteracting Surrealism's "demonic transformation of man" by re-humanizing and re-spiritualizing man, indicating that he has the capacity to move in an upward direction rather than only toward "the nether abyss."[9]

In short, Jimmy wanted an art that would have spiritual meaning, whatever its primordial impact. His ingenious achievement of such an art shows that Jimmy is in fact the son of Daedalus, but more Perdix than Icarus. Max "seemed to feel that I belonged in the American camp, and he in the European camp,"[10] but it was the difference in character between the camps that counted, and the fact that World War II showed that Europe had fallen from the sky, not America. Which is why, as Jimmy said, America did not need the fallen angels of European art to develop its own art. "It would have happened without the Europeans," he wrote,[11] because America was a place of aspiration, not desperation.

There is more to the symbolism of Max's 1920 collage: the aquarium of dinosaurs represents the primary process thinking of the imagination (and insanity), while the photograph of Jimmy represents the secondary process thinking of reason (and sanity). Max was comfortable among the monsters—comfortable with the terrors of the unconscious—but Jimmy was not, having been the victim of Max's monstrous life-style. Max could not commit himself to a "lasting relationship,"[12] not even with his own son and certainly not with any woman. He betrayed Jimmy's mother and every other woman he was later involved with. He was unable to establish a reciprocal relationship with anyone, only one on his own terms. In fact, he was contemptuous of women, however much he sexually used and emotionally fed off them: "All women have vaginas, but only in a few of them are they properly connected to their heads," he said.[13] Jimmy identified with the many women who had "suffered . . . painful rejections" by Max, and like them he was "unable to explain to anyone, not even to [himself], the rational reasons" for Max's attitude toward him.[14] As Jimmy said, "as a son I had experienced some of the terror that others, most particularly women, must have felt at the unexplained appearance of an impenetrable barrier that would freeze attempts to approach the inner person." Max "seemed always apprehensive that the end result of emotional involvements was a detestable prison," which allowed him to become detestable and conscienceless toward others. Jimmy wrote: "The human population (often victims) in Max Ernst's *Laterna Magica* had never properly understood that they were in fact only aspects of a magic slide show, likely to be discarded at the brightest possible moment."[15] Max may have been a "great artist, a man of brilliance, charm and grace," but he was also a "flawed, often hermetically cold human being."[16] That is, he was an emotional monster, if on the outside a talented social charmer (and climber).

Max's coldness—his emotional unavailability, not to say lack of support—almost drove Jimmy mad. Only his mother's support seemed to stand between him and insanity. But he also had enough instinct of self-preservation to consciously realize that he had to escape from the emotionally disturbing world of his father, a Surrealist dinosaur ready to eat alive whatever came across its path, in order to avoid becoming truly mad or ending up like Picasso's son, Paolo, whom he had met several times. He wrote of Paolo in his autobiography: "Of the same age as I, he had become a street delinquent, a thoroughly demoralized adolescent, in his inability, it was said, to meet the mercurial behavior of his father with any alternative other than outright hatred, running in tandem with utter dependence."[17] Unlike Paolo, Jimmy was determined to become independent of his mercurial father, which meant neither to hate him nor to destroy himself in lieu of destroying his father. Jimmy's mother was not always a help despite all her efforts to "clarify" Max to him. For in excusing Max's behavior on the grounds of his greatness, she only confirmed his superiority to Jimmy, all the more so because his ego was not yet strong enough to stand on its own. According to her, "the works of great masters" such as Max and

Picasso should not be evaluated "by using the yardstick of their personal life-conduct."[18] This was small comfort to Jimmy. His mother may have let Max off the hook because of his artistic greatness, accepting his personal shortcomings and irresponsibility as the price of his greatness—indeed, accepting the split in his character as the source of his creativity[19]—but Jimmy had experienced the Max who was somewhat less than personally great and had learned from the experience. Thus he was determined not to be another of Max's victims, at least not emotionally, however much he in historical fact was.[20]

Peter Blos argues that only with the "protective magical spell" of the "father's blessing" can the son find his own "personal meaning" and destiny.[21] As Freud wrote, "protection through love [is] provided by the father," and the sign of that loving protection is the father's blessing. It transmits his goodness and strength to his son as well as affirms "the manhood attained" by him.[22] Without the father's spiritual presence and love, the son feels helpless—unprotected. Max may have been Jimmy's biological father, but he was hardly his psychological father—his loving protector—however much Jimmy partly identified with him by becoming an artist. Max may have given Jimmy a blessing of sorts when, in 1941 in New York, he sent Jimmy some canvas and paint when he discovered that Jimmy had begun to make paintings,[23] but that hardly meant that he gave Jimmy the "approval, recognition, and confirmation"—offered the "responsive presence"—necessary to "instill in him a modicum of self-possession and self-assertion."[24] Jimmy had to find that by finding "substitute father imagos," the first of whom was Heinrich Augustin, "a somewhat domineering but eminently civilized and fair-minded giant of a man,"[25] who headed the prominent firm of J. J. Augustin, where Jimmy learned the craft of printing and became particularly sensitive to typography—which had great influence on his innovative conception of abstraction. The second of them was William Baziotes. Jimmy felt "most comfortable" with him and his wife, Ethel, and "could talk to them easily and, from the very beginning, there was no doubt that both, but particularly Ethel, felt very protective of me."[26] Without these surrogate fathers, one from Jimmy's old German world, the other from his new American world, as well as a surrogate mother, Jimmy would never have developed and escaped the "Surrealist ghosts" who, he realized, held "my talent" captive.[27]

If Jimmy had not moved to America he would have literally as well as spiritually died. It was above all his move to New York that was the biggest blessing. In New York he found surrogate artistic fathers, such as Matta and Arshile Gorky as well as Baziotes, and experienced a new sense of spirituality from an unexpected source: the street spirituality of jazz became especially catalytic for his art. New York, which afforded a wealth of artistic and street experiences—they converged for Jimmy—became a truly facilitating environment for him and a genuine spiritual community in which he finally found his identity and true self, ripening and individuating into his own independent person and artist. It was there that he was able to recreate his body and spirit through his art. Matta's *The Earth Is a Man* (1942; Art Institute of Chicago) was a guide to a new approach to the body—from the inside rather than the outside. Jimmy wrote: "It was a visceral interior as vast as any imaginable universe. With a surgical curiosity bordering on mania, Matta had invaded one of Yves Tanguy's enigmatic flesh machines."[28] From Matta Jimmy learned to restore his body ego (the first ego, as Freud said), which his father had insidiously destroyed through his neglect and indifference. For Jimmy the body became a sacred cathedral, however much it retained, subliminally, the catastrophic character of Matta's "cosmic nebula in breathing bursts of detonation and pulsation."[29] He learned to work with surgical precision and deliberateness rather than with the old Surrealist automatism of his father. And from the "soul music" of jazz Jimmy learned about the possibilities of spirit—discovered a new artistic form of spirituality. It was ultimately jazz that led Jimmy to make "images and spaces [that] diverged radically from the biomorphic ideas of Matta, Gorky and Baziotes (that extraterrestrial biology),"[30] however much his work was subliminally influenced by them. For biomorphic imagery and space were the abstract residue of Max's half-mythical monsters, and as such remained a substratum of Jimmy's art. But jazz was more important, for it led Jimmy to pure abstraction—visual scat.

The new spiritual expression of American jazz fused with memories of the old spiritual expression of Gothic art. In Jimmy's innovative abstraction, the fragile web of improvised jazz united with the sturdy towers of transcendence he had experienced in his German youth. It was an idiosyncratic amalgam, at once progressive and regressive in outlook, contemporary and traditional in approach, and it led to a unique brand of abstraction. Gothic jazz—this was Jimmy's achievement. It was a personal as well as artistic triumph—humanly as well as aesthetically gratifying—for to Jimmy street jazz and the Gothic cathedral were equally

warm, empathic, communal modes of art, the antipodes of Max's cold, harsh art.

One of Jimmy's most formative, influential experiences, for his art as well as his attitude toward life, occurred on the streets of New York. One day in the forties, at the Fifty-ninth Street entrance to Central Park, in the shadow of the statue of Christopher Columbus—symbol of Jimmy's own discovery of America's freedom and humanity—Jimmy witnessed the performance of "a spasm band of nine or so black youngsters."[31] It was as important a musical event for him as the snake dance of the Hopis was to be. Jimmy instantly identified with the black youths, just as he did later with Native Americans, both because they were outcasts, as he felt himself to be, and because they had made something artistically profound and innovative as well as popular and humanly appealing out of their marginality and suffering. For the enigmatic art of both drew crowds—a novelty in the modern world, in which modern art, as Jimmy repeatedly and unhappily noted, was a "minority" activity, too mysterious for the many and too elitist for its own good. Jimmy wanted an art that would have the same outreach as jazz while remaining as inwardly enigmatic—avant-garde—as it.

Jimmy joined the spasm band as "collector of contributions." This "seemed to astound the pedestrians"—a white boy working for black boys rather than the other way around, as it was supposed to be. Fascinated by jazz, one night he went with one of the band members to Carnegie Hall to hear a jazz concert devoted to "spirituals to swing." "I had the feeling of being an eavesdropper at a private event," he wrote. "More than a performance, each musician seemed to communicate far beyond instrument and voice." This became Jimmy's artistic ambition. He wanted to make spiritual music that was as full of "subtle tonalities" as the blackness of the musicians. Jimmy "felt deep empathy" with them and their private music, in which each seemed to transcend—reach beyond—himself. And he was drawn to their society, for they created a private artistic space that was closed to society yet inviting and emotionally accessible to individuals.[32]

Like the black musicians, Jimmy had "genes" that made him "an outcast," and like them he felt "lonely." Like them he could make exciting music out of his loneliness, if in a different medium: "And suddenly, on this new island of refuge, I had come face to face with the pain of the rejected, expressed through a music that I had heretofore associated only with dancing."[33] But the dancing of the Hopis also expressed rejection and loneliness, even as it

transformed and transcended them by turning them into music and dance. Instead of passive acceptance of their fate as outcasts and social rejects, they made a unique, rare, exciting—hyperactive—art that appealed to the lonely outcast and reject in everyone.

Spasm music and dance had a certain resemblance to Surrealist automatism, but they were more ritualized—ceremonial, and so communal—than automatism, which articulated the asocial, autistic unconscious. With spasm music and dance, Jimmy was finding his way out of the dream world of Surrealism, toward the halfway house of a communal art—an art that spoke for the community of hurt, rejected human beings within the larger society, affording them consolation and a sense of transcendence, which gave them hope and made them feel real however implicitly "unreal" they were to society. They had turned their suffering into creativity, or rather their suffering catalyzed their primary creativity, as D. W. Winnicott calls it,[34] which allowed them to recreate themselves—to personalize their spontaneity—and to assert their true selves in defiance of society's falsification and betrayal of them. Spasms of creativity became a way of survival, as it were; improvisation became the truth of the self as well as of creativity. That is, the self could only be improvised in a society that rejected it, just as spirituality could only be improvised in a secular modern world. Jimmy's art was also spasmodic spiritual swing. It, too, perpetually recreated an always tentative, because always rejected, identity, whether it be that of the black, the Native American, or the artist—all social outcasts in Jimmy's mind.

But Jimmy's sense of the spiritual—his need for a spiritual community—had formed long before he arrived in New York. New York reawakened—invoked—it. The city's skyscrapers were "strange castles," "towering monoliths" and "totems" that reminded him of "the symbolic Gothic spires of my childhood," even though, in their "brusqueness" and "utter self-confidence" they conveyed "a concept of order and logic for which no rules had as yet been written, defiant of human scale, with allusions, in stone, of impatience and cynicism toward ordained limitations."[35] Jimmy never lost his nostalgia for the Gothic spires, for they represented the community of which he had been deprived when he was an unknowing infant and child.

Again and again in Jimmy's *A Not-So-Still Life*, medieval churches and sometimes medieval castles are mentioned, in a kind of persistent if varied refrain of memory. They, more than any surrogate father, did what Max could not do; they gave Jimmy a sense of personal destiny while satisfying his need for a loving community.

Religion became the paradoxical site in which one could be one's true self without being exploited or cast out of the community for one's "difference." Jimmy wrote about the time when Maja Aretz, the Catholic woman who cared for him while his mother worked after Max had left him and his mother, "took me to the country, where we stayed with her mother and sisters. Across the road was a walled-in abbey of monks who had dedicated themselves to the care of the mentally disturbed....I began going to the lovely chapel almost daily and then, regularly, to vespers and Sunday masses."[36] Later he "went to many of Cologne's beautiful churches to hear musical masses or to see the wonder of stained-glass windows and altarpieces by the Rhenish masters. The church bells, particularly those of Cologne's pride, the majestic Dom, became as much a part of my life as the voice of the cantor."[37] Jimmy's mother was Jewish, and she took him to the synagogue as well as the churches on the principle that he would choose between Judaism and Catholicism—Max's religion—when he grew up.

It is worth noting that the thread of religion and a sense of the sacred flow through Max's life as well as Jimmy's, entwined with a sense of being an outcast and thus strangely special, no doubt in part because one needed special care. Max's father, a devout Catholic—just as Jimmy's mother's father was an orthodox Jew—had painted Max as Jesus Christ when he was a child. Max's father "was the principal of a state-run school for deaf-mutes"—another kind of social outcast, reject, misfit—"but his real passion was painting. Apart from commissioned portraits, he produced very beautiful landscapes and skilled copies of sacred paintings, particularly those from the Vatican."[38] Surrealism, of course, was a kind of church—Breton was called its "pope"—and when Max joined the Surrealists to find the comprehensive myth of his time, he was acting like a good Catholic in need of a total world picture, or *Weltanschauung*. In fact, the Surrealist attitude toward the mystery of the unconscious (made artistically and miraculously conscious and self-conscious) was as superstitious, scholastic, and devout as the Catholic attitude to the mystery of God (spirit made consciously and self-consciously suffering body). Max's paintings were as sacred in spirit as those of his father were in the letter. His landscapes can be regarded as the antithesis of those of his father, just as Jimmy's landscapes can be regarded as the antithesis of Max's, that is, a return to his Catholic grandfather's idea of sacred beauty, if now modern rather than traditional in character. All the Ernsts, in their different ways, were religious painters—indeed, medievalists.

Jimmy always cherished the religious experience and the sense of sanctuary and healing religion conveyed, all the more so because it was associated from the start with the care of the mentally ill—the refusal to abandon them, to treat them as social rejects, but rather to bring them into the community by caring for them. As a boy he built religious structures in the center of his room, which was an altogether private domain, a sanctuary from the world and suffering, "a fortress, a world unto itself." He built "fantastic and precariously balanced high structure[s]" of "wooden blocks or a constantly expanding erector set."[39] They had pride of place, along with his "precious collection of primitive carvings from various parts of the world that were gifts from Lou's museum friends." Clearly, these ritual objects put him in the proper frame of mind for the primitive snake dance and equally primitive spasm music. Jimmy explicitly associated his soaring, uncertain structures, which embodied at once his sense of awe and aspiration and his precarious psyche, with church steeples and skyscrapers.[40] They were "complicated monoliths," and they became the transpersonal alternative to the "mysterious personal biomorphy" of Surrealism, symbols of spontaneous assertion that countermanded its "overly literate dicta."[41] When, in 1936, the Museum of Modern Art staged the exhibition *Fantastic Art, Dada and Surrealism*, Surrealism had "the unmistakable aura not of an alive movement but rather of a closed circle of licensed practitioners."[42] Ironically, conservative, obsolete, outcast religious art, full of "medieval" longing for transcendence, had more future potential—emotional as well as aesthetic—than radical, thoroughly modern art. The modern was over; what was needed was an amalgamation of it and the traditional.

Jimmy's major abstract murals—among them *Across a Silent Bridge*, 1957 (pages 66–67); *Painting with a Secret Title*, 1957 (page 69); *Overnight*, 1961 (page 81); *Icarus*, 1962 (page 83); *Silence at Sharpeville*, 1962 (page 84); and *Another Silence*, 1972 (pages 104–5)—are thus a complex compound of the modern and the traditional, the latter inspiring and intermingling with the former. They evoke at once the architecture and stained glass of the medieval churches Jimmy saw as a boy—"a magic environment of constant surprises,"[43] like the visionary architecture of Frederick Kiesler, who had taken Jimmy under his wing—and the scat singing of jazz. That is, their visionary architecture is improvised; it is in constant process of unfinished construction. As such, it is simultaneously Expressionist and Constructivist, and thus "postmodern" or transmodern—a hybrid that brings together what in modernity

were supposed to be separate and at odds, or kept pure, as Theodor W. Adorno argued.[44]

Even more, Jimmy's spiritual architecture forms a matrix of bodily tissue, signifying his recreated body ego, as I have suggested. On its most microscopic level it recreates Jimmy's first watery experience with his parents. As Gilbert Rose writes, Jimmy thought that his visionary architecture "looked partly like transparent skin," in which "underlying structures and occasional bleeding points [were visible] within the fragile and intricate network of crosshatchings" (a sign of his knowledge of German prints and of printing). They "reminded him of water spiders on the surface of a pool," and thus of his mother and father "standing knee-deep in water," his mother handing him to his father and he refusing to be in his father's hands (which is, in a sense, the story of his life).[45] The "water spiders on the surface"—it is they who improvise or scat sing the meandering abstract web that gives the surface depth—are a telling detail that "stood out with particular clarity in his mind. External evidence established that the incident took place at the age of two, during the same summer that the father had abandoned the mother and infant son. The mother later died in a Nazi extermination center,"[46] thus overloading the original painful memory with an extra layer of suffering. As Rose says, Jimmy's "paintings provided a glimpse into the pool of time behind the skin."[47] Indeed, the deep pool was still alive with water spiders for Jimmy, only their striations or movements now seemed to be blood and tears in one—the blood his mother shed, the tears of mourning he shed for her and for the unhappy past.

But Jimmy's visionary architecture is not only full of misery and suffering; the deep pool not only marks his mother's unknown grave, as Rose suggests. It is not only Jimmy's unconscious, in which she swims, half-alive, half-dead, a ghost haunting him to his dying day. Jimmy's spiritual architecture is also a joyous macrocosm of towering, dancing totemic figures that present a final statement of his primitive yearning for community. In short, Jimmy's murals—and a mural is communal in spirit, in comparison to an easel painting, which is meant for individual edification and enjoyment—are an extraordinarily dense, overdetermined synthesis of numerous contradictory impulses; they are a remarkable achievement of multidimensionality and integration. It is in and through their sacred space and structures that Jimmy healed himself, that is, overcame his feeling of abandonment and helplessness by turning it into a form of transcendence. In his murals he is all the rejected figures he ever identified with—from the mentally disturbed people in the abbey and the deaf mutes in his paternal grandfather's institution to the blacks on the New York streets and the Native Americans on the Western reservations—but also their spiritual caretaker and healer. His visionary architecture embodies and contains them, and thus gives body to his suffering and self-containment.

Fortune, that serpentine and crooked line whereby He draws those actions His wisdom intends in a more unknown and secret way.

—Thomas Browne, *Religio Medici*[1]

Examine once more those ugly goblins, and formless monsters, and stern statues, anatomyless and rigid; but do not mock at them for they are signs of the life and liberty of every workman who struck the stone.

—John Ruskin, "The Nature of the Gothic"[2]

That aspect of trauma that is never resolved or resolvable, far from being a lamentable impediment, is a universal predicament that provides a driving impetus to mastery.

—Peter Blos, "When and How Does Adolescence End"[3]

PART THREE

DEVELOPMENTAL OVERVIEW
FROM UNCONSCIOUS EPIC TO LYRICAL CONSTRUCTION

DEVELOPMENT is rarely in a straight line, and Jimmy's development was no exception, as Vivien Raynor suggests in her perceptive review of a large exhibition of paintings and works on paper by him:

> Ernst, like Masson and other émigré Surrealists, has an erraticness that makes him hard to pin down chronologically as well as stylistically. But though he occasionally "quotes" the blotted and squeegeed effects pioneered by his father, he is less a Surrealist than an abstractionist. And if the essential Max is in the frightening, seamless collages made from turn-of-the-century magazine illustrations, the true Jimmy is the persnickety craftsman packing canvases with gray shapes like scales or feathers and superimposing on them designs resembling scaffolds. These quietly colored, slightly Japanese-looking canvases are his best works.[4]

But Raynor does not grasp the full implications of Jimmy's development of an independent abstraction, which at once recapitulates and moves beyond his father's Surrealism. Abstraction deals with the mystery or "secret"—to use a word that appears in the titles of many of Jimmy's paintings—of transcendence to a spiritual height of self-understanding and self-integration, rather than of descent into the unconscious depths in which the control and sense of self are lost, indeed, deliberately forfeited, as in Surrealism. Jimmy is eager for enlightenment, while Max accepted darkness. Enlightenment is difficult to achieve and sustain, though we are all susceptible to darkness, which easily overtakes everything, especially our minds.

This is why Max already had a sure sense of identity in his twenties—his early, most revolutionary art is that of a glorified adolescent—while Jimmy had to wait until his forties to truly come into his own, that is, had to achieve maturity and strength of self before

Hieroglyphics, 1950
Gouache on black paper,
18 × 21 inches

he could make significant paintings. In a century in which avant-garde and youth are synonymous—in which there is more art made for adolescents than adults, as I have argued[5]—Max's art necessarily seems more significant than Jimmy's. But now that the avant-garde has become a cliché and dead letter, and youth seems increasingly problematic and pretentious, Jimmy's mature works—complex images that speak to the adult struggling for mastery rather than the adolescent wallowing in obvious trauma—will take their important place in the history of art. Raynor describes Max as having "the look of a temporarily sated predator," while Jimmy is "kindly faced."[6] Though the predator continues to be honored—indeed, an ideal—in our society, whatever his walk of life, kindness is more than overdue to come into its own.

Jimmy's shift from a labored, belated Surrealism, evident in his essentially adolescent work of the forties (change becomes apparent in the fifties), to the fully realized constructions of the sixties and beyond is, paradoxically, a regression toward symbiotic intimacy with his mother as well as a final accommodation and assimilation of his father's angry Surrealism. The shift from the predatory plant of *The Flying Dutchman*, 1942 (page 37), to the self-elaborating, proliferating lines of *Painting with a Secret Title*, 1957 (page 69), is a shift from Max's phallic aggressivity to the loving matrix Lou signified. Slowly but surely he filled the picture with elusive, figurelike structures, coming together into a kind of scaffolding, as Raynor says—but it is not yet stable and complete, sturdy and enduring, but rather tentative and thus lyrical.[7] In this and similar works, Jimmy is in effect building—or rather rebuilding—the nest he lived in with his mother in Germany.

The new, American-made nest is full of ambivalent, restless energy, suggesting at once uprooted figures and, under them, a new ground, rising out of nothing. They are haunting, subliminally grotesque, anatomyless expressions of a new-humanity-in-the-making, as exemplified by *Self-Portrait When Last Seen (Out of the Past)*, 1961 (page 82). They are indeed featherlike, as Raynor suggests, and convey a sense of construction, as does *Rimrock*, 1960 (page 76), of roughhewn stone piled upon roughhewn stone—raw plane or shingle piled upon raw plane or shingle (not scale, as Raynor suggests)—to form a kind of eccentric Cubist structure, New England stone fence, and Colonial shingle house in one. No mortar holds the pieces together, only careful placement. The structure will stand or fall on the basis of its seemingly natural however subtly calculated unity. In 1965 Jimmy wrote that it is the "duty" of the artist "to advance the adventure of the human spirit by forever curiously testing new opinions and courting new impressions. . . . his success or failure [depends upon] . . . how the stones he has thus formed fit into the structure of the house which he shares with all of humanity."[8] In Jimmy's constructions the building blocks, whatever they may be—stones, shingles, feathers, planes, lines—are peculiarly crude and refined at once, being freshly carved and in the process of being tested. Will they be strong enough to support and become part of a structure grander and more important than themselves, or will they have to be discarded as having no place in the house of humanity? That is the question Jimmy's 1960s constructions raise; indeed, they embody the question of the shape and reliability of the future house of humanity—will it really protect humanity from itself?—and Jimmy's questionableness to himself as well as his quest for an independent sense of self.

In short, the works of the 1960s show Jimmy's self-questioning contribution to the house of humanity, which itself has become questionable. It is in the process of being rebuilt in modern terms—necessarily so, for the old ones are no longer viable, indeed, make no sense, in the modern world. Jimmy's nest house has its affinities with the idealized, solidly built cathedrals of his youth, as he was aware—his mother and woman in general were clearly associated with them. But it is a modern cathedral, somewhat less solid and built from scratch (literally, it seems, for Jimmy's striations have an incised or etched look). It is, ironically, jerrybuilt (German-built), for the traditional cathedral lost its sacred meaning in the destructiveness of World War II, more particularly, of Germany.

The equivocal lyricism of Jimmy's mature pictures is a repudiation of the epic, Germanic aspect of Max's art. It is as though Jimmy dissolves Max's aggressive figures back into the matrix of touch from which they emerged and uses a less rough touch to build potentially more human, however tragic, figures—like the luminous figure of Icarus. Despite this, Max played a secondary role in Jimmy's artistic development, as indicated by the fact that Picasso's *Guernica* was the catalyst that transformed Jimmy into an artist. Max was an unavoidable given, but other artists were greater influences. It is normal that Max's influence be evident in such 1940s works as *Surreal*, 1942 (page 41). His influence is particularly conspicuous in a number of untitled figurative drawings and painted landscapes, including *Untitled (Blue Max)*, 1942 (page 38), and *Untitled*, ca. 1942–43 (page 40). But already by the end of the 1940s Jimmy was moving, however awkwardly and

uncertainly, beyond Max and Surrealism toward more all-over, abstract expression, as indicated by several untitled gouaches and *Counterpoint* (page 47), all 1949. Jimmy acknowledged the influence of Baziotes in making this move, and especially the "heavy influence" of Matta's "morphological approach," which "left the narrow scope of figuration behind for a world of as-yet-unseen realities."[9] Stanley William Hayter, "the great graphic pioneer," was also crucial in the transition from, in Jimmy's words, "the orthodoxy of a dying Surrealism and the about-to-be-born art of the School of New York.... Hayter had taken the Surrealistic tool of automatism a giant step away from its dependence on Freudian interpretation toward the idea, long cherished by artists, that a work of art be self-subsistent, released from the demands of all-too-limiting cross-references." Indeed, Hayter's "linear energy-storms," as Jimmy called them, were a direct model for his sixties constructions.[10]

But I want to suggest that these influences, however important, were secondary. The deeper influences, however subliminal, were Matthias Grünewald's Isenheim altarpiece (in Colmar) and Piet Mondrian. The dervishing figures, at once angelic and demonic, emerging from the stormy mists in many of Jimmy's constructions, and the appearance of the cross in many of them—*Across a Silent Bridge* and *Silence at Sharpeville* (pages 66–67, 84) have both—as well as their intricate, forceful use of vertical and horizontal lines, convey the influence of Grünewald on the one hand and Mondrian on the other. Jimmy is neither a purist nor an imitator, and so the similarities are inexact and erratic. Jimmy uses vigorous diagonals—anathema to Mondrian (except in the later diamond-shaped paintings)—and his iconography is far removed from tradition, but the same sense of religious drama and tension pervades and structures his works that pervades and structures those of Grünewald and Mondrian. Jimmy has perhaps more kinship with Grünewald's violence than with Mondrian's quiet transcendence (which was not so quiet in his last years), but both helped focus his sense of existential purpose.

Jimmy acknowledged that "the most important painting in my life is the Grünewald Altarpiece."[11] Hari Scordo, in his master's thesis on Jimmy Ernst, perceptively remarks that many of Jimmy's figures derive from the "raised stick-like appendages in the gesture of Grünewald's *Rising Christ*" as well as the "stick-like representations" used in Native American sand paintings.[12] In the altarpiece, Jimmy was "especially intrigued" by "the mysterious chamber pot next to the Virgin Mary's bed with its Hebrew characters."[13] I

believe these Hebrew letters, which clearly had an association with his Jewish mother and represented his Jewish side, were the basis, however unconscious, of the enigmatic emblems or strange symbols that appear in many of the constructions. They are a kind of sign from God, at once a catastrophic handwriting on the wall and burning bush guiding one through the wilderness in the pictures. It is as though the lines were words in a strange, incomprehensible Hebraic chant, evoking an image of the *deus abscunditas*—the mysterious, all-powerful God whose name cannot be spoken or even written in its proper form. Grünewald's influence is pervasive in Jimmy's sacred constructions, in terms of both their space and ideology, for Grünewald's holy picture, placed in a hospital for the desperately ill, symbolized the course of healing in depicting the transition from the grimly crucified body of the rejected Christ to the luminous, resurrected, and disembodied Christ who will save us from ourselves and each other. Jimmy wanted his grand visionary constructions, which also fused suffering and healing—destructive and reconstructive forces—in one singular space, to have the same "consummate magic" and "immediacy and universality"[14]—profound, transformative effect—as Grünewald's altarpiece.

The influence of Mondrian is more subtle and indirect. Jimmy was apparently witness to a meeting between Breton and other Surrealists and Mondrian. Asked what he thought of Surrealism and in particular Yves Tanguy's paintings, Mondrian replied that they were "too Abstract" and "too cold" for him.[15] Breton was astonished, for he regarded Mondrian as the epitome of an abstract painter—no doubt Breton thought that all geometry was cold—and felt that Mondrian aimed "to cleanse the vision absolutely of the irrational and that . . . means dreams as well as reality."[16] But Mondrian refused to accept this, declaring that there was more than one way to define abstraction and that his in particular involved "a deep involvement with reality."[17] I believe this made a deep impression on the young Jimmy, as did Mondrian's acceptance of a painting by Jackson Pollock for the first Spring Salon (1943) in Peggy Guggenheim's Art of This Century Gallery. Mondrian, who was one of the exhibition's jurors, defended his choice to Peggy Guggenheim—she was as surprised by it as Breton was by Mondrian's conception of Tanguy's work—with the statement "where you see 'lack of discipline,' I get an impression of tremendous energy."[18] This was in effect the first recognition of the New York School, which Jimmy defended in similar terms: "where others saw 'rawness,' 'lack of discipline,' or 'chaos,' I felt a sense of 'imme-

diacy' and 'action on the canvas.'"[19] Mondrian showed Jimmy that it was possible to deal with irrationality abstractly, that it could be controlled and that there was some kind of structure to its conflicts—thus the latent geometrical structures of Jimmy's visionary cosmos—and that it was a limitless source of energy, which could be harnessed for humane as well as aesthetic purposes. Where Max offered dreamlike images that mystified and falsified the unconscious by conceiving it as entirely destructive, for Jimmy Mondrian exposed the true dynamics and libidinous possibilities of the unconscious. He showed a constructive new understanding of it that saved Jimmy from Max.

Jimmy's experiments with energized structures occurred throughout the 1950s, noteworthily in the gouaches of the period, such as *The Circus II*, 1952 (page 53). Also, as in *Hieroglyphics*, 1950 (page 27), there are numerous attempts to create a sensational symbol, one resonant with emotion and energy, full of inchoate and unconscious meaning. The works dealing with mountains and nature at large are particularly successful in that they make the abstract character of reality transparent, as Mondrian wanted to do in a more fundamentalist way. *Thinking*, 1954 (page 58), is a particularly Mondrianesque work, which also seems to owe a certain amount to Mark Tobey's "white writing," as it has been called. Many works show an idiosyncratic interpretation and integration of Mondrian's geometrical realism and Max's Surrealism, for example, a gouache from 1951, *Honky Tonk* (page 52), and the 1949 gouache *Counterpoint* (page 47). In the 1960s Jimmy subsumed both in his own dialectic of energy and structure, creating consummate works such as *Monongahela*, 1960 (page 74), and *Nightscape IIIA*, 1969 (page 100). Native American symbolism, spasm music, and sacred space had become seamlessly unified, with great aesthetic sophistication. Jimmy had achieved his integration, thereby saving himself.

His identity as man and artist was never again in doubt. He could even deal tranquilly with his exile from his native country in such works as *Exile*, 1974 (page 108). And in *Silent Protest*, 1976 (page 111), he could concentrate all his mysticism and idealism to social purpose, as he had done earlier in such works as *Silence at Sharpeville* (page 84). Jimmy understood *The Importance of Silence*, 1963 (page 87), *Before It Is Too Late*, 1976 (page 112). For silence, which was a recurring theme in Jimmy's art—it is a basic modernist theme—signals not only the incommunicado space of refuge in which one's true self cannot be found out, as Winnicott says, but is also a way of witnessing and mourning the horrors of history and their devastating effect on the individual. Jimmy's mature abstract art, whether the silence of nature is its manifest theme or the silence of sacred space its latent theme, is a form of "'witnessing' presence," as Gilbert Rose calls it, that is, an artistic mode of "empathic interaction."[20] In eloquently integrating geometry and gesture—structure and energy—Jimmy achieved what Rose calls "feelingful awareness" or genuine "resonance,"[21] a rare enough achievement in modern art, especially abstraction, which indeed, as Mondrian implied, tends to be cold and unfeeling.

Jimmy's intense silence, then, is an expression of empathy as well as of suffering—silent witnessing as well as silent suffering. But then he was never really silent, for abstract art at its most empathic is silent protest against social and existential terror, which is the only way to be heard in a noisy, indifferent world. Abstract art alone invites us to see and remember in a world full of unsightly events we would prefer to avoid and forget—to blind ourselves to rather than inwardly witness in authentic silence. The drawings Jimmy made in 1978, when he was hospitalized and in fear for his physical life—as, many times before, he had been for his psychic as well as physical life—of an abstract, forsaken Christ fallen silent and turned inward on the cross make the point succinctly. Jimmy's visionary abstractions speak to all those who suffer pointlessly and need redemptive acknowledgment of their suffering—need a vision that will acknowledge the misfortunes of their existence, indeed, that befall every existence, yet show that some good can come of their suffering and pain.

Jimmy's abstractions come close to being theodicy. They are perhaps best understood in terms of Daniel Bell's idea of "the return of the sacred," that is, "the space of wonder and awe, of the noumenal that remains a mystery and the numinous that is its aura."[22] Is the sacred the only hope for art, once "the art which is drawn from the subconscious," the art that has as its "price...the inability to establish a human relationship"—Max's art—has exhausted itself in "sterility and derangement?"[23] That is the issue Jimmy's visionary abstractions raise. They are a form of psychic virtue, for they express the triumph of faith, hope, and charity—human community—over the devils in society as well as the unconscious. If, as Winnicott said, the problem of life is to accept one's solitude without remaining insular, then Jimmy solved the problem, at least artistically.

NOTES FATHER AND SON

1. Erik H. Erikson, "On 'Psycho-Historical' Evidence," in *Life History and the Historical Moment* (New York: W. W. Norton, 1975), 154.

2. Wallace Stevens, "Tradition," in *Collected Poems and Prose* (New York: Library of America, 1997), 595–96.

3. Jimmy Ernst, *A Not-So-Still Life: A Memoir* (New York: St. Martin's/Marek, 1984), 187.

4. In his autobiographical notes, Max wrote: "(1914) Max Ernst died on the 1st of August 1914. He was resuscitated the 11th of November 1918, as a young man aspiring to become a magician and to find the myth of his time"; quoted in Elizabeth M. Legge, *Max Ernst: Psychoanalytic Sources* (Ann Arbor: UMI Research Press, 1989), 2. The dates, of course, mark the beginning and end of World War I. Max served as a soldier in the war and blamed it on his father's generation. His father was in fact a German patriot. He was proud of the Iron Cross Max won and upset when Max rejected the medal and repudiated the war. Jean Arp, Max's friend and fellow Dadaist and Surrealist artist, remarked that Max's art, in the decade after World War I, was a symbolic castration and cannibalizing of his father. Referring to Max, Arp wrote: "one doesn't consume Sir Father, except slice by slice: impossible to finish him off in a single picnic"; quoted in ibid., 10. Arp was alluding to the cannibalistic myth of the sons devouring the father in Sigmund Freud's *Totem and Taboo*. Max, who was psychoanalytically knowledgeable, probably also read this work.

5. Werner Spies, *Max Ernst: Oeuvre-Katalog*, 5 vols., vols. 2–5 with Sigrid and Günter Metken (Houston: Menil Foundation, 1975–98), S-2395, S-3127.

6. Ibid., S-615, S-2377.

7. Ibid., S-2410, S-3822, S-2153, S-2154, S-2474.

8. Hans Sedlmayr, *Art in Crisis: The Lost Centre* (London: Hollis & Carter, 1957), 153–58 passim.

9. Ferdinand Tönnies, *Community and Society* (New York: Harper & Row, 1963), 33–34.

10. Ibid.

11. Ibid.

12. Ernst, *A Not-So-Still Life*, 130. Jimmy's 1938 visit to the Hopi and Navaho reservations, where he witnessed the Hopi snake dance—an "almost Surrealist spectacle," he said (ibid., 128)—was an important formative experience in his life and art. He internalized the stoicism and nature worship of the Native Americans. On the one hand, they were able to "stoically endure pain" (ibid., 126). Indeed, the ceremonies of the Indian Penitentes, who literally acted out the suffering of Christ, caused Jimmy to "instinctively recall the Crucifixion panel of the Isenheim altarpiece by Grünewald wherein Christ is also covered with the sores from thorns, lashings and spikes driven through his hands and feet" (ibid., 125). On the other hand, they had faith in nature and depended on its miraculous fertility for their existence, as indicated by their fertility rituals and kachina dolls, which represent the shamans who performed the rituals. (Jimmy depicts them in a nostalgic mist, idealizing mystification, in *Kachina*, 1982, as well as in the *Southwest Solstice* frieze, [page 122].)

The Native Americans gave equal artistic voice to their death instincts and life instincts, striking a balance between them and thus overcoming their opposition. For them, faith followed despair the way summer followed winter, an emotional cycle of depression and mania that correlated with the physical cycle of nature and articulated the antipodes of individual identity. These extremes of nature and human nature, which seemed different manifestations of one and the same divine spirit to the Native Americans, were symbolized in communal and religious ceremonies, more particularly through the performance and body of the shaman. Like them, Jimmy learned to suffer without losing faith, to stoically endure without losing the will to live. Nor did his personal suffering cause him to lose his feeling of belonging to and his dependence on an intimate community of artists and intellectuals, however small it was within the larger society. (Jimmy repeatedly emphasized, with a certain sense of despair and impotence, that the community of artists and intellectuals was a minority culture within a popular culture.)

This sense of artistic community, of identification with an elite group of people who privileged their own vision of the lifeworld, never failed to sustain him. As a child, he grew up surrounded by the community of Surrealist artists associated with his father, absorbing the Surrealism in the atmosphere by osmosis, as it were. As an adolescent, he was part of the community of exiled German artists and intellectuals associated with his mother, who lived in Paris. Always full of faith in humanity—clearly not justified by her own fate, which was to die in a Nazi concentration camp—she held the depressed group together. And as an adult Jimmy was one of the so-called "Irascible Eighteen," famously photographed at the Museum of Modern Art in 1951. All these communities were riven by conflict and competition, but they remained a source of personal faith, hope, and charity for Jimmy—something to fall back on in fantasy, however difficult they were in reality. The Native American community in effect epitomized Jimmy's consistent sense of community identity, whatever the historical and emotional vicissitudes of his life.

It is worth noting that when the integrity of the community was threatened by the elevation of one of its members over the others, Jimmy felt it had sold out to society, or at least been seriously compromised and falsified. Thus, in an obituary for Jackson Pollock published in the *Denver Post* one week after his death in 1956, Jimmy wrote that he admired Pollock for reaching "that secret place" within the self "where language no longer needs sound and where eyes no longer depend on sight alone" (the same place he thought he had reached)—an achievement of inwardness made possible by the support of the artistic and intellectual community. But he also deplored, without rancor and envy I believe, "the transformation of a talented alcoholic into a 'Kultur'-hero," which was "the real beginning of the denigration of the American artist," as he wrote to Frank Getlein on April 5, 1967, on the occasion of the Museum of Modern Art's retrospective of Pollock's work (copy in Jimmy Ernst Archives). He told Getlein that he felt the loss or devaluation of "privacy" involved in bringing "Kultur in dem Lustpalast" was a form of "degradation." "In glorifying [Pollock's] 'savagery,'" the letter continued, "the nouveau-riche rabble found that admittance to culture was now as easy as greasing the maitre d' to let the rope down and escorting them to a front seat," which ignored the reality of the life of the "artist-stripper"—Pollock for Jimmy was a "turbulent," disturbed alcoholic—and more crucially the ambiguous truth about his art. For Jimmy, Pollock's work was simultaneously "symbolic of a freedom which denies any narrowly proscribed continuity for creative thought" and "the sand-painting [of a] pseudo Navajo from Wyoming." That is, Pollock's art was both authentic—an expression of his "utter loneliness"—and inauthentic, that is, dependent on a primitive art he did not truly comprehend. No doubt Jimmy felt implicated in Pollock's dilemma—in his peculiar mix of true and false selfhood. There was also no continuity in Jimmy's creativity, for he moved between styles, often mixing Realism, Surrealism, and abstraction, and he too felt indebted to Navajo art. But the point is that Jimmy respected and maintained its communal meaning, while for Pollock Native American art had a strictly personal, private meaning, which was to sell it short and betray the larger meaning of art.

Jimmy probably associated, no doubt unconsciously, the Hopi "summer ritual asking for the miracle of rain to give fertility to the soil" (*A Not-So-Still Life*, 130) with his earliest memory. It was of water, more particularly of being "in a lake, in a pond, very still water, with insects skating on the water" (Jimmy Ernst with Francine du Plessix, "The Artist Speaks: My Father, Max Ernst," *Art in America*, November 1968, 54). As he said in a statement

written on August 27, 1983, since he was a child he was "intrigued by bodies of water washing against reeds, grasses and trees" (manuscript, Jimmy Ernst Archives). (His *Sea of Grass* series of 1982 [page 120] lovingly deals with this primitive experience.) I believe it symbolized a harmonious convergence of opposites, quite unlike the relationship between his mother and father, and his preference for the former rather than the latter, however much he grew to accept—though not without resignation—Max. For his "very first childhood memory" is not simply of water, but of his "father standing up to his waist" in it and his mother handing the infant Jimmy to Max, when the infant "didn't want any part" of his father, didn't "want to go near" his father, and "screamed [his] head off" to make his position unmistakably clear (Ernst with du Plessix, "The Artist Speaks," 54). (As an adult, Jimmy abstracted the pleasurable, life-giving water—unconsciously identified with his mother—from the larger emotional and human reality of the situation. He used water, idealized, to deny—altogether blot out of awareness—the painful, "outrageous" [Jimmy's term] reality of his father. His dreamy ponds and lakes hold a secret: at their bottom lies the drowned, murdered body of his father.)

This instinctive rejection of his father contrasts strongly with his later impersonal adult acceptance of Max as a "great artist" to be forgiven everything, which is the way everybody thought about Max and thinks about "great artists" in general: their inhumanity and cruelty to others is excusable because of their apparent "genius." Max's behavior, in which people were dispensable but art was indispensable, is in fact typical of the artist. As Heinz Kohut writes in *The Restoration of the Self* (New York: International Universities Press, 1977), 277, the artist's "enormous narcissistic involvement in his own creativeness" comes at the expense of human relationships: "his self-extensions relate only to his work and to those people who can be experienced as aspects of his work." (In Max's case, they were mostly women, whether as symbols of his "natural" creativity, for example, Leonora Carrington, or as instruments of his career, for example, Peggy Guggenheim.) Or, as Melanie Klein writes in "Love, Guilt, and Reparation" (in *Love, Guilt, and Reparation and Other Works, 1921–1945* [New York: Free Press/Macmillan, 1975], 322), the artist has "little interest and love to spare for his fellow men."

Jimmy's triumph—it was a triumph over his father as well as the artist's narcissistic hubris—was to be an atypical artist: to be humane without sacrificing the intense narcissistic investment and concentration necessary to make important art, to seriously make art but not at the expense of one's humanity. That is, Jimmy was able to transform narcissism into

creativity, overcoming feelings of vulnerability, self-depletion, and inadequacy, without sacrificing other people to his insatiable creativity. As Kohut says, creativity is a way of dealing with "self-defects," and as such it is a form of self-healing (*Restoration of the Self*, 277).

I believe it was his experience of Native American art that made the triumph possible, allowing him to balance his narcissism and individuality with a sense of community, that is, to be creative within a communal context, indeed, to make art for other people, not just for himself. As Jimmy writes, "for all of its anonymity" Native American art was made "by individual human beings with a force that eclipsed mere dogma [ideology]" (*A Not-So-Still Life*, 126). A "personal expression" that served an interpersonal and communal purpose, it became the model for Jimmy's art, along with medieval art. It achieved and represented a similar synthesis of self and community without sacrificing one to, or raising one over, the other.

13. Tönnies, *Community and Society*, 34.

14. Spies, *Max Ernst: Oeuvre*, S-1880.

15. See Stephen J. Newton, *The Politics and Psychoanalysis of Primitivism* (London: Ziggurat, 1996), 20, for a discussion of the distinction, as well as the surreal recovery of the archaic space of the unconscious—evident in Egyptian, Byzantine, and other Archaic arts, as Anton Ehrenzweig argues—from its Renaissance repression by perspectival space.

16. Spies, *Max Ernst: Oeuvre*, S-2446.

17. Ibid., S-2967.

18. Ibid., S-984.

19. Werner Spies, *Max Ernst: Inside the Sight* (Houston: Rice University Institute for the Arts, 1973), 57.

20. In the context of a discussion on "Malignant Aggression: Cruelty and Destructiveness," Erich Fromm, in *The Anatomy of Human Destructiveness* (Greenwich, Conn.: Fawcett, 1975), 307, describes "ecstatic destructiveness." I believe this pervades Max's pictures. Fromm writes: "Suffering from the awareness of his powerlessness and separateness, man can try to overcome his existential burden by achieving a trancelike state of ecstasy ('to be beside oneself')." The "momentary ecstasis of sex" is one way of doing so, but another way of "arriving at ecstasy" is through "hate and destructiveness," a kind of "going berserk." Indeed, as Fromm points out (p. 308), "going berserk" was "found among the Teutonic tribes." It involves destructive "rage for the sake of rage," "a trancelike state . . . organized around the all-pervasive feeling of rage." It has come to be called the *furor teutonicus*, and it is what Max

renders over and over, with compulsive intensity, in his blurred, overexcited, self-dramatizing surfaces.

21. For a historical as well as theoretical account of the negative vision that pervades modern art, see my *Cult of the Avant-Garde Artist* (New York: Cambridge University Press, 1993), particularly chap. 2. Theodor W. Adorno's *Negative Dialectics* (New York: Seabury, 1973) is the most exhaustive, (ironically?) endorsing account of modern negativity I know of. It is worth noting that Anna Freud described "negativism" as the " 'refusal to establish relationships with other people,' or, in psychoanalytic terms, 'absence of object relationships'—i.e., the opposite of emotional surrender or total dependence on a single person" (Uwe Henrik Peters, *Anna Freud: A Life Dedicated to Children* [New York: Schocken, 1985], 188). This suggests the anti-social dimension, or at least the disgust with modern society, behind the negativism of modern art, as well as the feeling of isolation that never left such negativists as Max. In refusing to surrender to a society he hated, he achieved a certain sense of independence, but also of isolation—a false separateness. This narcissistic defensiveness and angry despair became the basis for Max's dandyism, that is, the ironic, "inverted religion" of the self, as Baudelaire called it: "To be a great man and a saint *for oneself*, that is the only thing that matters" (quoted in Roger L. Williams, *The Horror of Life* [Chicago: University of Chicago Press, 1980], 36). This is especially so when one is disappointed by and despises society and has little or no sustained sense of community.

22. Spies, *Max Ernst: Oeuvre*, S-843, S-2145.

23. Ibid., S-1888.

24. León Grinberg, *Guilt and Depression* (London and New York: Karnac, 1992), 39.

25. See Jimmy Ernst, "The Artist—Technician or Humanist? One Artist's Answer," *College Art Journal* 15, 1 (fall 1955): 51–52. This essay, written when Jimmy was thirty-three, halfway through his life, symbolized his coming of age (thirty-five was the age at which one became a man in ancient Rome). It repudiates his father's anti-humanism (the paradox of Max is that for all his hatred of a cruel society, he was as full of hatred and as cruel as it was) without describing the shape the new abstract humanist art would take.

26. Ernst, *A Not-So-Still Life*, 78.

27. Ibid.

28. Ibid., 78–79.

29. In conversation with the author. Jimmy appears in Rose's *The Power of Form: A Psychoanalytic Approach to Aesthetic Form* (Madison, Conn.: International

Universities Press, 1992), 102, as "Bruno."

30. Thomas Bulfinch, *The Age of Fable* (New York: Heritage, 1942), 160.

31. Ibid.

32. Ernst, *A Not-So-Still Life*, 239.

33. Bulfinch, *The Age of Fable*, 162.

34. Ibid., 161.

35. Ernst, *A Not-So-Still Life*, 200–204.

36. Ibid., 186, 189.

37. Ibid., 184. In the article Jimmy wrote with Francine du Plessix, he notes that Max "never *changed* his life for me" and that he, Jimmy, never felt more than "just being accepted." He claimed he "never felt bitter" about Max's close to indifferent treatment of him ("The Artist Speaks," 55, 56), but he indicates otherwise in *A Not-So-Still Life*. Jimmy may have grown up with the "understanding" that "Max was a very unusual and very great man" (*A Not-So-Still Life*, 56), but that was not particularly helpful emotionally, that is, it did not change the fact that Max was in large part responsible for his sense of helplessness and deprivation. Being with Max was hardly a facilitating environment except intermittently in obvious material ways, and in fact Max was a cause of Jimmy's emotional problems, which were great enough to keep him from being drafted during World War II.

38. Ernst, *A Not-So-Still Life*, 197.

BEYOND SURREALISM

1. Ernst, *A Not-So-Still Life*, 131.

2. Ibid., 143.

3. Ibid., 248.

4. Ibid., 132.

5. Ernst with du Plessix, "The Artist Speaks," 57.

6. Nicholas Berdyaev, quoted in Sedlmayr, *Art in Crisis*, 151.

7. D. W. Winnicott, "Ego Distortion in Terms of True and False Self" (1960), in *The Maturational Processes and the Facilitating Environment* (New York: International Universities Press, 1965), 148, argues that "the True Self comes from the aliveness of the body tissues and the working of the body-functions, including the heart's action and breathing. It is closely linked with the idea of the Primary Process, and is, at the beginning, essentially not reactive to external stimuli, but primary." It involves "the spontaneous gesture and the personal idea" ("sensory hallucination," p. 145). In contrast, "the

False Self is represented by the whole organization of the polite and mannered social attitude, a 'not wearing the heart on the sleeve,' as might be said" (p. 143). It is "a defence against that which is unthinkable, the exploitation of the True Self, which would result in its annihilation" (p. 147). "Only the True Self can be creative and only the True Self can feel real. . . . the existence of a False Self results in a feeling unreal or a sense of futility" (p. 148).

I believe Jimmy spent his youth feeling somewhat less real and certainly less creative than Max, who in effect annihilated him. Max denied the value of Jimmy's existence relative to his own and thus induced a sense of futility in Jimmy that never entirely left him. (Thus Jimmy's sense of helplessness and hurt.) I also believe that by the time Jimmy had grown up, Surrealism had become a mannered fixture of polite artistic society and as such was false to itself. The abstract intricacy of Jimmy's adult art improvises the sensory hallucination of the bodily tissue that had all but died because of Max's self-centeredness and absence. Jimmy's adolescent ambition to be a boxer was his initial attempt to restore his sense of bodily aliveness and power, and with that his sense of being really alive. Hitting and being hit—physically hurting and being hurt—were no doubt a realistic way of learning that one had a body.

It is interesting that Jimmy found his way to art—which as an adolescent he found "superficial, meaningless"—not through Max's Surrealism but when he "saw Picasso's *Guernica* mural at the Spanish pavilion" of the 1937 International World's Fair in Paris. "It totally reversed my negative ideas about art. I saw that it was a human thing, a crucial vehicle of human expression" (Ernst with du Plessix, "The Artist Speaks," 57). Max was very unhappy about this (*A Not-So-Still Life*, 89), as well he might be, for it marked the beginning of the end of his dominance of Jimmy. (I believe he unconsciously wished Jimmy was dead, or had never been born. Or that the dinosaurs had consumed him.) I believe the importance of Picasso's *Guernica* for Jimmy had not only to do with its implicit humanism, but more deeply with its representation of helpless victims in the process of being annihilated, body and soul. Jimmy identified with them and their suffering, which was true to his own emotional experience. No doubt he also found Picasso's painting more spontaneous and personal in its idea than Surrealist painting, which had become rather standardized and heartless—overcoded and perfunctory—by 1937.

8. Sedlmayr, *Art in Crisis*, 152.

9. Ibid., 151.

10. Ernst with du Plessix, "The Artist Speaks," 58.

11. Ibid.

12. Ibid., 56.

13. Ernst, *A Not-So-Still Life*, 91.

14. Ibid., 10. *A Not-So-Still Life* is in part an attempt to do so, but it ends up rationalizing and excusing Max's "enigmatic" behavior and attitude. Nonetheless, Jimmy's autobiography is one of the most emotionally candid and insightful as well as socially observant and sensitive "portraits of the artist as a young man" that has been written. It certainly shows much more self-understanding than Benvenuto Cellini's self-congratulatory autobiography.

15. Ibid., 9.

16. Ibid., 90.

17. Ibid.

18. Ibid.

19. This is suggested by her quoting a poem in which William Butler Yeats declares that "the intellect of man is forced to choose/Perfection of the life, or of the work," and that it is better to choose the latter rather than the former, even though one has regrets whatever choice one makes ("The Choices," in *The Collected Poems of William Butler Yeats* [New York: Macmillan, 1950], 242). This of course implies, however unwittingly, that it is easier to make a perfect work of art—a perfect poem or a perfect painting—than to live a perfect life, no doubt because life is full of emotional involvements, which are more difficult to master than any medium and any kind of work. In *Playing and Reality* (London: Tavistock, 1982), 54, D. W. Winnicott points out that the perfect work of art is not necessarily a product of the true self. Indeed, it is unlikely to be, for perfection is an ideal of the false self—a social ideal—and as such lacks spontaneity and "personality," signs of the true self.

20. The issue of the relationship of the artist's work to his conduct of his life—to his relationships with other human beings—is a perennial one, unconsciously haunting the appreciation and understanding of art. It is absolutely crucial to appreciating and understanding the significance of Jimmy's artistic and human achievement.

It is conventionally assumed that the artist has the license to sacrifice others to his work—to treat others badly if it benefits his work. ("Artistic license" has human as well as aesthetic meaning.) Indeed, the artist's immoral and emotionally inconsiderate treatment of others is often regarded as a prerequisite for success at work and as such is tolerated and even encouraged. Thus, Freud takes a fellow psychoanalyst to task "for being 'overdecent' and insufficiently ruthless to his patient," and advises him "to behave like the artist who steals his wife's household money to buy paint and burns the furniture to warm the

room for his model" (quoted in Janet Malcolm, *Psychoanalysis: The Impossible Profession* [New York: Knopf, 1982], 80.) Similarly, Winnicott remarks that the artist's "ruthlessness" often can "achieve more than guilt-driven labor" (quoted in Winnicott, "Psychoanalysis and the Source of Guilt," in *The Maturational Processes*, 26). And Bruce Cook, reviewing Adele Mailer's *The Last Party: Scenes from My Life with Norman Mailer*, in which she describes his "frequent fist fights" and drunkenness, his hitting her in the stomach when she was pregnant with their second child and finally stabbing her twice with a three-inch penknife, excuses Mailer's brutal, inhumane behavior by arguing that this "should remind us that the only true way to judge a writer is by his work, and not by his private life—even when his private life is made public" (Bruce Cook, "Ancient Evenings," *Washington Post* [national weekly edition], June 23, 1997, 34).

This idea (along with Freud's and Winnicott's assumption about the artist's permissible ruthlessness) seems to me highly debatable (although what I am about to suggest is no doubt not "the true way" to judge a "real" artist and his work). To turn Jimmy's mother's assertion on its head, consciousness is truly critical and evaluative not only when it uses an artist's personal life conduct to gain insight into his works, but when it uses his works to gain insight into his personal life conduct. This may be hard to do, because the works are more likely to survive than accurate accounts of his personal life. Is someone like Max willing to sacrifice relationships because of their seeming impermanence in comparison to the permanence of a perfect work of art? But it seems to me that artists are, after all, only (all too) human, and that like all human beings they are best understood in terms of their total behavior rather than by splitting off and elevating one part of their existence over another.

Of course, it may be that such modern artists as Max are unavoidably split, that is, necessarily lack integrity, because they have been traumatized by the modern world. T. S. Eliot suggests as much with his 1927 concept of the dissociation of sensibility— the split between and tendency to separate thinking and feeling that he posits has been operational since the late seventeenth century (T. S. Eliot, "The Metaphysical Poets," in *Selected Essays, 1917–1932* [New York: Harcourt, Brace, 1932], 247). So does Goethe, who may have been the last traditional— integrated—artist, if also one suffering from modern splitting, as suggested by his assertion: "I have totally separated my political and social life from my moral and poetic one and in this way I feel at my best.... Only in my innermost plans and purposes and endeavors do I remain mysteriously self-loyal and

thus tie my social, political, moral and poetic life again together into a hidden knot" (quoted in Heinz Lichtenstein, *The Dilemma of Human Identity* [New York: Jason Aronson, 1983], 237). Goethe was a modern artist on the outside, a traditional artist on the inside. But today artists seem to be modern—split— on both the outside (surface) and inside (in the depths).

The importance of Jimmy is that he was the rare example and perhaps harbinger of a new breed of "postmodern" artist who attempts to heal the split between outside and inside, surface and depth, the sociopolitical and the poetic—who tries to achieve an integrated identity in his life and art.

21. Peter Blos, *Son and Father: Before and Beyond the Oedipus Complex* (New York, Free Press, 1985), 12.

22. Quoted in ibid., 11.

23. Ernst with du Plessix, "The Artist Speaks," 57.

24. Blos, *Son and Father*, 11.

25. Ernst, *A Not-So-Still Life*, 83.

26. Ibid., 186.

27. Ibid., 189.

28. Ibid., 188.

29. Ibid.

30. Ibid., 192.

31. Ibid., 143.

32. Ibid., 145.

33. Ibid., 146.

34. Winnicott, *The Maturational Processes*, 148

35. Ernst, *A Not-So-Still Life*, 18

36. Ibid., 21.

37. Ibid., 28.

38. Ibid., 66.

39. Ibid., 34.

40. Ibid., 112.

41. Ibid., 248.

42. Ibid., 234.

43. Ibid.

44. Theodor W. Adorno, *Aesthetic Theory* (London: Routledge and Kegan Paul, 1985), 65, argues that they are at their best when neither mediates the other but is pursued as an end in its own right. But postpainterly abstraction and Minimalism have shown that Expressionism and Constructivism carried to a modernist extreme reduce to empty absurdity, becoming trivial culs-de-sac.

45. Rose, *The Power of Form*, 102.

46. Ibid.

47. Ibid.

DEVELOPMENTAL OVERVIEW

1. Thomas Browne, *Religio Medici and Other Writings* (New York: Dutton, 1951), 19.

2. John Ruskin, *Stones of Venice* (New York: Thomas Crowell, 1905), 2: 161.

3. Peter Blos, "When and How Does Adolescence End: Structural Criteria for Adolescent Closure," *Adolescent Psychiatry* 5 (1977): 4–17.

4. Vivien Raynor, "Two in Stamford: Jimmy Ernst and Stairways and Chairs," *New York Times*, April 17, 1988, 34.

5. Donald Kuspit, "Act Out, Turn Off," in *Idiosyncratic Identities: Artists at the End of the Avant-Garde* (New York: Cambridge University Press, 1996), 71–76.

6. Raynor, "Two in Stamford," 34.

7. The most comprehensive account of Jimmy's development is Hari V. Scordo's "Homage to Jimmy Ernst" (master's thesis, California State University, Los Angeles, 1980). I am less concerned with tracing Jimmy's development step by step, which Scordo already does, than with indicating the significance of each step, and the basic pattern of transformation—and self-transformation—in Jimmy's art.

8. Jimmy Ernst, "Freedom of Expression in the Arts II," *College Art Journal* 25, 1 (fall 1965): 46–47.

9. Ernst, *A Not-So-Still Life*, 196.

10. Ibid., 218.

11. Quoted in Scordo, "Homage to Jimmy Ernst," 20–21.

12. Ibid., 21.

13. Ernst, *A Not-So-Still Life*, 28.

14. Ibid., 87, 126.

15. Ibid., 228.

16. Ibid., 227.

17. Ibid., 228.

18. Ibid., 242.

19. Ibid., 218.

20. Gilbert Rose, *Necessary Illusion: Art as Witness* (Madison, Conn.: International Universities Press, 1996), 1.

21. Ibid., 19.

22. Daniel Bell, "The Return of the Sacred?" (1977), in *The Winding Path: Essays and Sociological Journeys, 1960–1980* (New York: Basic Books, 1980), 353.

23. Ibid., 345.

JIMMY ERNST

PLATES

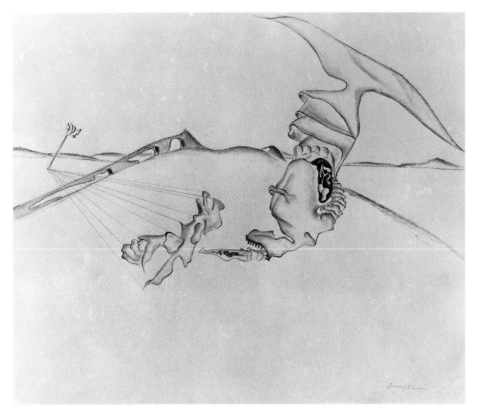

BORDER INCIDENT, 1941
Pencil on cardboard, 11⅛ × 13¼ inches
The Museum of Modern Art, New York
Gift of Max Ernst and Howard Putzel
Photo © 1999 The Museum of Modern Art, New York

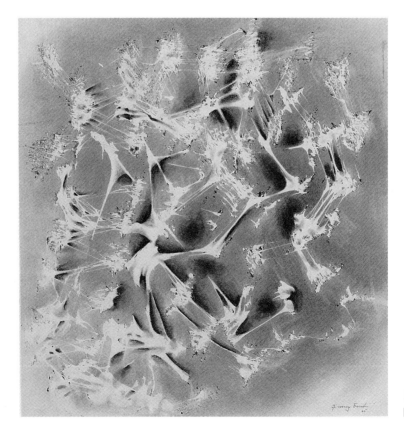

UNTITLED, 1945
Ink and ink wash on paper, 10¼ × 11 inches

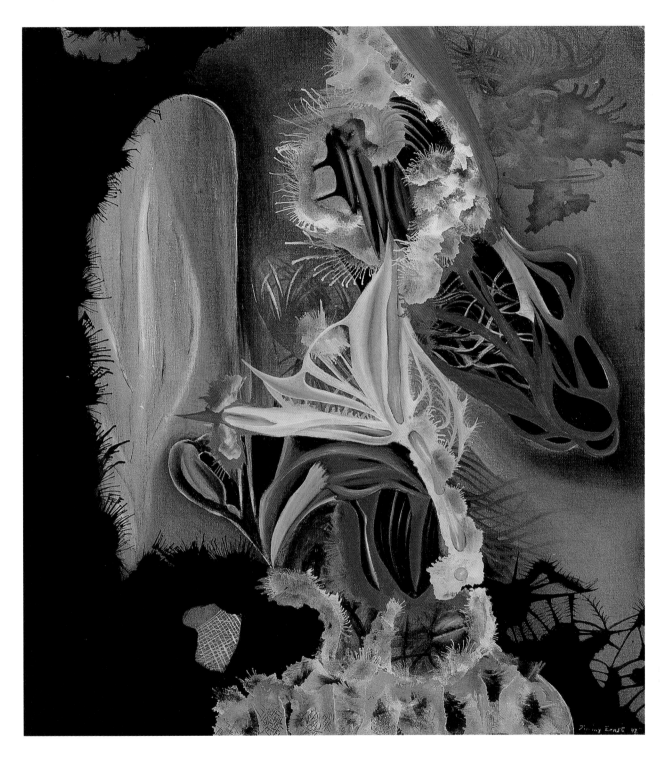

THE FLYING DUTCHMAN, 1942
Oil on canvas, 20 × 18⅛ inches
The Museum of Modern Art, New York
Purchase
Photo © 1999 The Museum of Modern Art,
New York

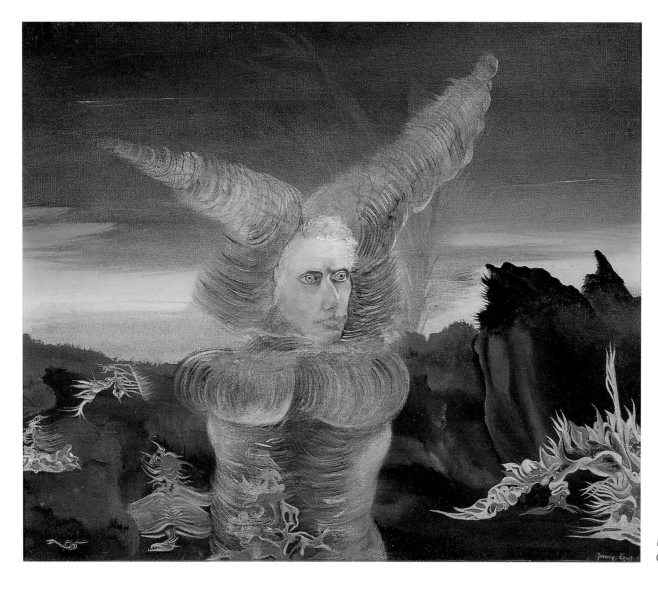

UNTITLED (BLUE MAX), 1942
Oil on canvas, 20 × 24 inches

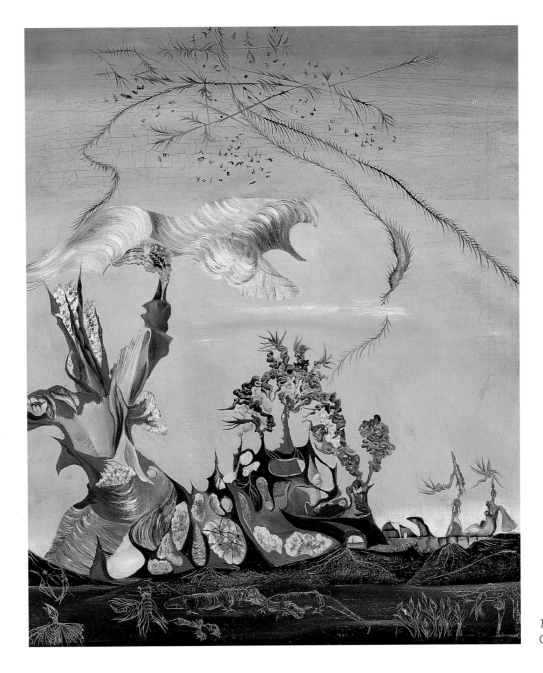

THE ELEMENTS, 1942
Oil on canvas, 24 × 20 inches

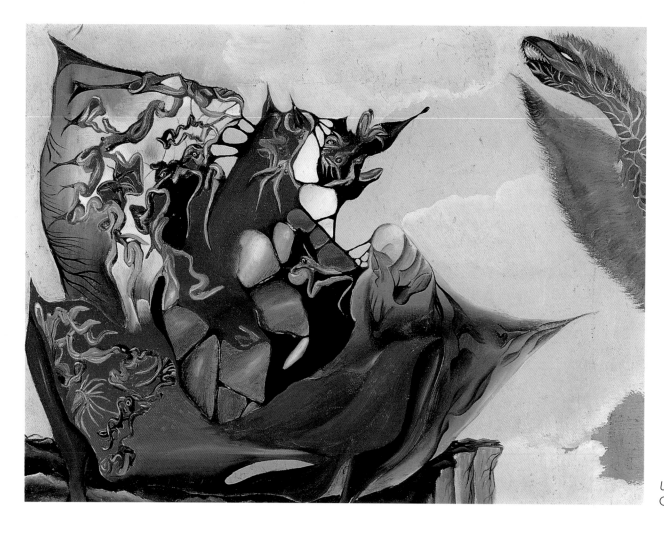

UNTITLED, ca. 1942–43
Oil on canvas, 12 × 16 inches

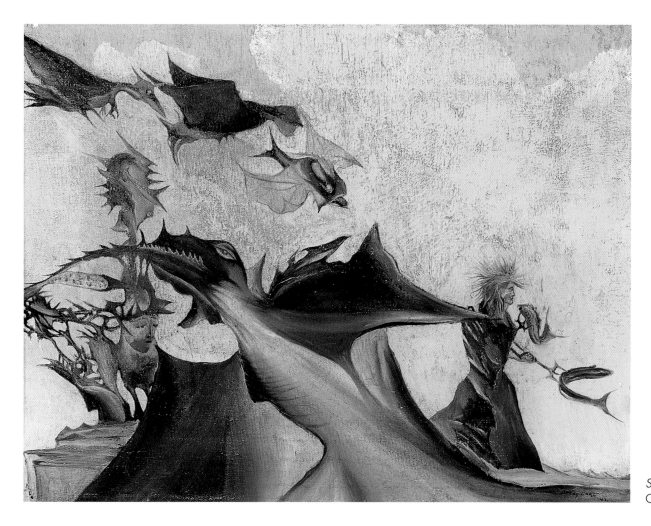

SURREAL, 1942
Oil on canvas, 12 × 16 inches

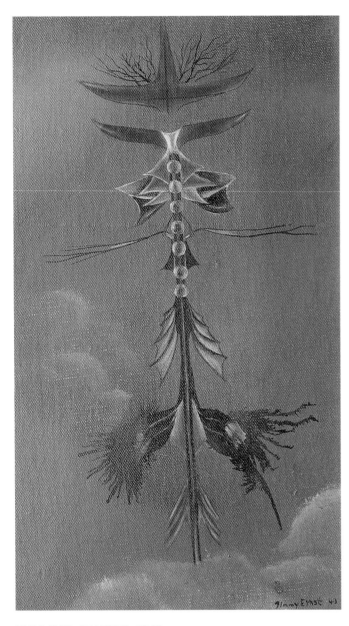

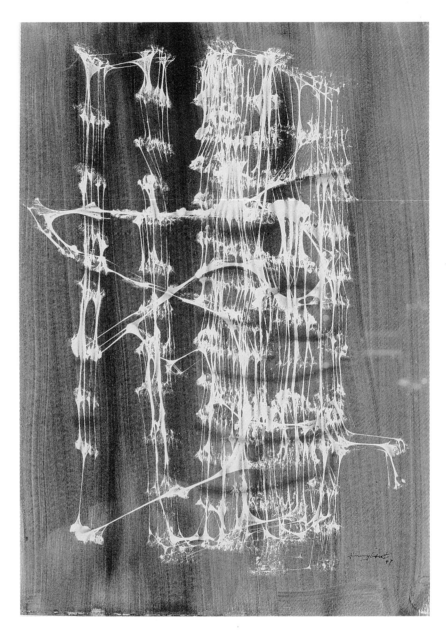

THUNDER FEATHER, 1943
Oil on canvas, 11 × 6⅛ inches
Collection of Mr. and Mrs. Alan Brecher
Photograph courtesy of Timothy Baum

NIGHT SEQUENCE, 1947
Ink and ink wash on paper, 15 × 10 inches

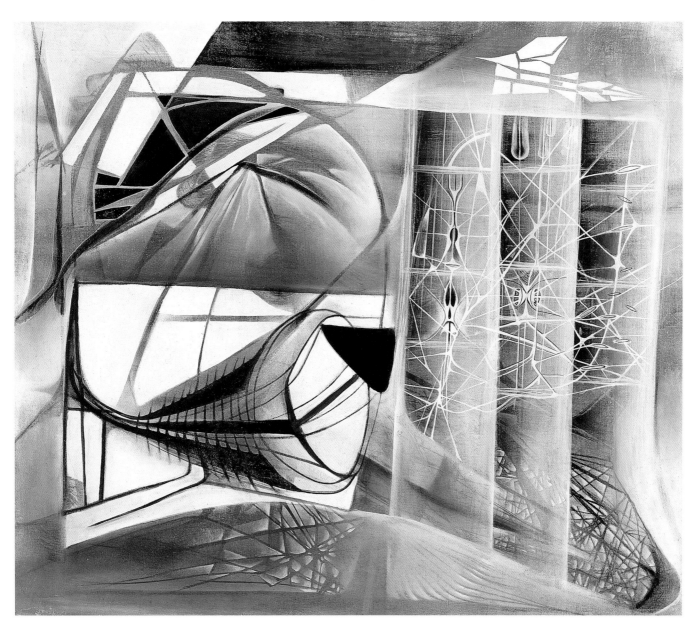

BLUES IN BLACK AND WHITE, 1946
Oil on canvas, 20 × 23 inches
Pompidou Center, Paris

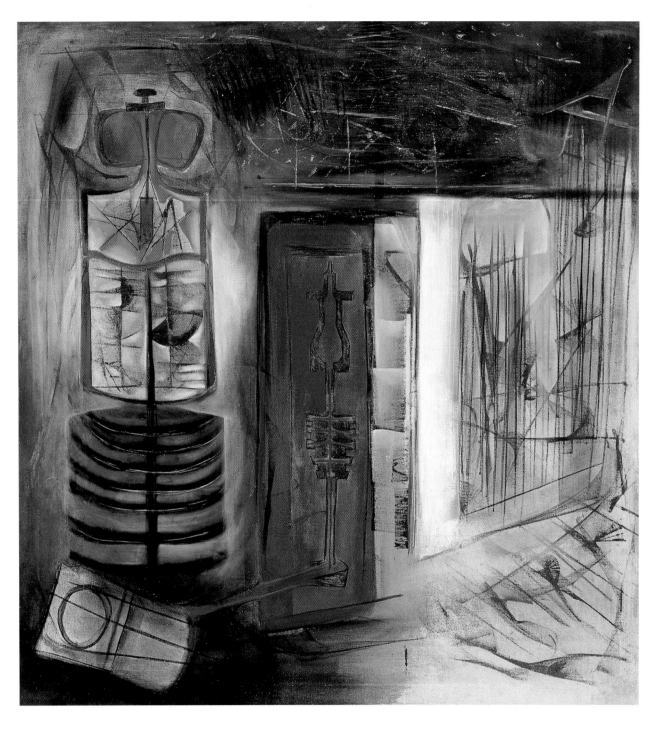

MAHOGANY HALL STOMP, 1946
Oil on canvas, 36 × 34⅜ inches

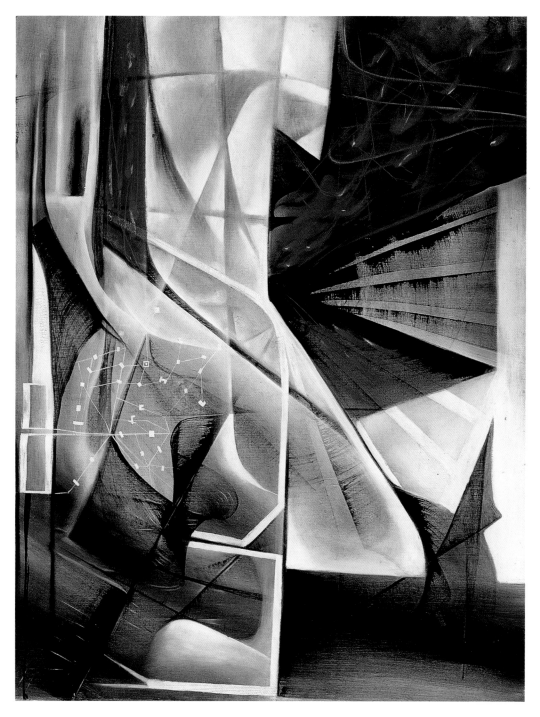

DALLAS BLUES, 1947
Oil on canvas, 36 × 28 inches

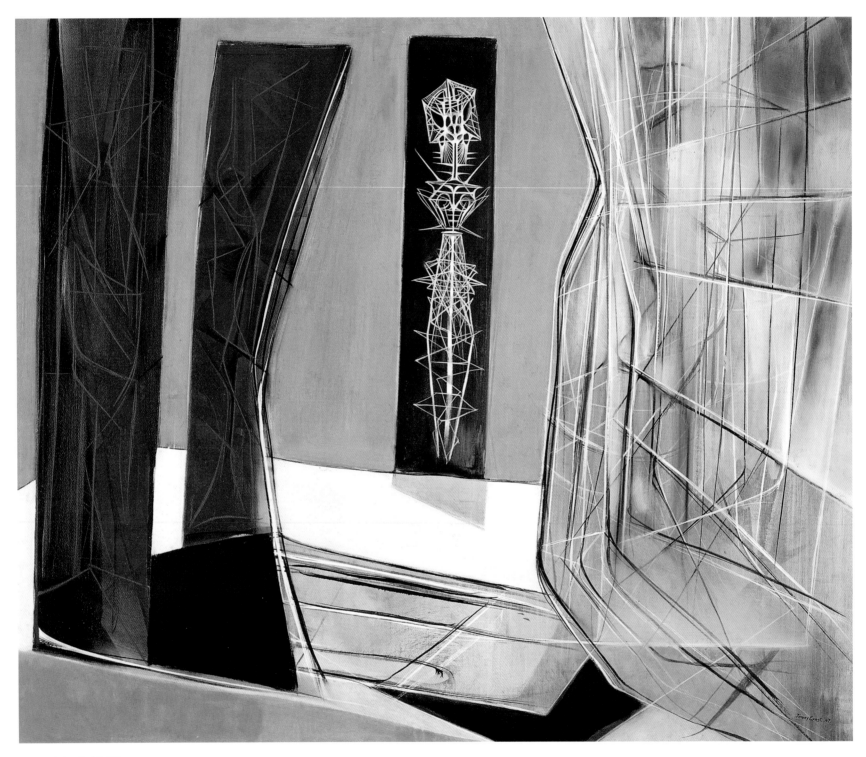

THE WAKE, 1947
Oil on canvas, 30 × 36 inches

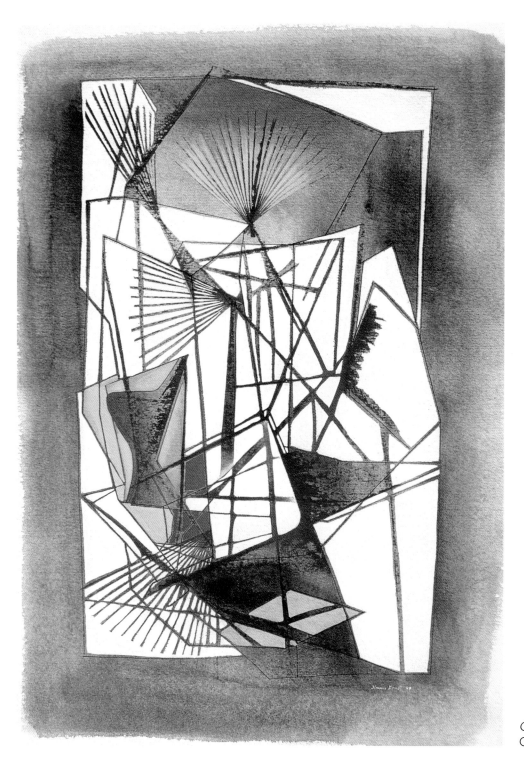

COUNTERPOINT, 1949
Gouache on paper, 26 × 20 inches

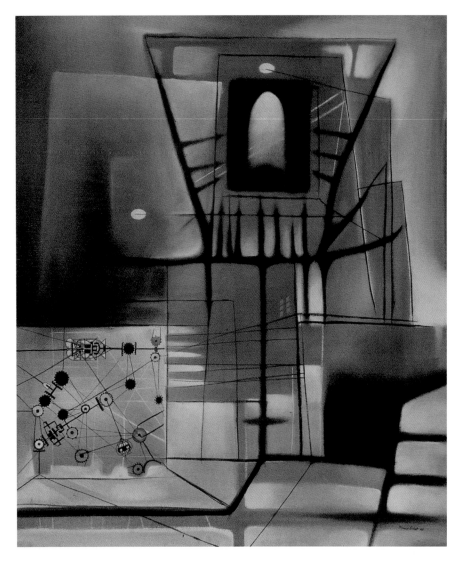

A TIME FOR FEAR, 1949
Oil on canvas, 23⅞ × 20 inches
The Museum of Modern Art, New York
Katherine Cornell Fund
Photo © The Museum of Modern Art,
New York

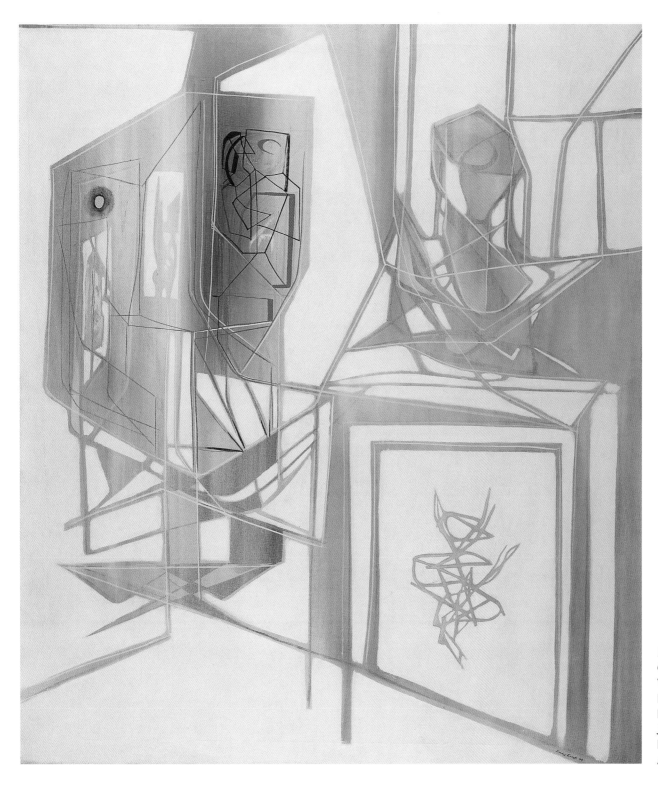

PERSONAL HISTORY, 1949
Oil on canvas, 46 × 40 inches
Whitney Museum of American Art,
New York
Purchase, with funds from the
Juliana Force Purchase Award (50.10)
Photo © 1999 Whitney Museum of
American Art, New York

NON-FICTION, 1950
Oil on canvas, 41⅞ × 32 inches
Brooklyn Museum of Art, New York
Gift of Mr. and Mrs. Warren Brandt
(71.169.1)

BIRTH OF AN IDEA, 1951
Gouache on paper, 25 × 20 inches
Virginia Museum of Fine Arts,
Richmond
The John Barton Payne Fund
(1954.12.3)

HONKY TONK, 1951
Gouache on paper, 22⅜ × 30 inches
Munson-Williams-Proctor Institute, Utica, New York
Edward W. Root Bequest (57.140)

THE CIRCUS II, 1952
Gouache on black paper, 18¼ × 24½ inches
Parrish Art Museum, Southampton, New York
Gift of the Rimrock Foundation

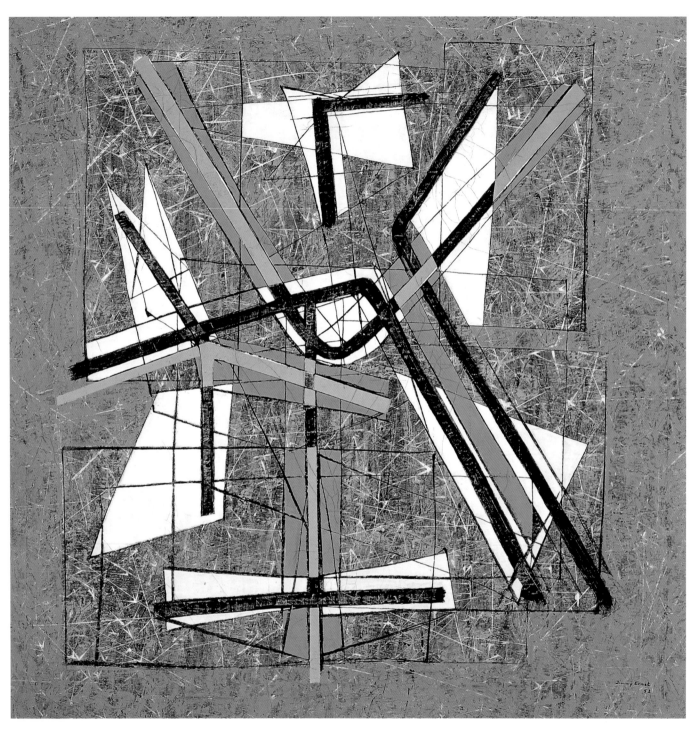

ANIMAL AND MINERAL, 1952
Oil on canvas, 43 × 43 inches

CIRQUE D'HIVER, 1952
Oil on canvas, 25 × 36 inches
Toledo Museum of Art, Ohio
(1953.149)

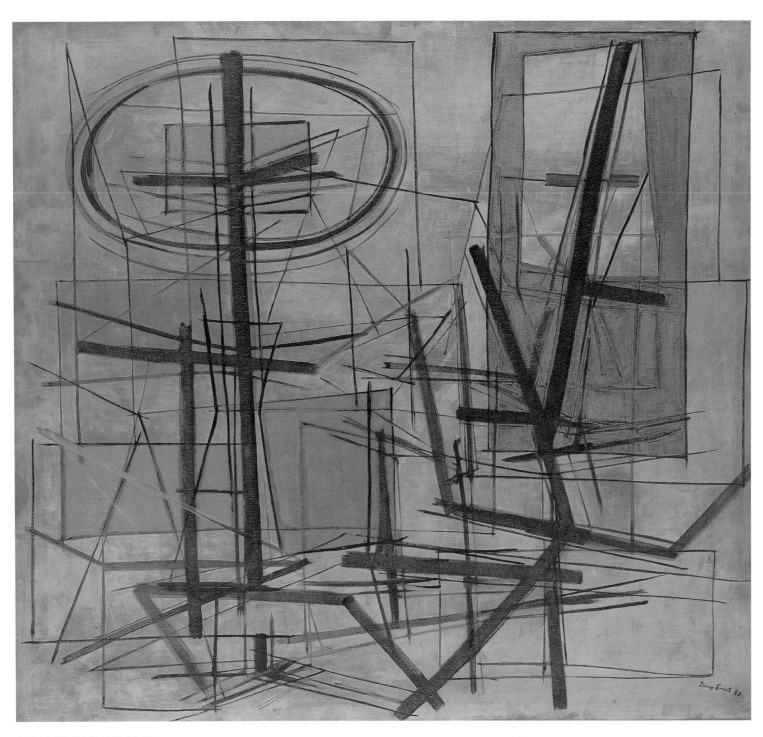

ALMOST SILENCE, 1952
Oil on canvas, 44 × 48 inches
The Metropolitan Museum of Art, New York
Mr. and Mrs. Roy R. Neuberger Gift Fund, 1953 (53.172)
Photo © 1999 The Metropolitan Museum of Art, New York

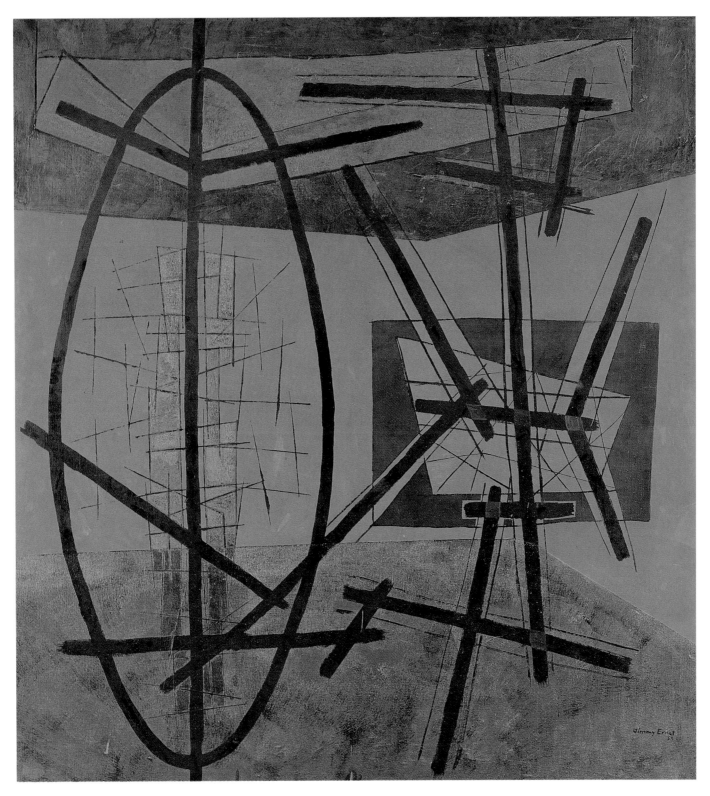

ALONE, 1954
Oil on canvas, 51 ⅞ × 48 ⅛ inches
Solomon R. Guggenheim Museum, New York (54.1400)
Photo Carmelo Guaradagno
© The Solomon R. Guggenheim Foundation, New York

THINKING, 1954
Oil on canvas, 52 × 48 inches
Art Gallery of Ontario, Toronto
Gift from J. S. McLean, American Fund
(54.4)

SILENT MOMENT, 1954
Oil on canvas, 59⅞ × 51¼ inches
Munson-Williams-Proctor Institute,
Utica, New York
Gift in memory of Edward W. Root (57.30)

THE CHANT, 1955
Oil on canvas, 50¼ × 60 inches
Albright-Knox Art Gallery, Buffalo, New York
Gift of Seymour H. Knox (K1955:7)

HIGH TENSION, 1956
Oil on canvas, 47 × 40 inches
William Benton Museum of Art,
University of Connecticut, Storrs
Gift of William Benton

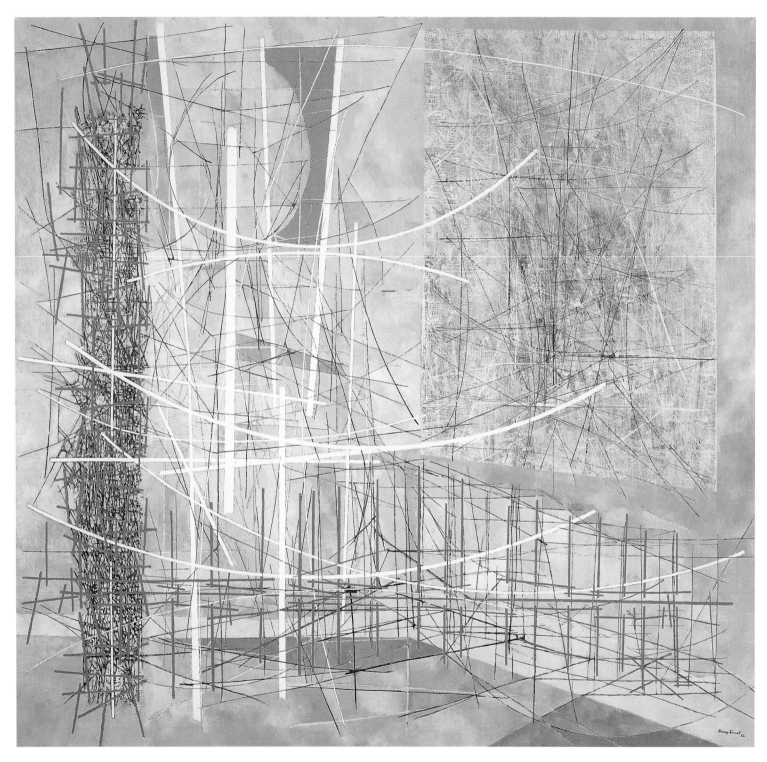

LANDSCAPE AND MOMENT, 1956
Oil on canvas, 48 × 50¼ inches
Rose Art Museum, Brandeis University,
Waltham, Massachusetts
Gift of Mr. and Mrs. Willard Gidwitz, Chicago
(1961.245)

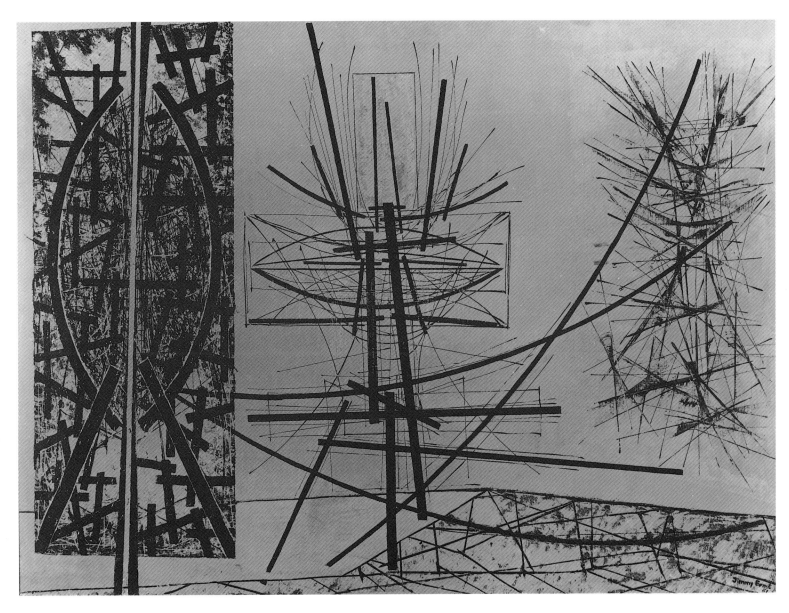

NARRATIVE II, 1956
Oil on masonite, 35 13/16 × 49 1/8 inches
Brooklyn Museum of Art, New York
Anonymous gift (63.43)

STILLNESS, 1956
Oil on masonite, 48 × 60⅛ inches
Walker Art Center, Minneapolis
Gift of the T. B. Walker Foundation, 1960

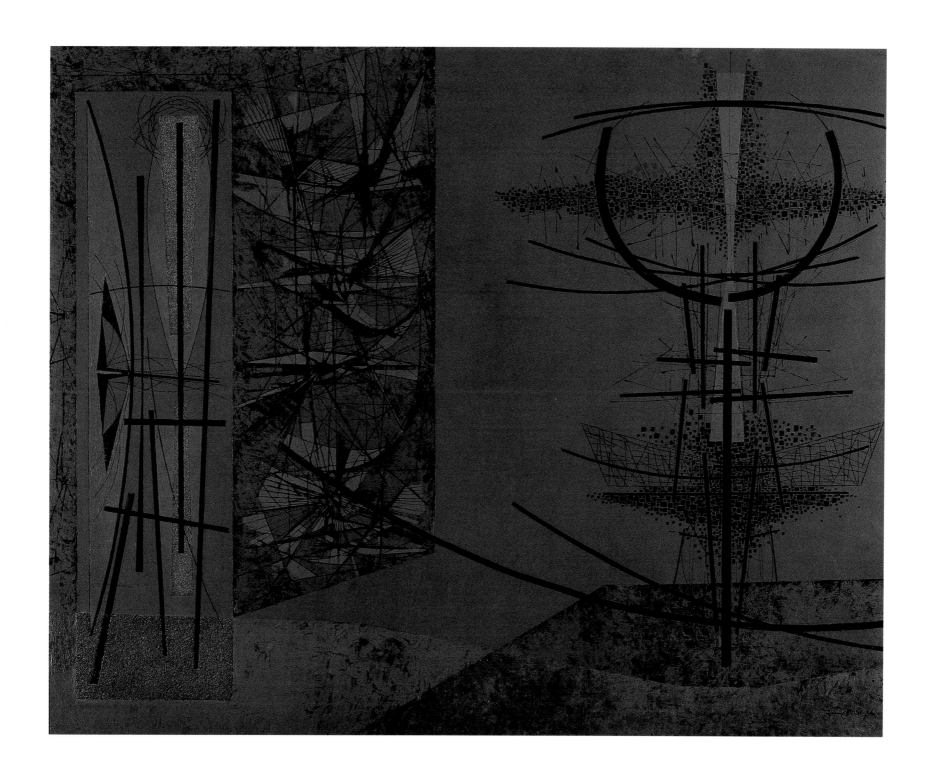

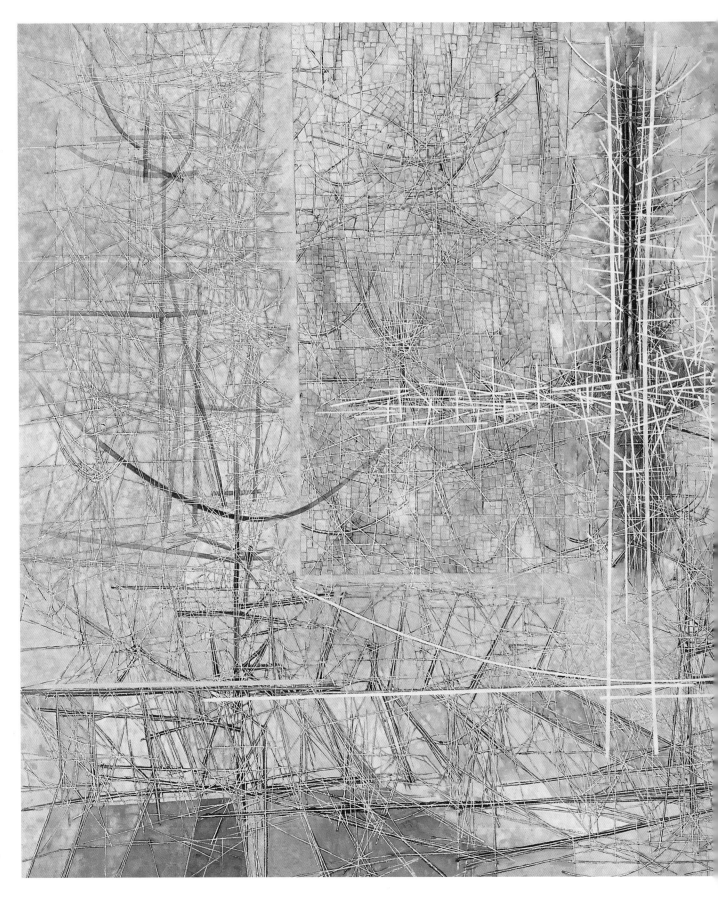

ACROSS A SILENT BRIDGE, 1957
Oil on canvas, 50 × 90 inches

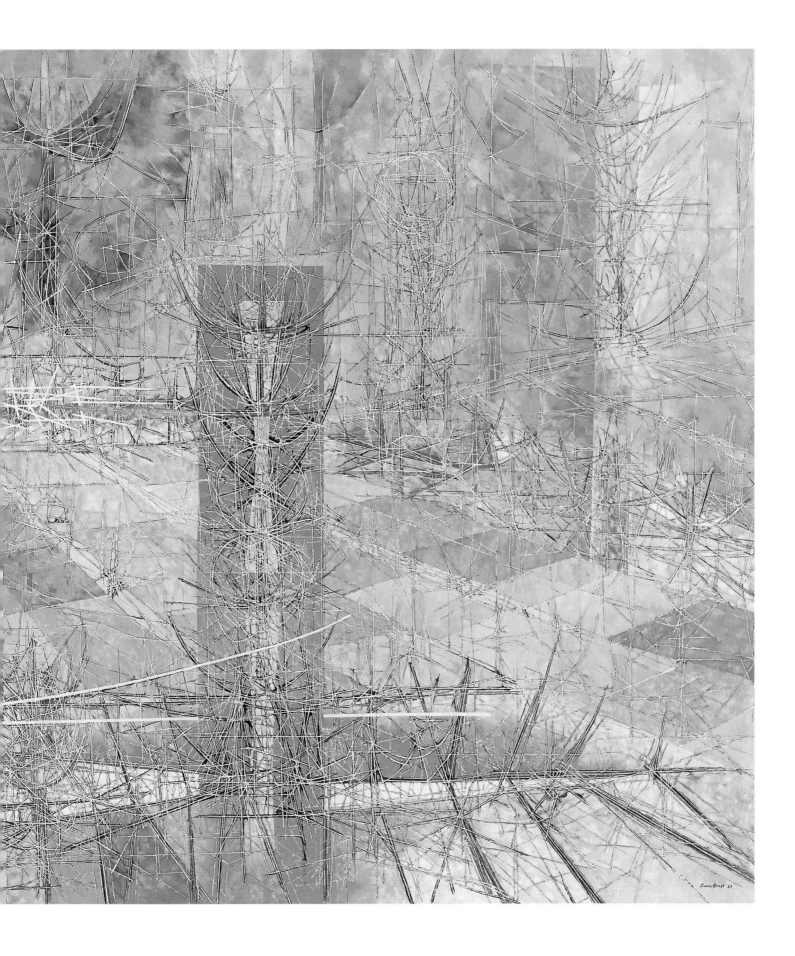

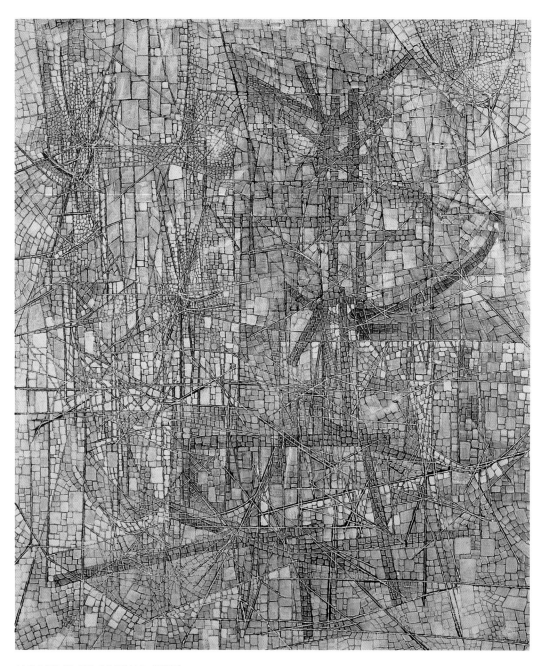

MOMENT OF ARRIVAL, 1957
Oil on canvas, 35 × 30 inches
Des Moines Art Center, Iowa
Purchased with funds from
Rose R. Rosenfield (1958.20)

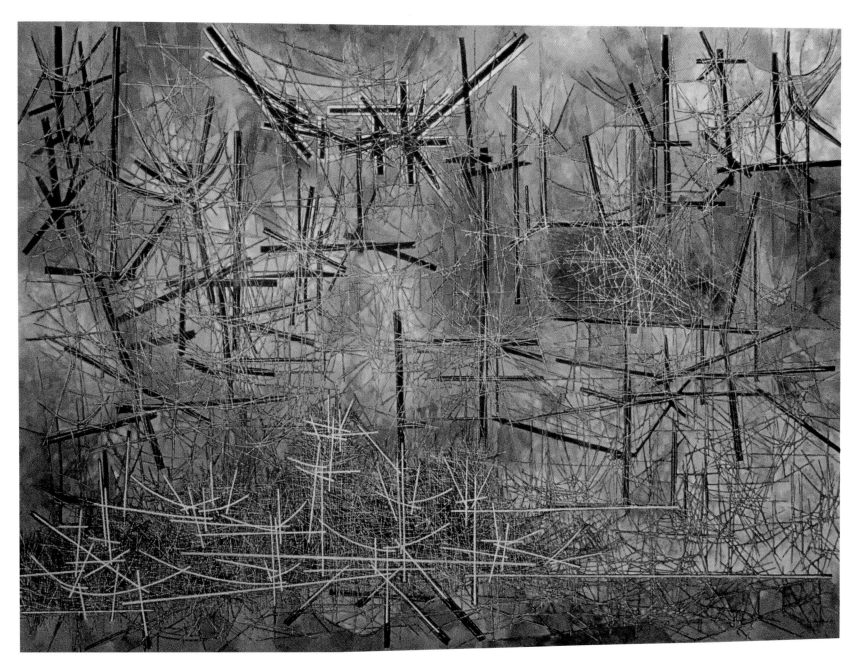

PAINTING WITH A SECRET TITLE, 1957
Oil on canvas, 51 × 70 inches
Grey Art Gallery and Study Center,
New York University Art Collection
Anonymous gift (1962.47)

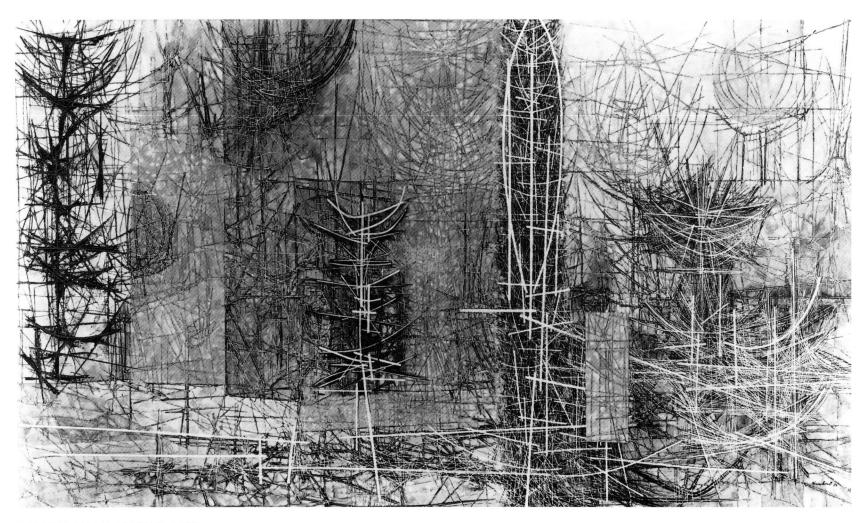

TOMORROW MORNING, 1957
Oil on canvas, 44 5/8 × 78 5/8 inches
Virginia Museum of Fine Arts, Richmond
The John Barton Payne Fund (1958.13.3)

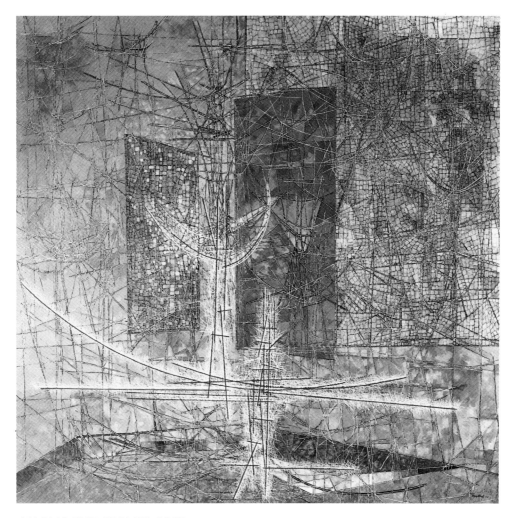

AMONG THE STONES, 1957
Oil on canvas, 43¾ × 47 inches
Wadsworth Atheneum,
Hartford, Connecticut
The Ella Gallup Sumner and Mary Catlin
Sumner Collection Fund
(1957.166)

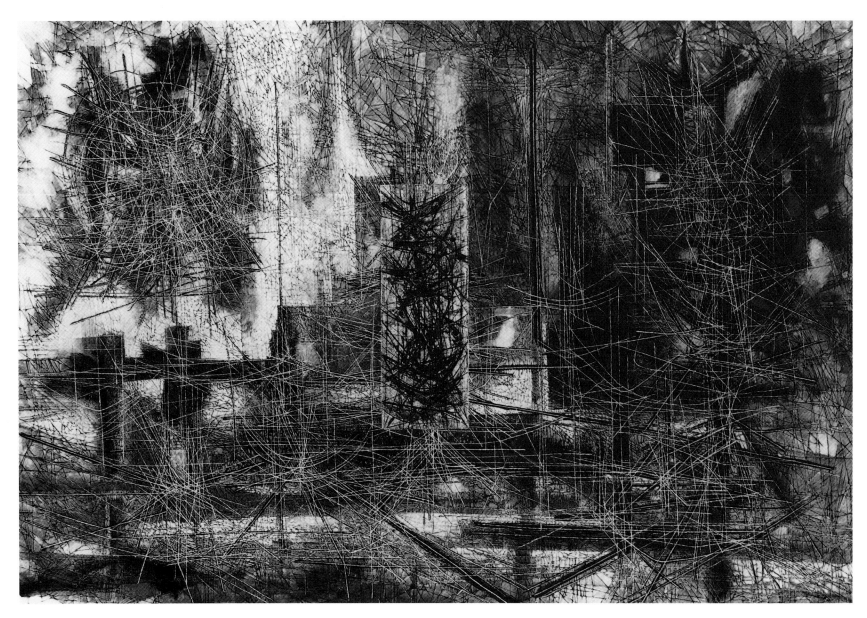

ANTICIPATION; 1960
Oil on canvas, 49 × 72 inches
Jack S. Blanton Museum of Art,
University of Texas at Austin
The James and Mari Michener Collection
Photo © 1986 The University of Texas at Austin

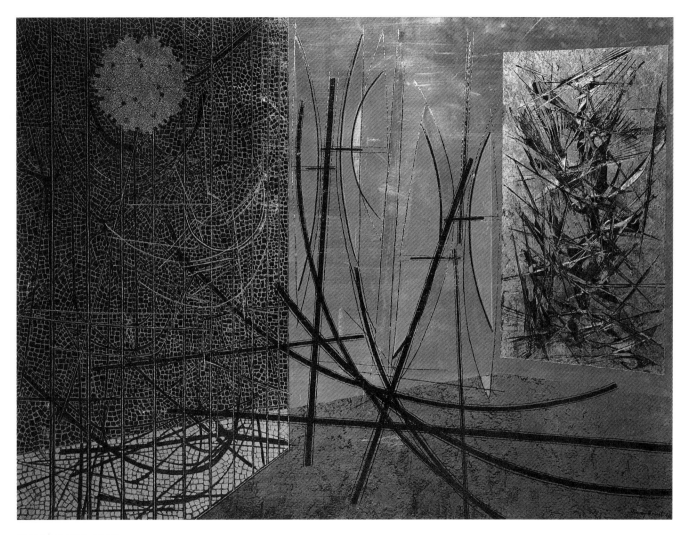

TIMESCAPE, 1960
Oil on canvas, 36 × 48 inches
Hirshhorn Museum and Sculpture Garden,
Smithsonian Institution, Washington, D.C.
(1966.1796)

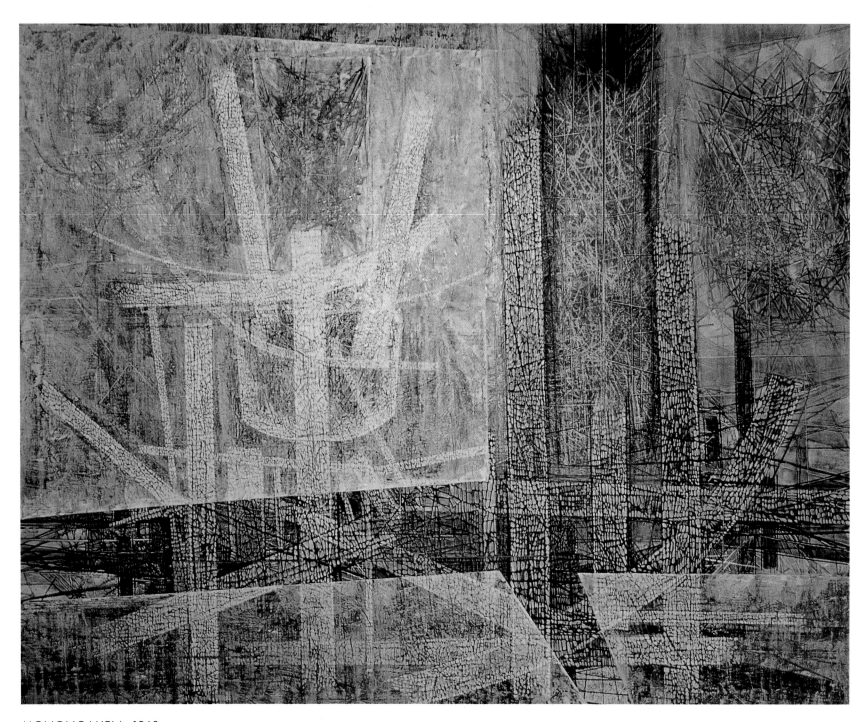

MONONGAHELA, 1960
Oil on canvas, 40 × 50 inches
Private collection

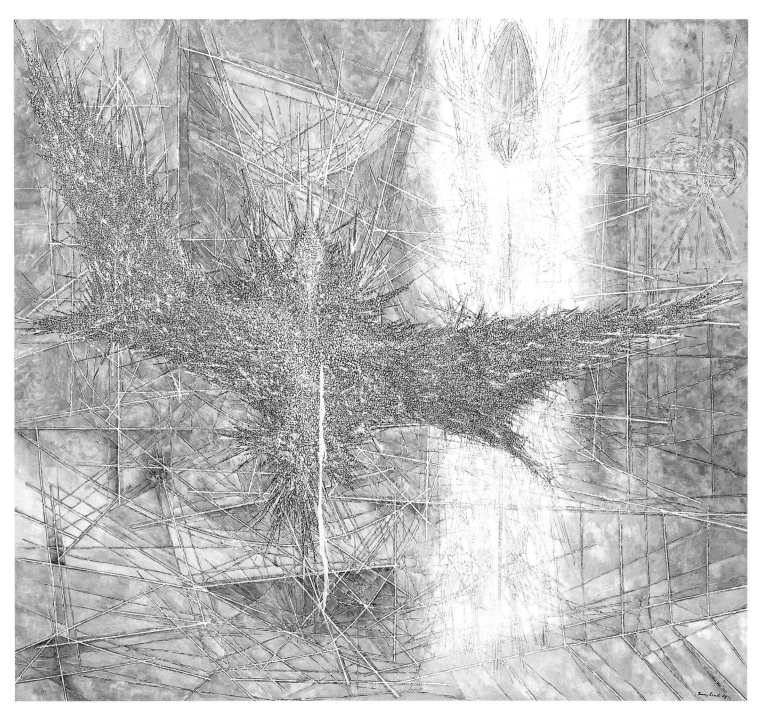

RECOGNITION, 1960
Oil on canvas, 45⅛ × 50⅛ inches
San Francisco Museum of Modern Art
Gift of Mr. and Mrs. Moses Lasky
(82.379)

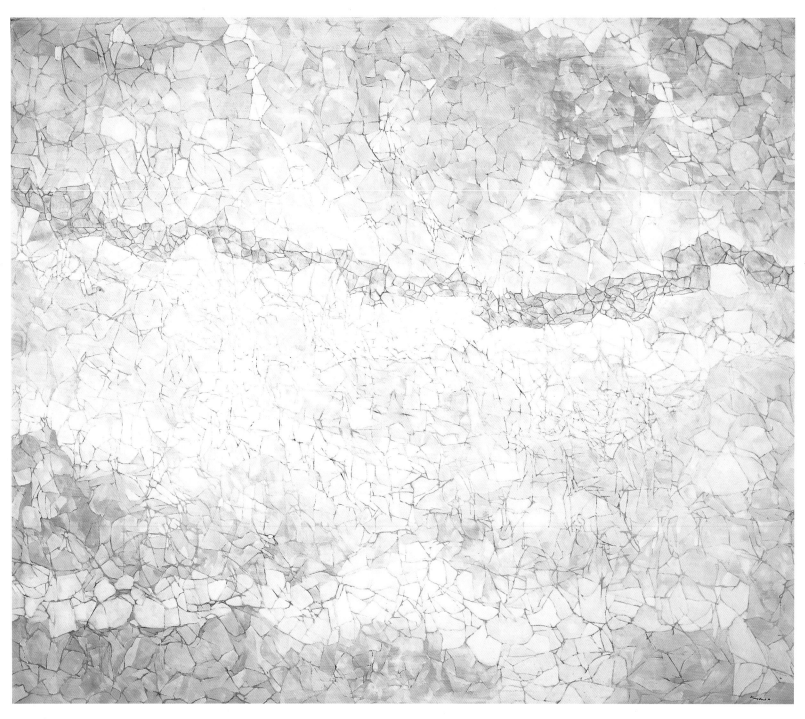

RIMROCK, 1960
Oil on canvas, 50 × 60 inches

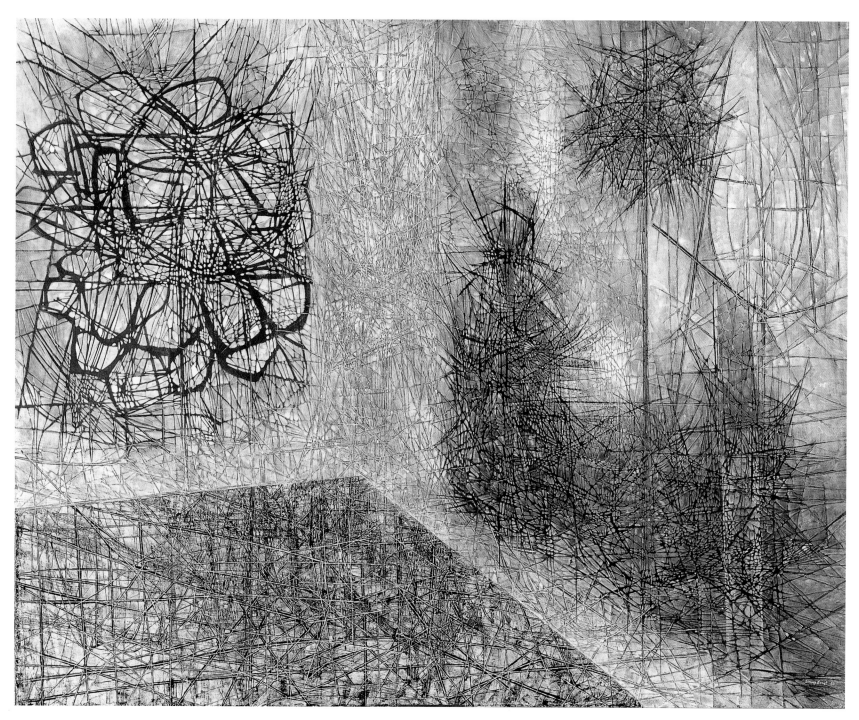

WARNING, 1960
Oil on canvas, 40¹⁄₁₆ × 50¹⁄₁₆ inches
Pennsylvania Academy of the Fine Arts, Philadelphia
Gift of Mrs. Herbert Cameron Morris

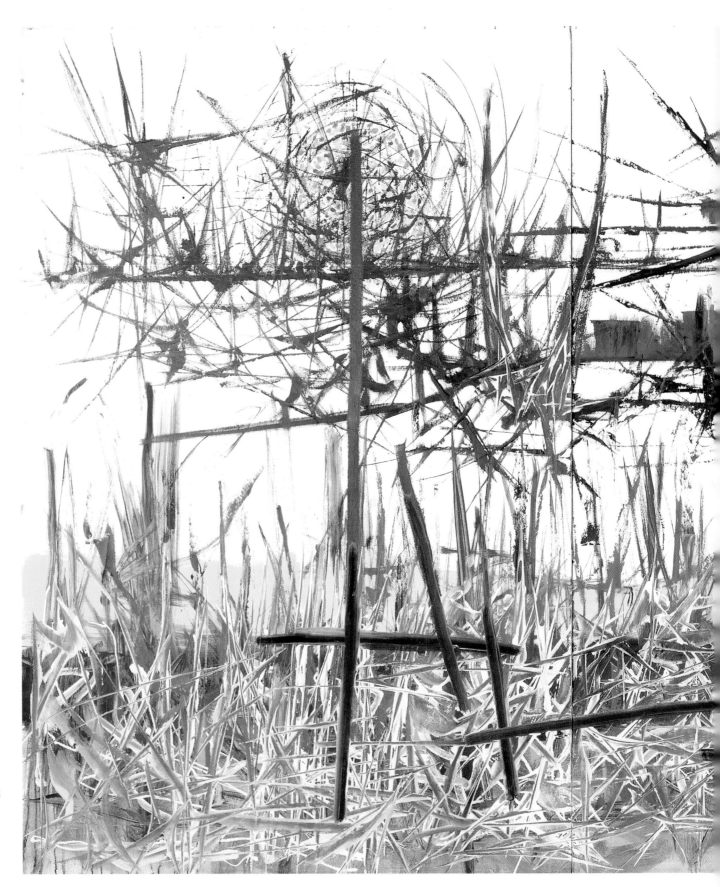

UNTITLED (ABSTRACTION), 1958
Oil on board, 71⅝ × 143 inches
Sheldon Memorial Art Gallery
and Sculpture Center, University
of Nebraska, Lincoln
Gift of the artist (1962.U-374)

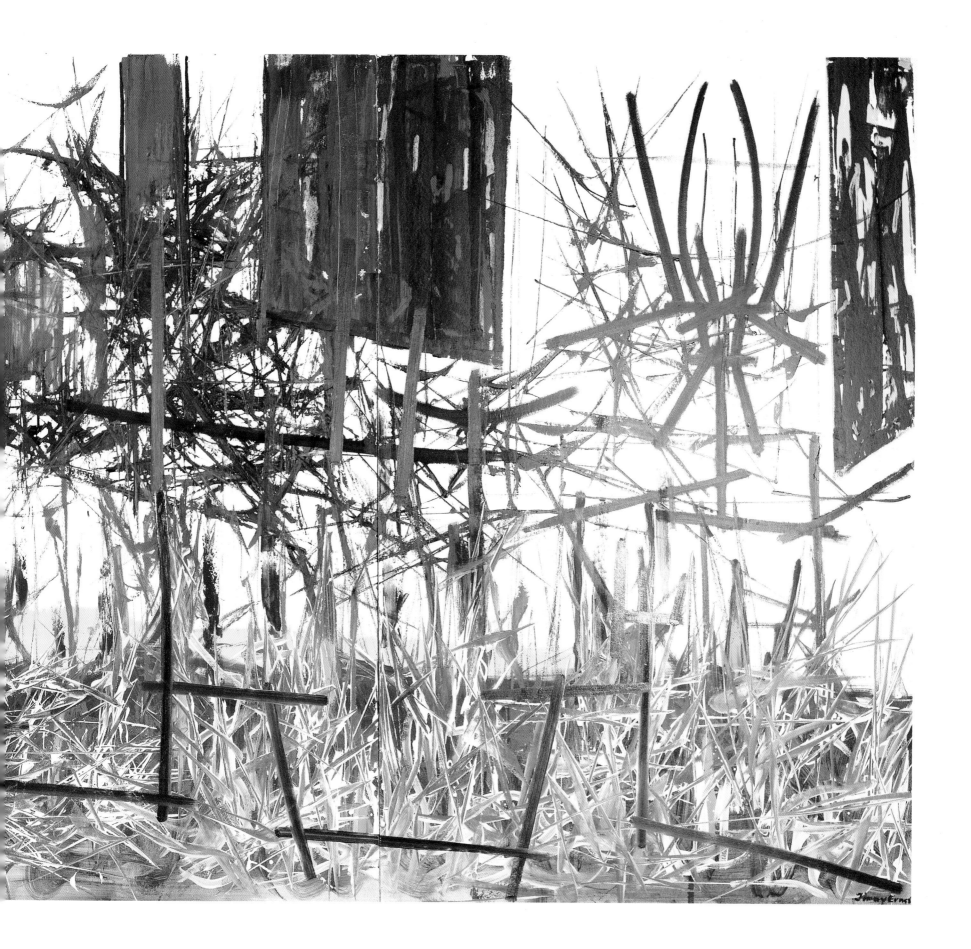

OVERNIGHT, 1961
Oil on canvas, 76 × 112¼ inches
Dallas Museum of Fine Arts
Foundation for the Arts Collection

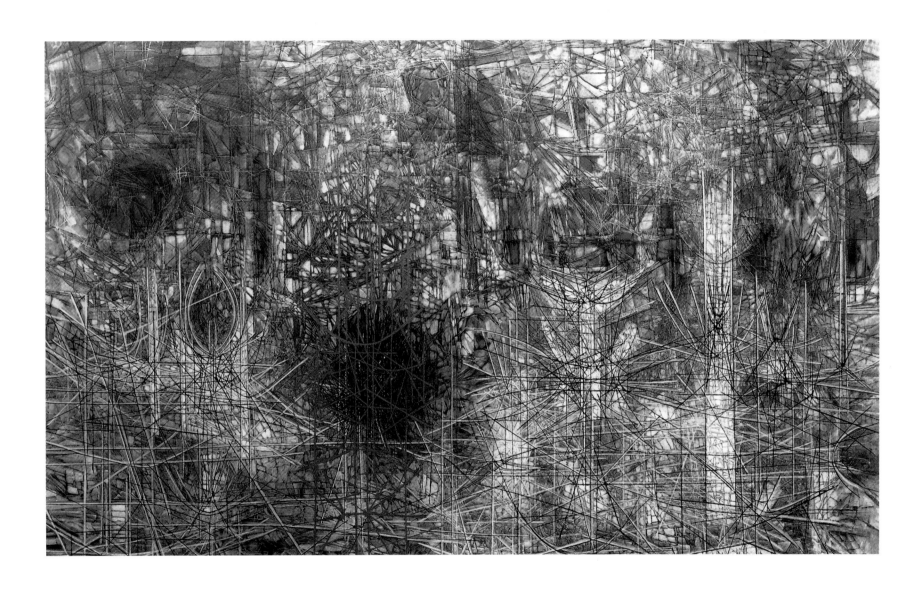

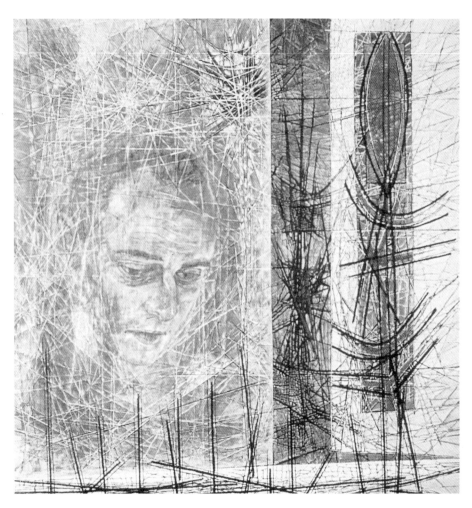

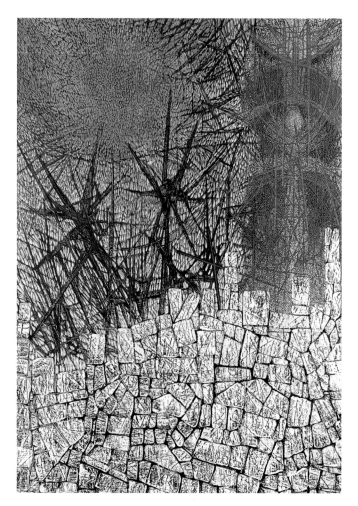

*SELF-PORTRAIT WHEN LAST SEEN
(OUT OF THE PAST)*, 1961
Oil on canvas, 21½ × 20 inches
Blount Collection, Montgomery, Alabama

SECRET DIALOGUE, 1963
Oil on masonite, 21 × 15 inches
Museum Ludwig, Cologne (76/3155)
Photo © Rheinisches Bildarchiv, Cologne

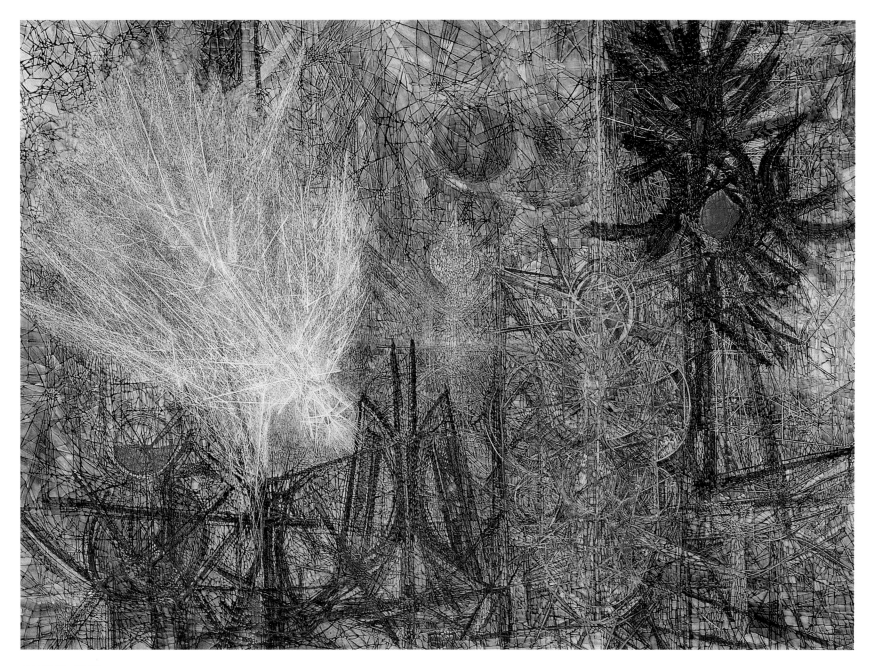

ICARUS, 1962
Oil on canvas, 55 × 76 inches
The Corcoran Gallery of Art, Washington, D.C.
Gift of the Ford Foundation (62.33)

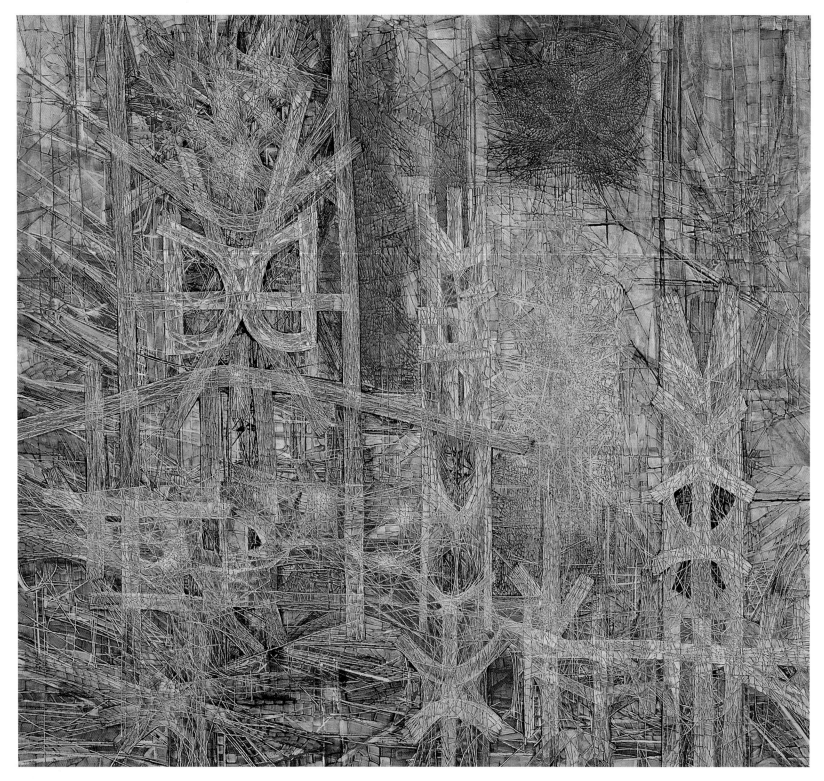

SILENCE AT SHARPEVILLE, 1962
Oil on canvas, 66 × 72¼ inches
National Museum of American Art, Smithsonian Institution
Gift of S. C. Johnson and Son, Inc. (1969.47.56)

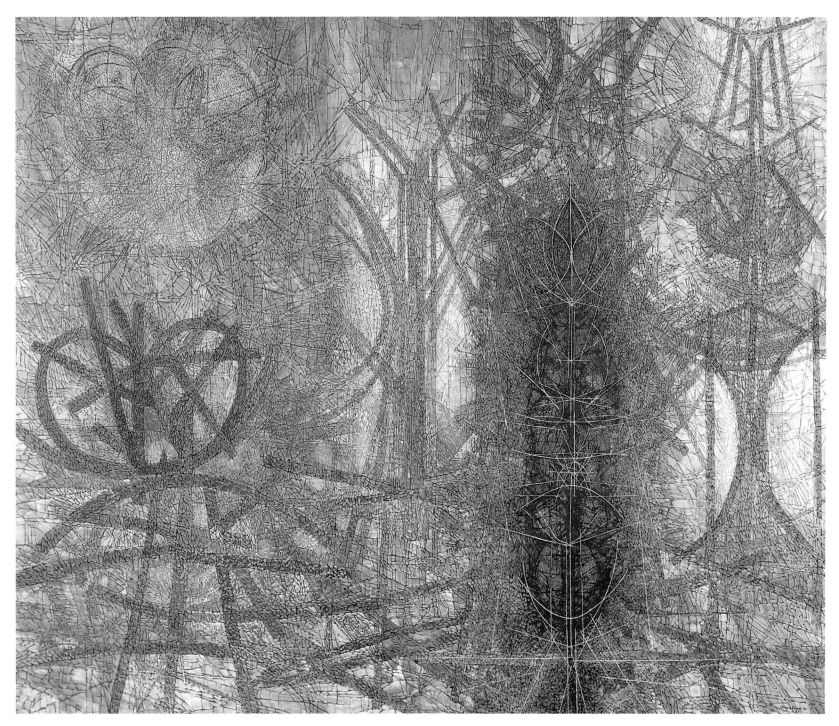

SOONER OR LATER, 1962
Oil on canvas, 50 × 60 inches
Whitney Museum of American Art, New York
Gift of Mr. and Mrs. Allan D. Emil (64.60)
Photo Geoffrey Clements
© 1999 Whitney Museum of American Art, New York

THE IMPORTANCE OF SILENCE, 1963
Oil on canvas, 52 × 42 inches

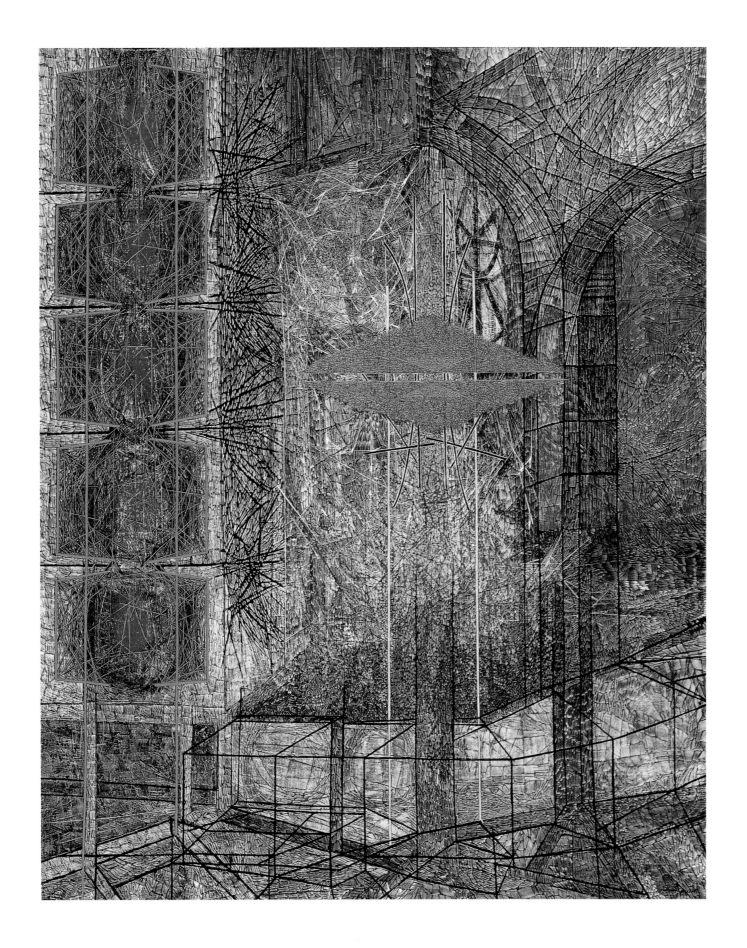

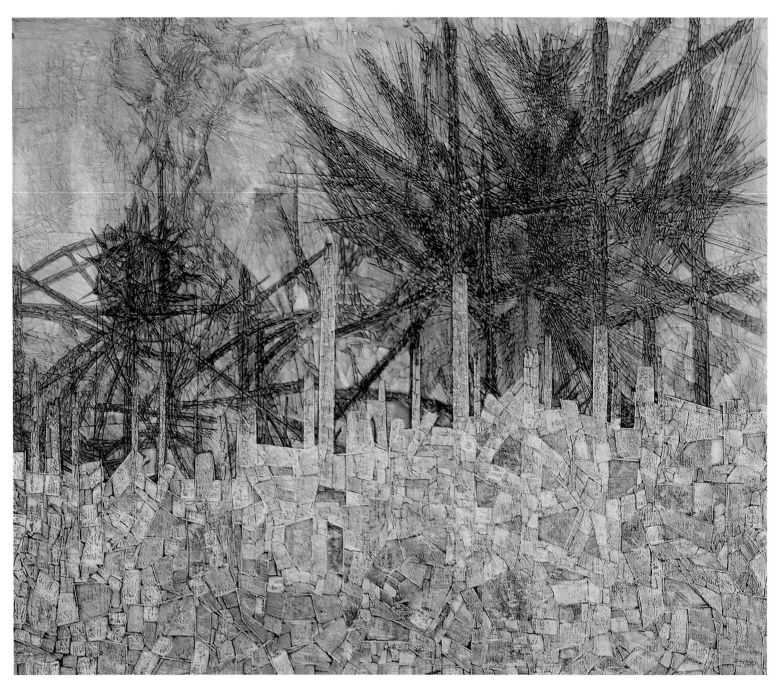

MEMOIR OF RECENT HISTORY, 1963
Oil on canvas, 40 × 48 inches

OCEANIA, 1963
Oil on canvas, 43 × 38 inches

THOUGHTS ABOUT NOVEMBER 1963, 1964
Oil on canvas, 50 × 70 inches
Städtisches Kunsthaus, Bielefeld, Germany

A SUDDEN SILENCE, 1965
Oil on canvas, 51⅞ × 65⅞ inches
Jack S. Blanton Museum of Art, University of Texas at Austin
The James and Mari Michener Collection (P1969.10)
Photo © 1986 The University of Texas at Austin

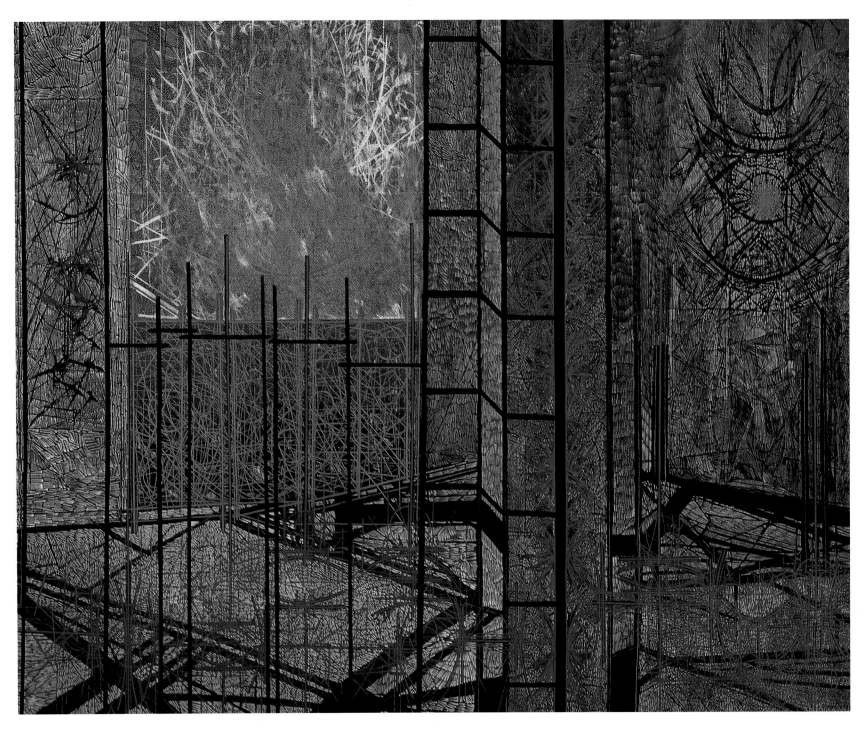

CHRONICLE, 1964
Oil on canvas, 41 × 51 inches

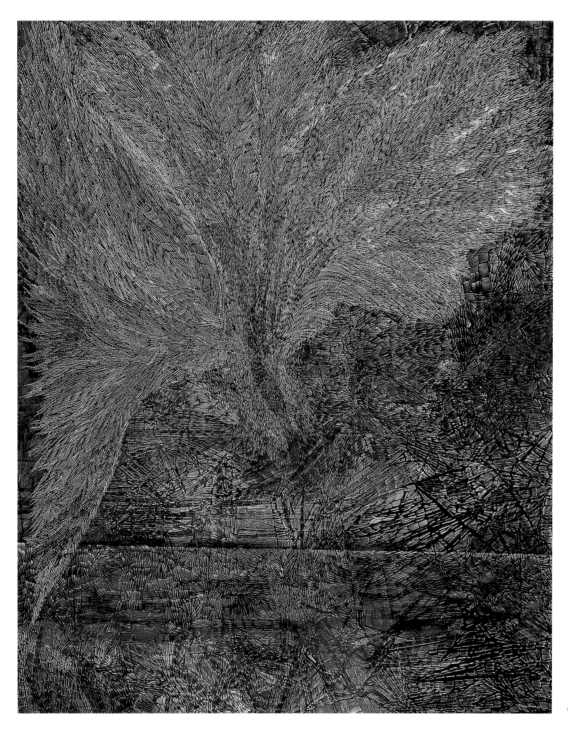

ICARUS, 1964
Oil on canvas, 50 × 40 inches

HOMAGE TO EDGAR VARÈSE, 1965
Oil on canvas, 50 × 65 ½ inches

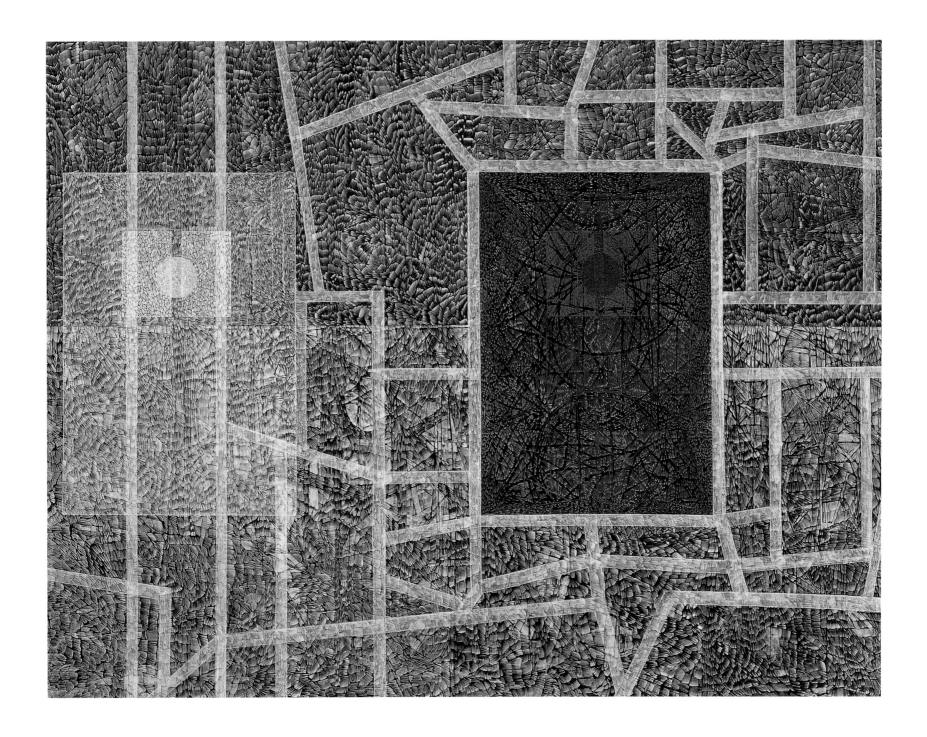

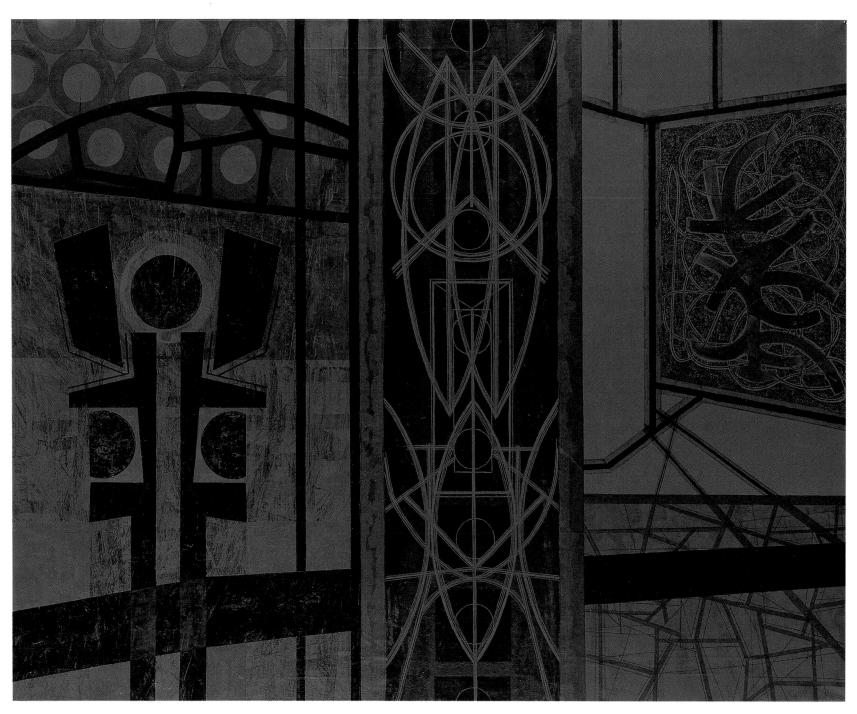

NIGHTNOON, 1965
Oil on canvas, 52 × 60 inches
National Museum of American Art,
Smithsonian Institution, Washington, D.C.
Gift of Mr. and Mrs. Jimmy Ernst (69.22)

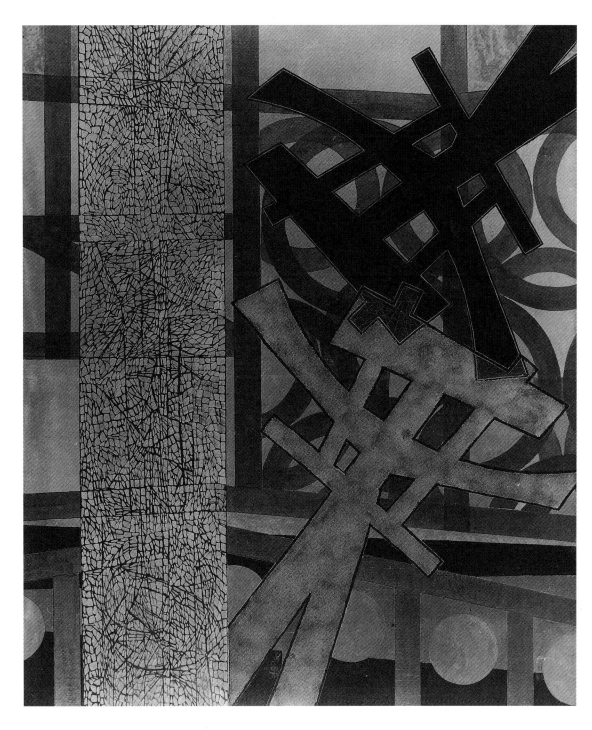

*THOUGHTS ABOUT W. B.
(WILLIAM BAZIOTES)*, 1965
Oil on canvas, 51 × 42 inches
Guild Hall Museum,
East Hampton, New York

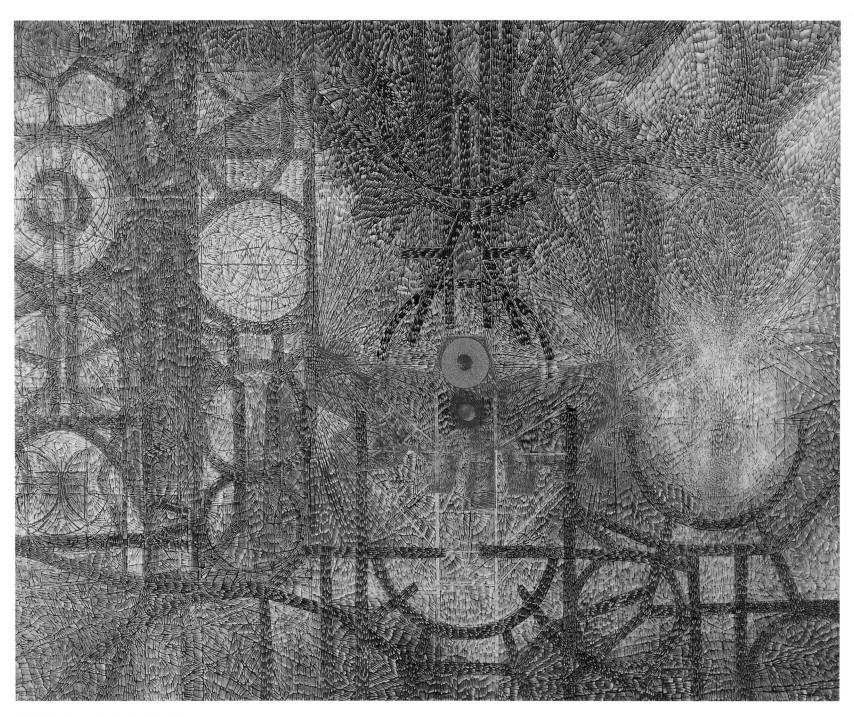

PASTURES AND PLANETS, 1966
Oil on canvas, 52 × 66 inches
Grand Rapids Art Museum, Michigan
Museum purchase (1968.1.2)

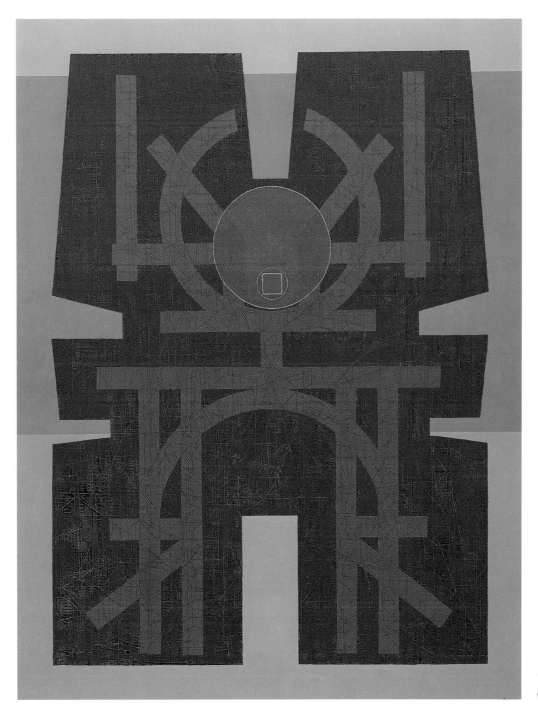

THE SENTINEL, 1967
Oil on canvas, 65 ½ × 50 inches

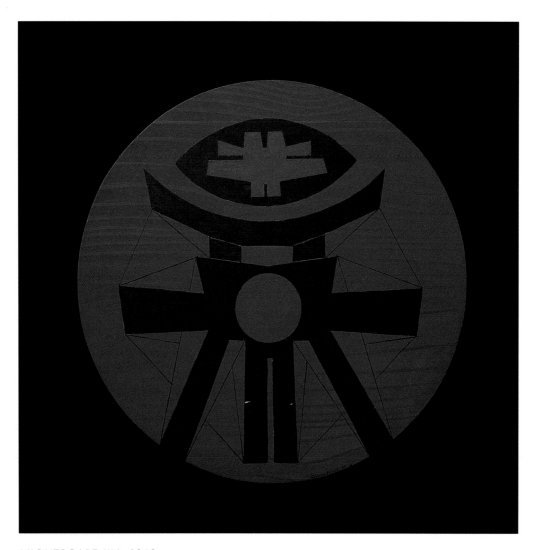

NIGHTSCAPE IIIA, 1969
Oil on plexiglass, 21 × 21 inches

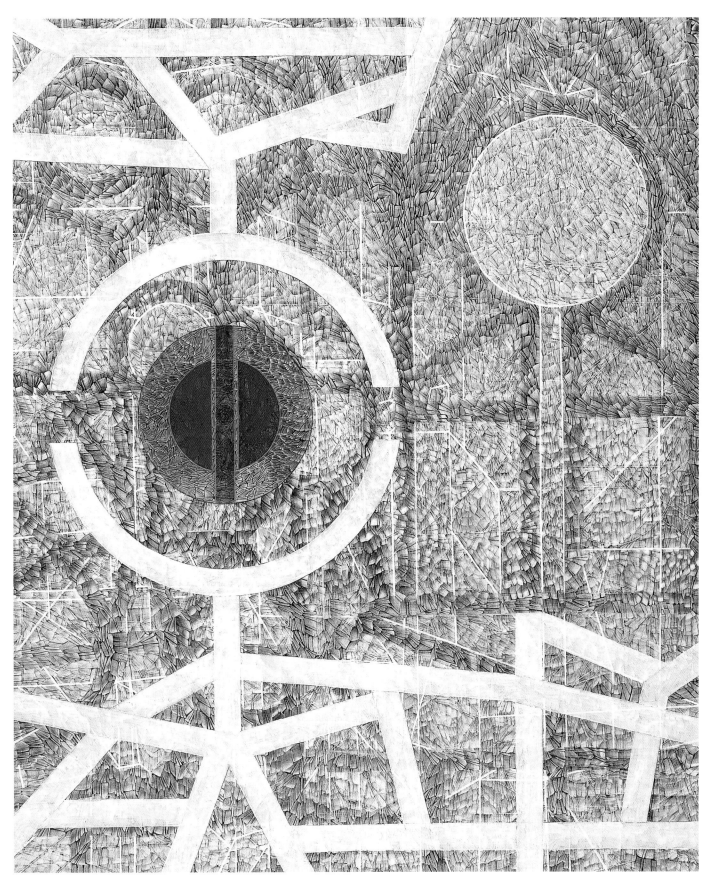

ONLY YESTERDAY, 1968
Oil on canvas,
60 × 50 inches

A TRIPTYCH, 1971
Oil on canvas, 50 × 180 inches
Solomon R. Guggenheim Museum,
New York

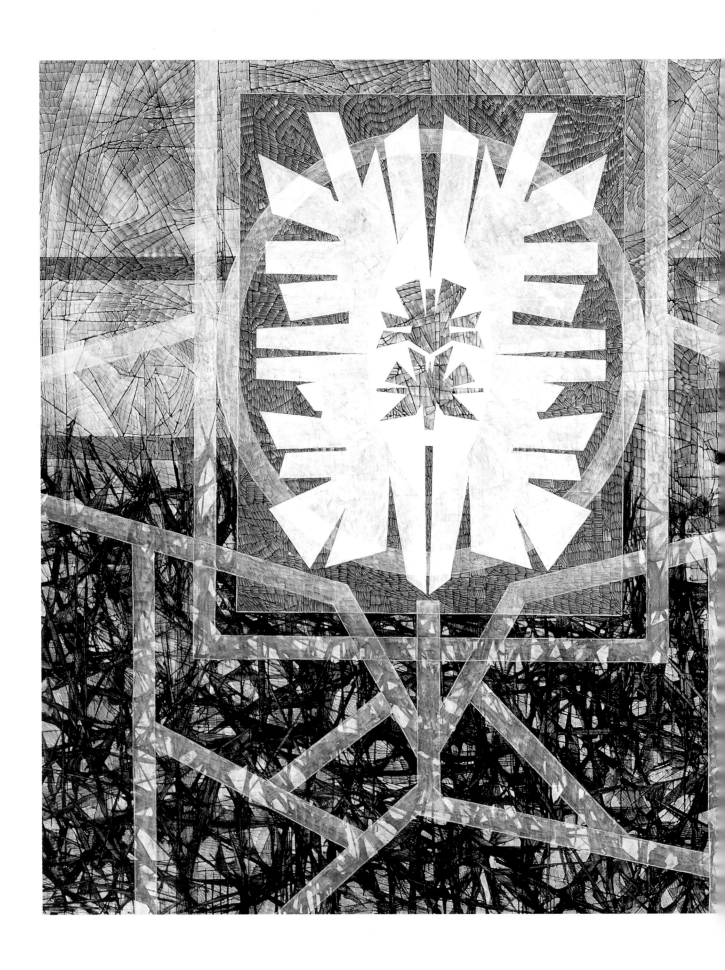

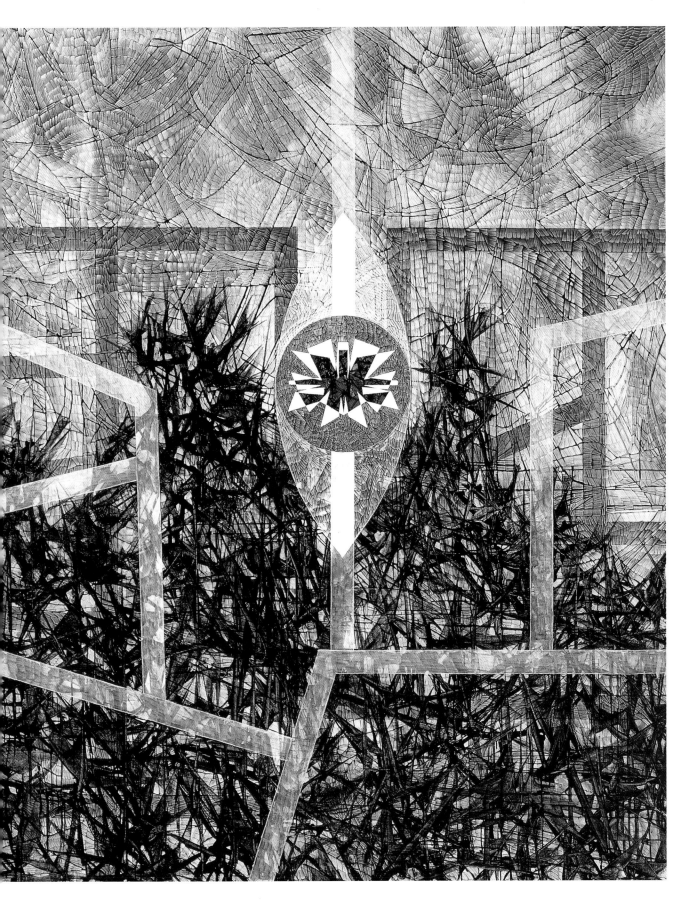

ANOTHER SILENCE, 1972
Oil on canvas, 72 × 120 inches

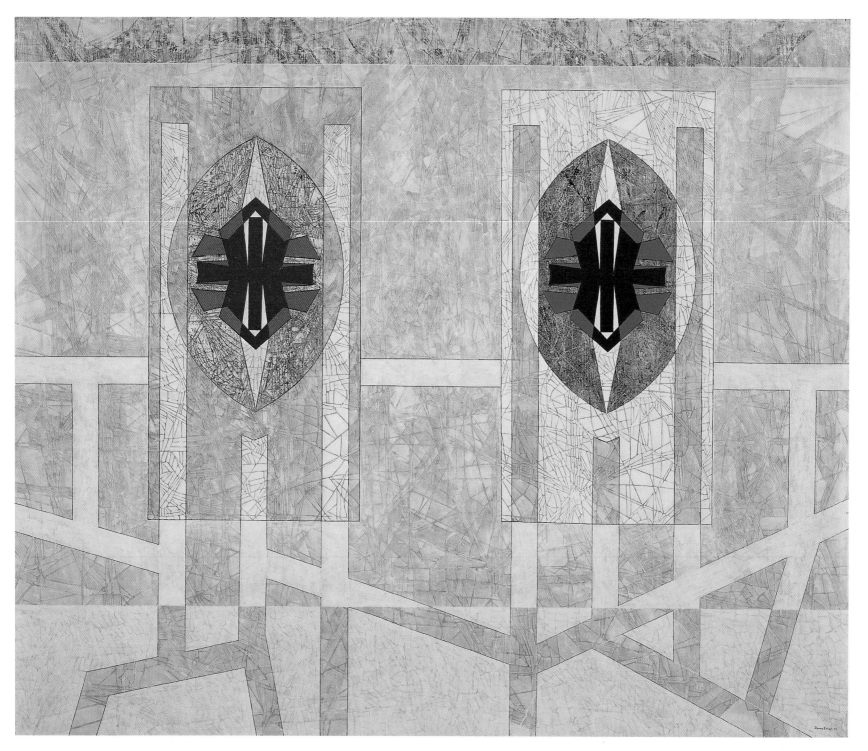

TWICE, 1972
Oil on canvas, 50 × 60 inches

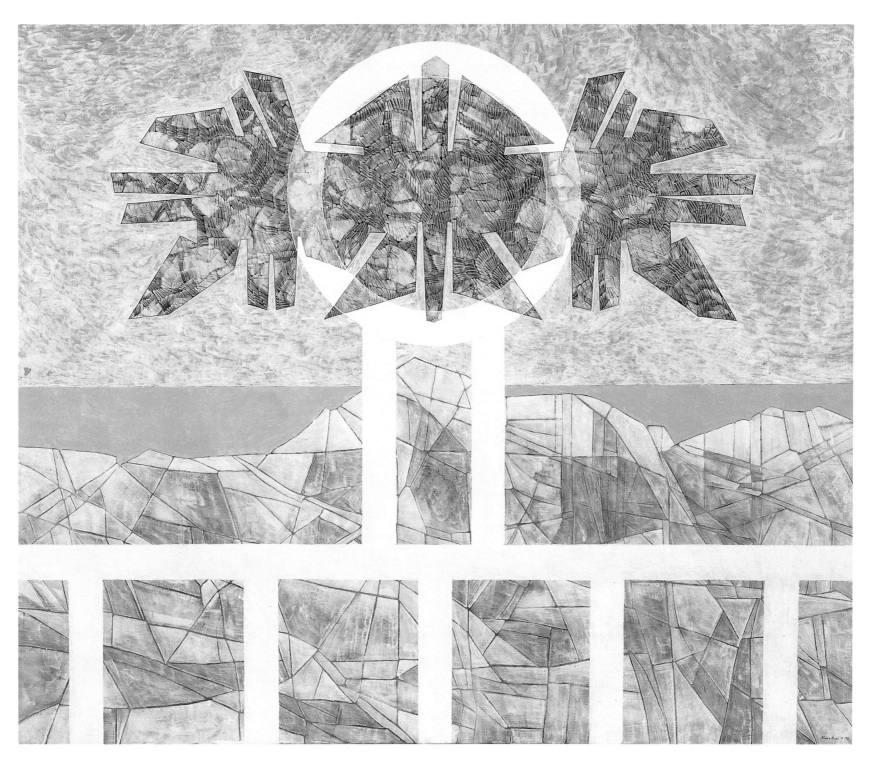

DUE NORTH, 1972–73
Oil on canvas, 50 × 60 inches

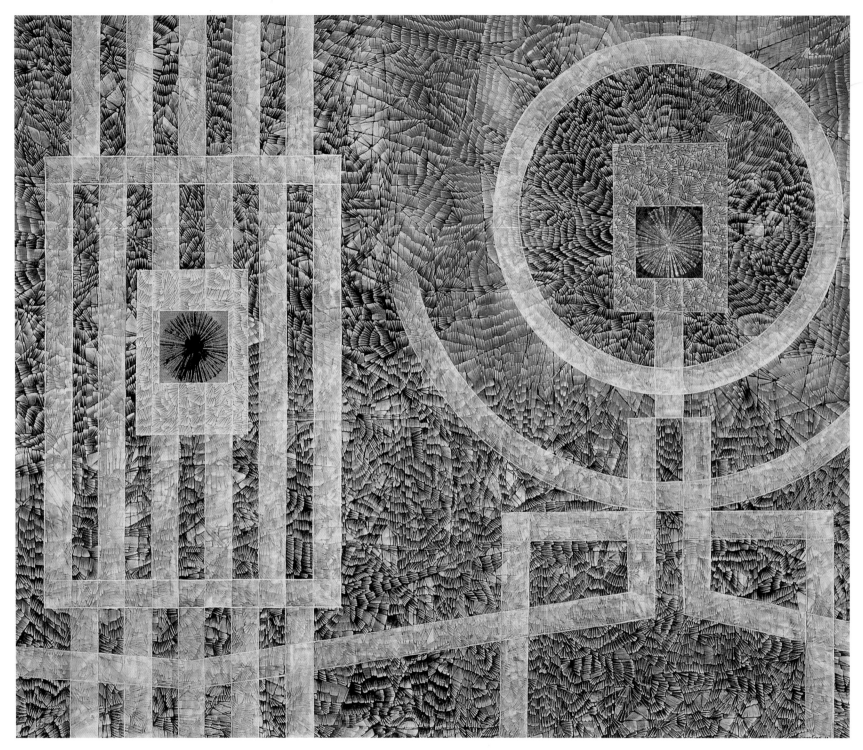

EXILE, 1974
Oil on canvas, 50 × 60 inches

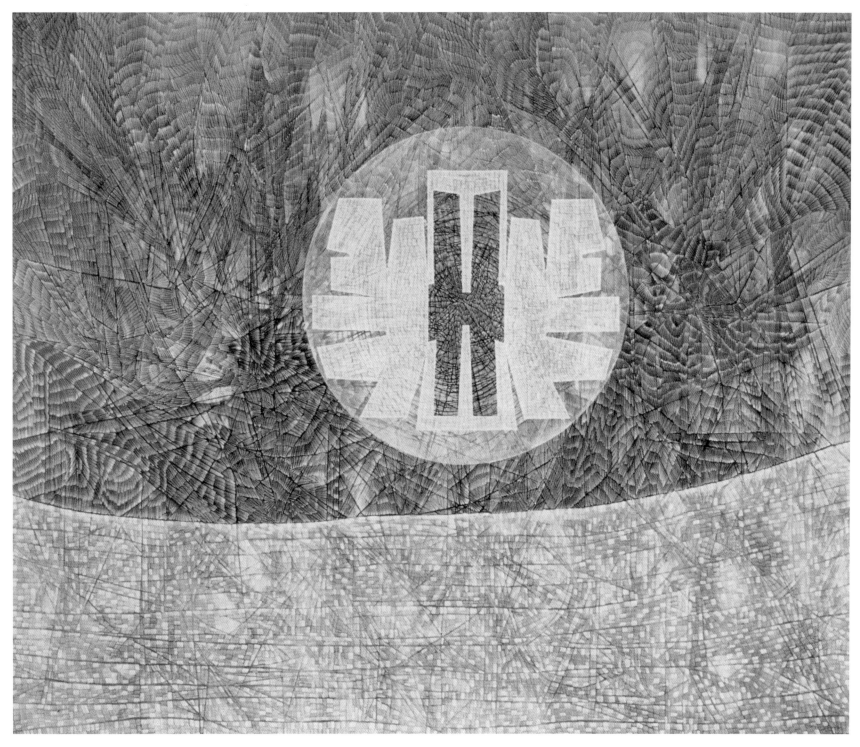

OLD ORAIABI, 1974–75
Oil on canvas, 50 × 60 inches
Brooklyn Museum of Art, New York
(1992.175)

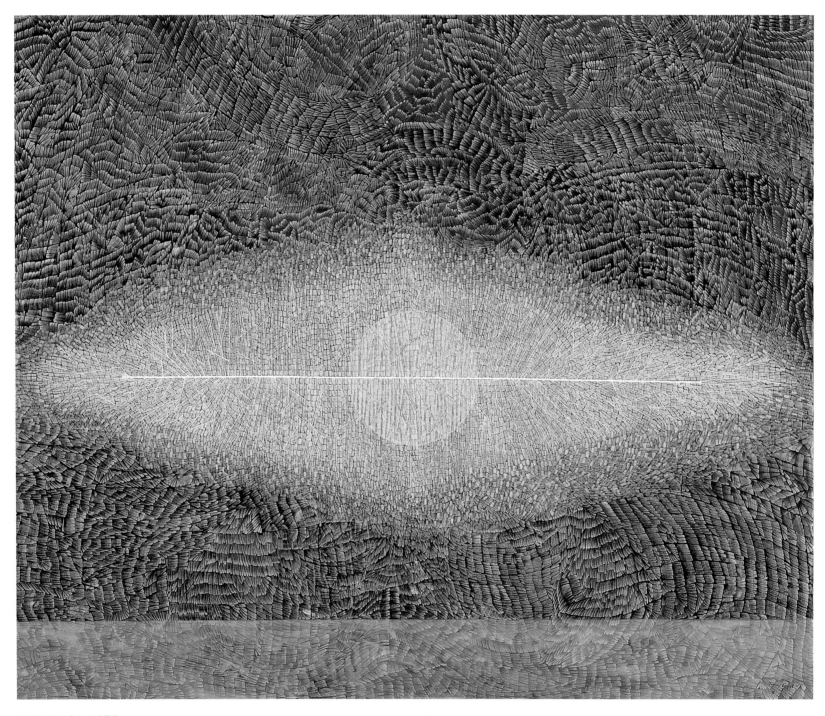

MOMBASA, 1975
Oil on canvas, 50 × 60 inches

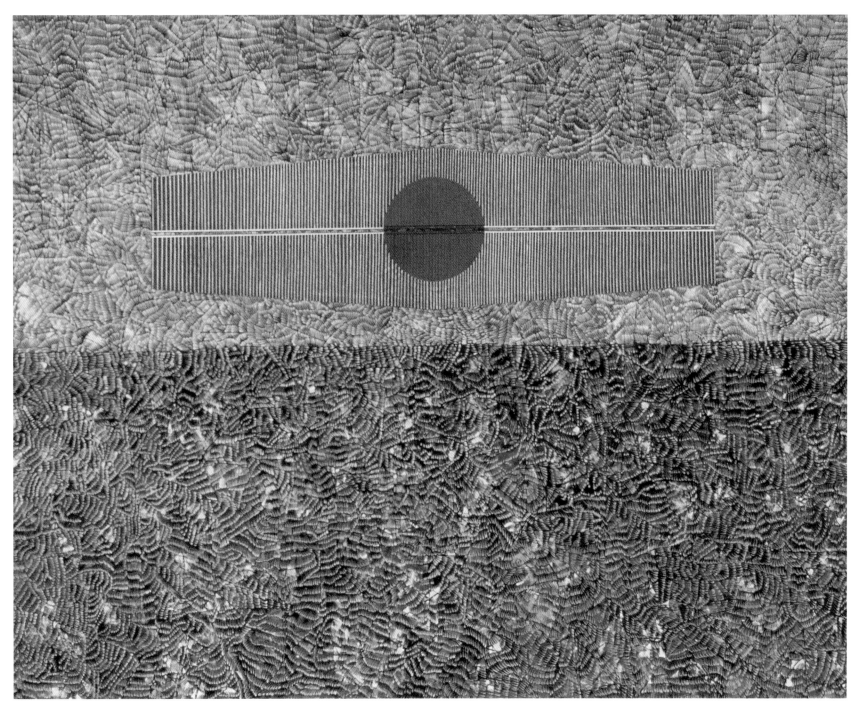

SILENT PROTEST, 1976
Oil on canvas, 50 × 60 inches

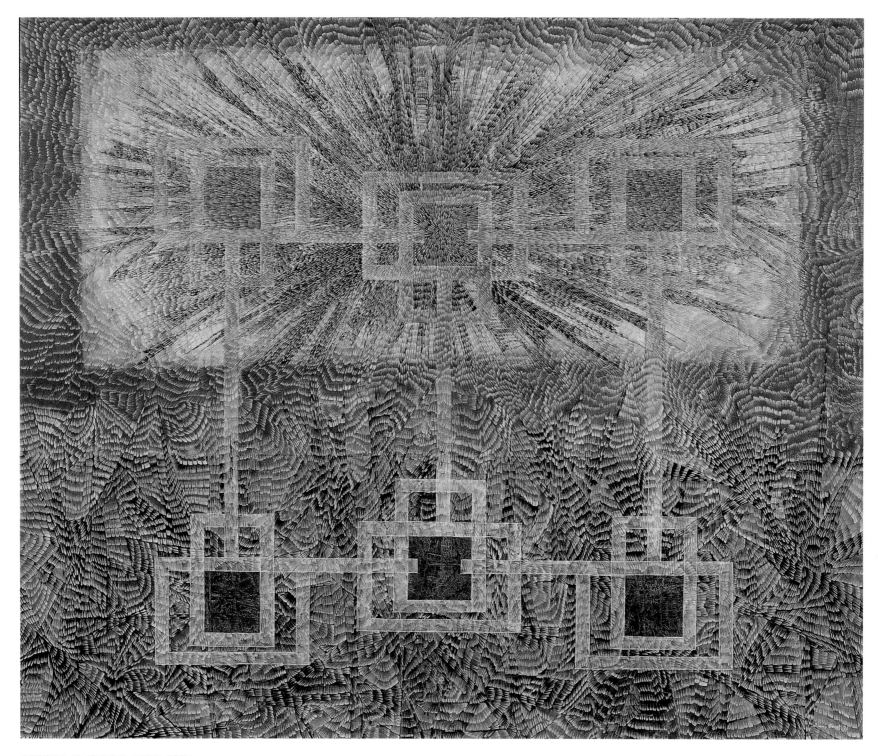

BEFORE IT IS TOO LATE, 1976
Oil on canvas, 50 × 60 inches

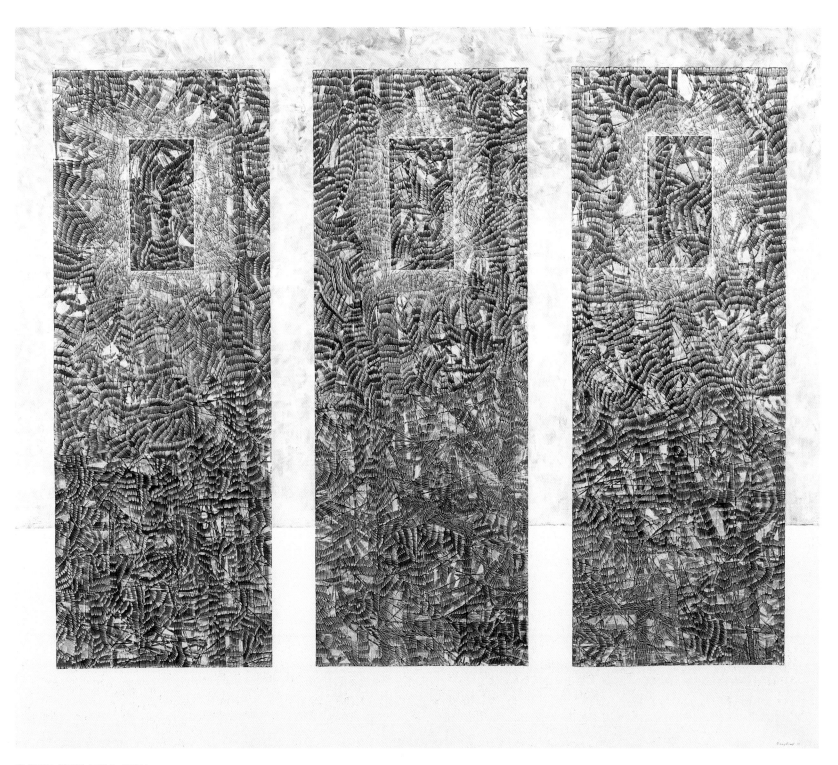

THREE SILENCES, 1976
Oil on canvas, 66 × 77 inches
Whitney Museum of American Art, New York
Gift of Dallas Ernst (91.70)

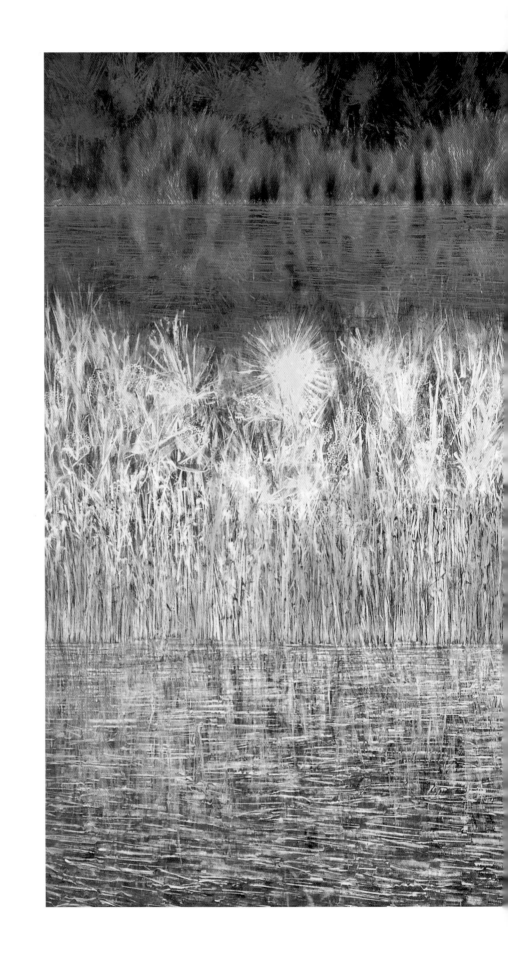

FIRE IN THE LAKE, 1981
Oil on canvas, 78⅛ × 132¼ inches
Solomon R. Guggenheim Museum, New York
Gift of Gloria Safier (86.3283)
Photo David Heald and Myles Aronowitz

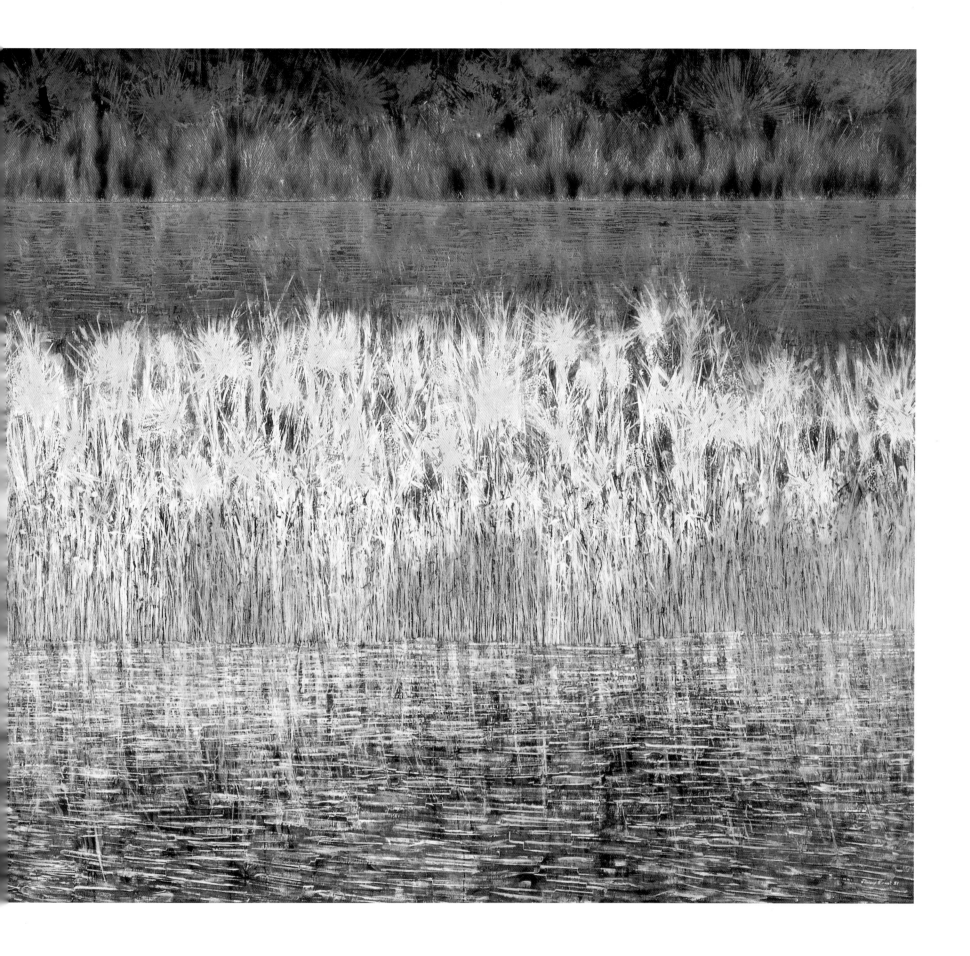

FIRE AT PEREDELKINO, 1981
Oil on canvas, 50 × 60
Collection of Rhoda Pritzker, Chicago

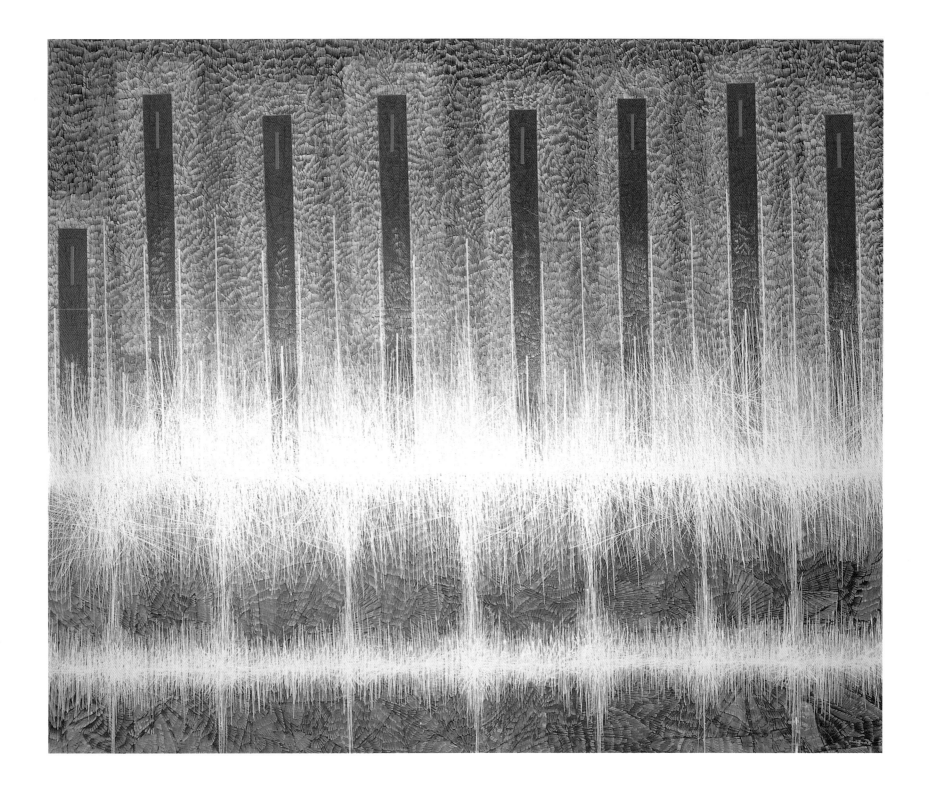

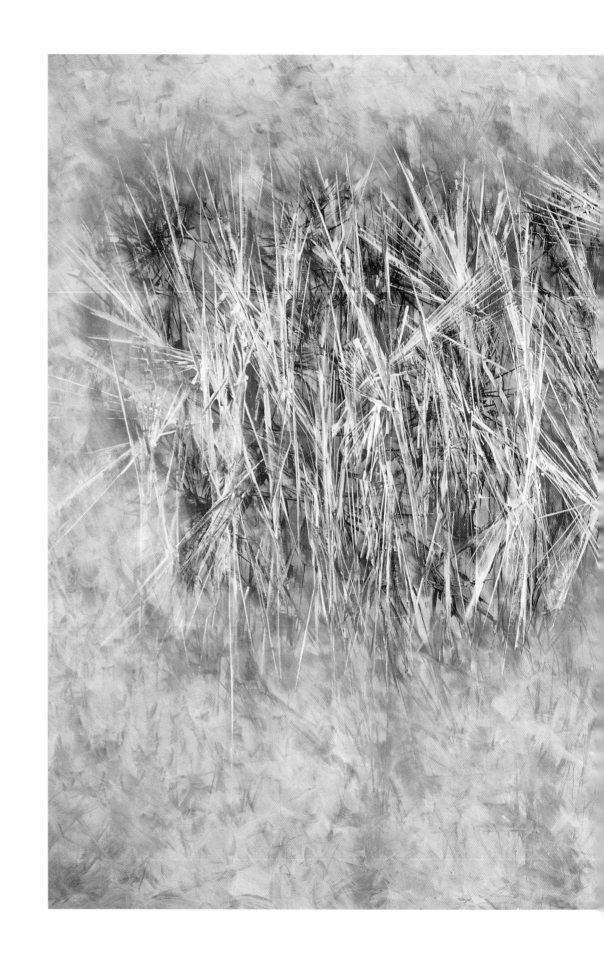

LAND IS WITHIN, 1983
Oil on canvas, 80 × 140 inches
Neuberger Museum of Art, Purchase College,
State University of New York
Photo Jim Frank

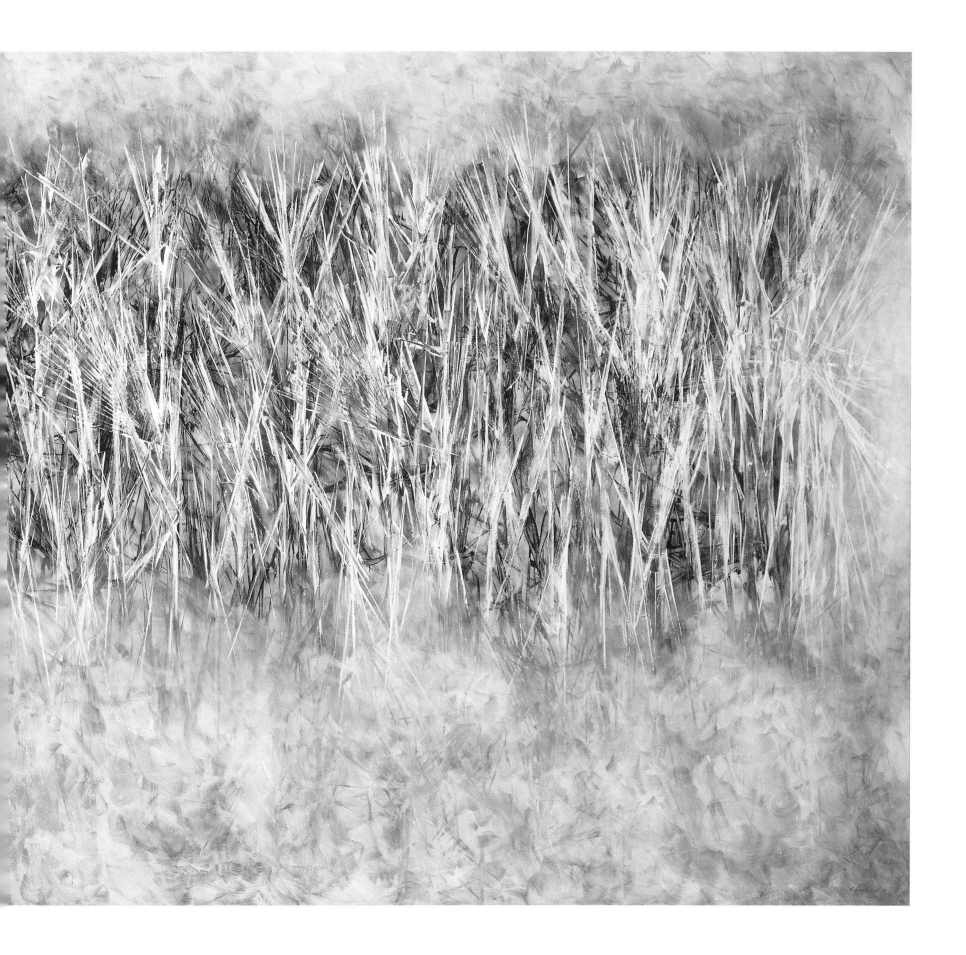

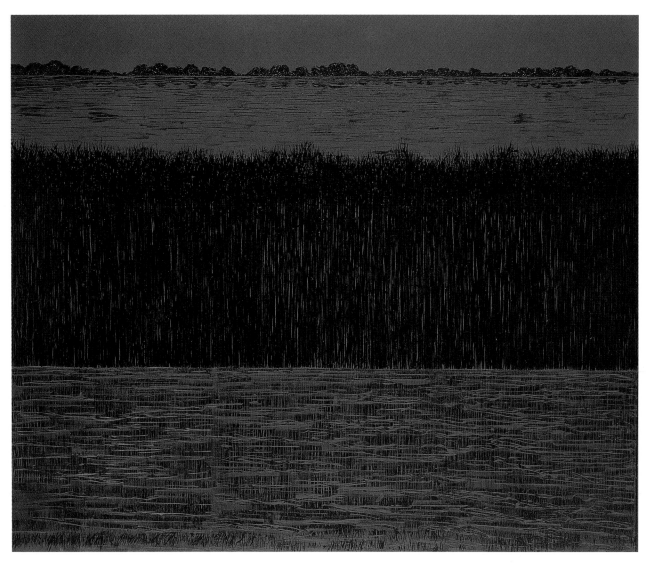

SEA OF GRASS (BLACK-ON-BLACK), 1982
Oil on canvas, 50 × 60 inches

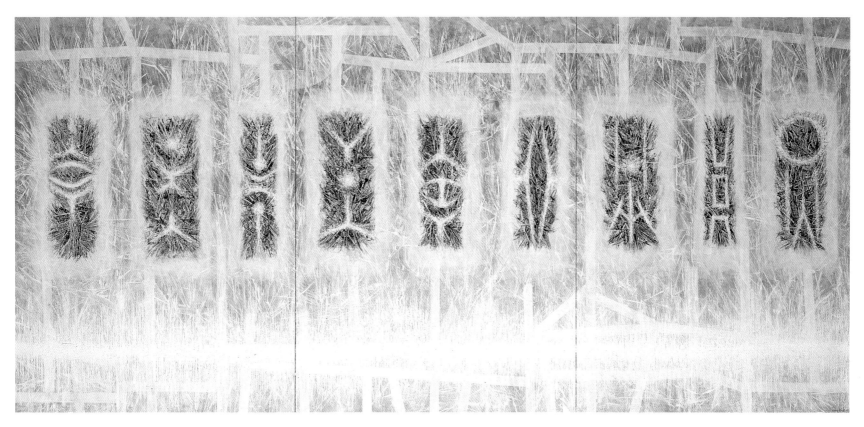

CELL BLOCK #12, 1983
Oil and acrylic on canvas,
80 × 143 inches
United States Holocaust Memorial Museum,
Washington, D.C.

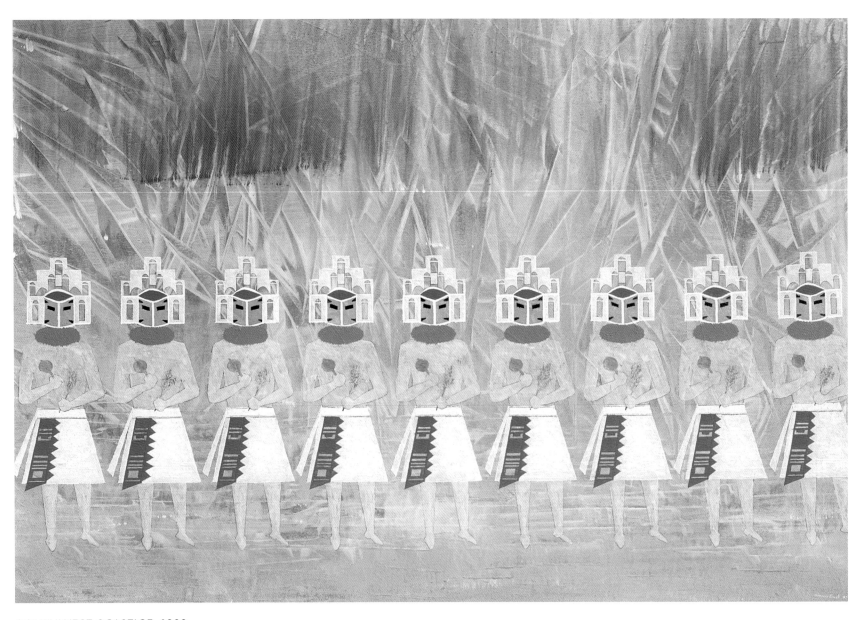

SOUTHWEST SOLSTICE, 1983
Acrylic on paper, 31 × 44 inches

JIMMY ERNST

INTERVIEWS

JIMMY ERNST *INTERVIEWED BY LOUISE SVENDSON*

This interview took place in June 1975 at Jimmy Ernst's studio in East Hampton, New York. Louise Svendson was curator at the Solomon R. Guggenheim Museum at the time.

LOUISE SVENDSON Jimmy, I understand from the history books that you were christened Ulrich, or, rather, Hans-Ulrich, I think you said.

JIMMY ERNST Yes, that's something I am trying to hide.

LS Well, we don't need to go into it, but just out of curiosity, how did you get to be called Jimmy?

JE During the British occupation of the Rhineland, my father apparently felt that Ulrich was much too Germanic. British occupation troops were nicknamed Jimmys in those days in the Rhineland. And so he said, "Well, why don't we call him Jimmy?" And it has been that way ever since.

LS Even when you came to America?

JE When I got my citizenship papers I tried to change the name to Jimmy, and the judge said, "No, you can't use a diminutive," and so I changed it to James.

LS Officially, legally, you are James?

JE Legally, yes, but I never use it.

LS Well, now you are grown up.

JE (laughing) People doubt that.

LS Since you were the son of Max Ernst, the very famous Surrealist painter, and your mother was a very well known art historian and critic, I suppose that your earliest memories must have been of an artists' milieu and an art historical milieu.

JE I never knew anything else except painting, literature, poetry, and things of that kind, as a result of which it took me until I was about eighteen or nineteen before I decided that I wanted to paint. I wanted nothing to do with that world.

LS What did you want to be during this period?

JE I have been trying to think back to what my ambitions were then. I think my ambitions in those days were conditioned by the fact that I had been chased out of Europe just about a week ahead of Kristallnacht and had constantly been on the run until I got here. Then when I got here my preoccupation was simply with trying to make a living.

LS Is that why you went to an arts and crafts school in Cologne?

JE No, that was mandatory. I had decided that I was going to leave Germany. My mother had already left but was financially unable to take me along to France. I stayed behind and decided that before I left for the United States I had better be able to do something with my hands. Through a friend of my mother's I got an apprenticeship in a big printing plant [J. J. Augustin] in north Germany. And as part of being an apprentice I had to attend arts and crafts school. But they didn't teach any arts and crafts there—only typesetting and stuff like that.

LS No painting, no drawing or sculpture?

JE No, no.

LS Or even lettering?

JE Layout probably. I don't quite remember. That was already under Hitler, and most schools had been converted into ideological training places. I don't really recall getting much manual training then, except as an apprentice.

LS Did you have friends in New York who would meet you and look after you when you first came over here?

JE Well, there was a son [Hans Augustin] of the printing plant owner. He was publishing in the United States and they were specialists in languages—Oriental, Sanskrit, all kinds of languages. I learned to set type in Sanskrit without visual identification. But the first Americans I really got to know were through Gladys Reichard, professor of anthropology at Barnard, who was then doing field-work in Ganado, which is a little village on a Navaho reservation. She decided that the best way for me to learn about America was to live with the Indians.

LS That was in one sense indigenous, but in another a little far-fetched. How was your English, by the way?

JE None, it didn't exist.

LS You never had any English in school?

JE No. So within ten days after arriving here I was herding sheep with the Navaho kids. And I think the first painting that ever excited me, really, other than the *Guernica*, which I had seen the year before, was a sand-painting ceremony. I lived on the reservation in Arizona for about three months—played my first game of baseball with the Hopis.

LS I noticed around your house and studio that you have a beautiful collection of Navaho rugs and Indian art.

JE Yes, I like them very much.

LS So that has always stayed with you?

JE Yes.

LS Do you think there is any influence on your work, in the sense of structure or color perhaps?

JE Not deliberately, not recently, but until about a year ago there were some very strong allusions to Indian imagery. I recognize the same thing with my painting when I go back to Europe, which I have been doing since the 1960s—very strong allusions to stained glass, Gothic architecture—not architecture, structure—a certain empathy you get when you walk into those cathedrals.

LS I think it is evident in all of your paintings, even from the very earliest ones, that you have a strong sense of structure underlying all the colors and the forms, however they may gradually develop over your stylistic life. But it would seem to me to be very natural for you, when you first started, to be somewhat under the influence of the Surrealists, whom you knew so well.

JE Certainly, very much so. The whole process of creating the form had to do with a certain measure of automatism—automatic procedure where you allow things to happen to the canvas and then work from there. Like most young painters who did this, the early work is quite biomorphic, having to do with one's insides.

LS How did you live during this period in order to paint?

JE The first job I had was in 1938, when I came back from the Indians. I was an office boy with a publishing house first, and then I worked at the Museum of Modern Art.

LS How did you get that job?

JE Well, I used to hang around an art gallery in New York called the Julien Levy Gallery—

LS A famous Surrealist gallery.

JE Which showed my father. I made it my second home, and I think Julien Levy got kind of annoyed. You know, what the hell is this kid doing here? So he used his influence to get me a job, and I was interviewed by Dick Abbott, who was then director of the Film Library. He asked, "What can you do?" And I said, "Well, I write Surrealist poetry, and I do this, that, and the other thing." And he said, "Okay, you start at fifteen dollars a week and you are an office boy."

LS Did you stay very long at the Museum of Modern Art?

JE Alfred Barr kind of protected me, I guess. I didn't stay very long at the Film Library. When the new building opened I was transferred to the mailroom.

LS Museums have always had, it seems to me, a string of very famous—later famous—mailboys.

JE There were some other people later who became well-known artists.

LS Well I suppose it's natural for artists to migrate toward a center of contemporary art.

JE Movie stars who used to be ushers, or actresses who used to check coats at Sardi's, like Lauren Bacall, I guess that happens.

LS How did you drift out of New York to Hollywood?

JE No, not Hollywood. I was a production man at Warner Brothers' home office in New York, which really consisted of being assistant to the art director.

LS And then you began to meet film actresses and actors and directors?

JE No, no. I met the talent scout for Warner Brothers [Dallas Bauman Brody], and I married her.

LS Then that is your connection with the stage, movies, and all?

JE Yes, yes.

LS When did you begin teaching?

JE In 1951 or 1952.

LS And that took away your financial worries at that point?

JE Yes. Prior to that the only time I had to paint was in the evenings or on weekends.

LS Well, then, chronologically you had, in 1943, your first one-man show. What sort of style were you painting in then? Was it still Surrealist?

JE They were fairly Surrealist things, fantasy things.

LS Did you use a definite imagery as so many Surrealists have?

JE Well, it was really more abstract even then. A lot of my images in those days—as they still do, but to a lesser extent now—came out of the way in which I applied paint. In the early paintings—the Museum of Modern Art has one, called *The Flying Dutchman* [1942; page 37]—I would put very liquid paint on the canvas and blow on it to make it spread in very feathery forms, out of which then I developed other images. So the procedure, or the application of paint, had a great deal to do with the image.

LS In that way you were very close to the methodology of what we later called Abstract Expressionism.

JE Yes, except they [the Abstract Expressionists] left it more alone, they did even less once a brushstroke was there, or an accidental converging of color. That became the painting. I was never that free and never allowed that to be the end-all.

LS There had to be structure in all of your things?

JE Yes, I wanted my hand in it.

LS What about the relation of image to ground? Did you consciously keep them flat, or did you want them to float in a sort of indeterminate space?

JE Whichever happened, that I left pretty much alone. But I always had a feeling that I ought to have something against a back of some kind, against some kind of space. Even when the paintings get very flat, I always try to have that interplay between form and space.

LS At one time you began to do what we call rock paintings. When did this happen? Did that develop naturally out of the method?

JE Well, in the 1950s I was artist-in-residence at the University of Colorado and spent two summers in the Rocky Mountain area, and I saw a lot of cliffs and stones. Then later I lived in Arizona for about six months, and I tried to make some drawings of my surroundings. But, as with other imagery that came, one day I was suddenly doing rock paintings. They were reminiscent of what I had seen, or what I had experienced.

LS When did you begin developing the black paintings?

JE The earliest one is 1947 or 1948, which made Ad Reinhardt very angry because he wanted to be the first one.

LS Was he aware you had been painting in black?

JE No, no. The painting had gone very sour, and I just covered it with a flat black paint that happened to be around the studio. Then I got angry or something, and I threw some other black paint on it, or by accident dripped some black enamel on it, and suddenly saw the difference between the two and then expanded on this idea. But that was in 1946 and 1947. The first one that I ever really painted I think is the one the Met owns.

LS The one the Guggenheim owns is, I remember, from 1954 [*Alone;* page 57].

JE I kept doing black-on-black not consistently, but two or three or four a year maybe. But there was just so much that I could do with it, or that I wanted to do with it. I recall one time in the 1960s or the late 1950s my dealer calling me from New York and saying, "Are you working on any black paintings?" And I said, "Well, yes and no." And she said, "Well, I have a waiting list." And I said, "No, I don't want that. I don't want to be known for having painted black pictures." But I did some things after that. I had a sort of retrospective that put most of them together. In the 1960s, I believe, in New York, I had a black-on-black show [1966 at the Grace Borgenicht Gallery].

LS I suppose an artist has to have a kind of resting period and a thoughtful period, taking notes on himself. What kind of abrupt change came about after this period of black painting?

JE I don't think there have been any abrupt changes. With me the development is fairly slow. I find that after five years suddenly the paintings have imperceptibly changed to a point where they are completely different. There was a short period in the early 1970s or thereabouts when I did very strong, almost hard-edged things that still had many linear things in them. I had been in Spain on a visit and somehow that affected me in the color and the intensity. But that was a hiatus, almost like the black paintings, except the black paintings kept going all the way through. This was a short period of about two years, three years, where there were practically no what you might call in graphics halftone values. Everything was either blue or red.

LS And flatter?

JE Very flat, yes.

LS Do you feel there is a particular imagery in your use of these very fine, weblike structures that pervade and control the canvas?

JE Not that I know of—certainly not a deliberate image. I like working with linear things. I like structure and forms. I like to allow forms to emerge out of the intersection or the combination of linear elements. I find it fascinating. It has never left me, and I keep coming back to it.

LS They always seem so precise, as if you planned them—pre-planned them—but that is not the way you work.

JE No, not at all.

LS How do you achieve those very fine lines?

JE Oh, there's a brush that Bill de Kooning uses, but in a very different way. It's called a Japanese sword striper. They used to use it, I understand, in the automobile plants in the early days to paint the stripes.

LS The thin lines along the fenders and across the doors?

JE That's where they were first used. I found a couple of those brushes in a paint store and played around with them and used them calligraphically, so that the first structure of most of the paintings is a calligraphic one, where I almost write on the canvas, in black usually.

LS The idea of gesture, in other words?

JE Yes, but then I make them more precise or more descriptive by adding a white line in the middle of the black lines, so that gives it an extra dimension.

LS To turn to another part of your experience, you say that you have been naturally evolving out of certain theories of Surrealism, from an unconscious gesture or form that you put on the canvas and then it [the painting] develops from that.

JE I have a fixed image of what it should look like. I think the most mysterious part of my anatomy is the gap between my hand and my brain. I don't know what happens in between.

LS Well, is not that called the creative process, after all?

JE (laughing) I don't know what the creative process is. I will leave that to the semanticists.

LS Many people who are not artists believe that an artist has a vision and that he simply sits down and expresses that vision in paint and in various colors and hues.

JE There are painters who can do that and do it admirably, very great painters, and it is very deliberate. They have complete control over what they are doing. In their case the magic has to be in how much of themselves they can put in there. Basically it is really no different from what I do except that I use a different avenue.

LS You talk about your early hardships in this country, coming almost alone and friendless without a word of the language. And then suddenly we were talking about your painting being bought by the Metropolitan, and one being bought by the Guggenheim Museum. What does it feel like when you have arrived at that stage?

JE When you get the news that a museum has bought you? It's marvelous, it's great excitement, it's great satisfaction. Larry Campbell said somewhere in some publication recently that I have more paintings in more museums than any other American artist. I can't believe that. That is something I will never get blasé about. When an important institution owns my work, it gives me great satisfaction.

LS Your father must have given you lessons or sent you to a private teacher to learn.

JE No, not at all. My father once visited me when I still lived in Connecticut, and we went into the studio, which had two floors at the time. We stood in front of a painting and he said, "How do you get that effect?" I told him, "You won't tell me how to get yours, I won't tell you how I get mine." Which is true. I once asked him, "How do you do that?" and he said, "I won't tell you." And

then I went upstairs with Dorothea Tanning to look at some drawings, and as I came down the old man was standing there, touching my painting with his finger. He wanted to know how it was done. Which I thought was a great compliment. But, I don't think he ever deliberately did not let me in on anything he was doing. In fact, I was there when he first did his drip paintings in New York, when he would punch a hole in a paint can and let it swing over the canvas, or use a funnel and with a pliers narrow the end of it and then put paint in it and let it swing around. When he worked in New York I was in his studio quite a bit. I saw how he made the decalcomania, with its spongy, feathery kind of effect. I saw him once making a frottage, an oil frottage, in fact. But I would not say I am self-taught, because I was immersed in that world so much that it was almost as if I had been doing it all my life.

LS I think it is very unusual—in fact, I think you are probably the only case I can think of in the whole history of art—where you and a very famous father have pursued the same career and then have emerged with totally different styles.

JE Yes, I think that is true. I think there are certain procedural similarities, even to this day, in the way we work. But I don't know whether that really has to do with the relationship, or where we come from, or the cultural background, or whatever.

LS But no one would ever mistake a Jimmy Ernst for a Max Ernst, ever.

JE No, no. But I think what helped there a great deal also was a lack of social pressure in America. I developed by myself in America, on my own, in other words, in a completely different environment, even artistically, than that of my father, even though I was familiar with that environment too. Ernst himself was quite pleased that I did not become a junior edition of him, even superficially that is.

LS In sum, I believe you think of your art as a continuing process.

JE Well, I hope so, because I think that is the only way in my case, with my temperament, with my outlook, whatever it may be, this is the way I would like to discover myself and have, in fact, conversations with myself. Because that is what I really think of painting—having a conversation with the surface, and at a certain point it begins to talk back. It is never completely separate from me, but it does begin to assert itself, and therefore it makes new demands. I find that the most interesting thing. It would be deadly for me to get hung up in an obvious gesture in the sense that each painting is only different from the other in its proportions, or in the parts or the forms, merely differently arranged. I think this must have been a problem for several American painters of the so-called New York School. They were almost condemning themselves to painting the same painting over and over again, with subtle nuances differently, but the overall appearance was unmistakable. What may have been the reason for this is that they stripped themselves completely of any superficial things and wanted to get down to their rock image. Well, once they discovered their rock image, they had nowhere to go. A lot of them led—I am talking about some who are no longer with us—rather tragic lives.

LS Do you blame some of that on dealer pressure?

JE In a minor way, yes. But I know that a lot of painters try to break out of it. And in his last years Franz Kline did indeed use color again. Now the man who has pretty successfully broken that is de Kooning. But he still worries about it. He worries about it to this day. I have been fortunate because the pressure was not there.

JIMMY ERNST *INTERVIEWED BY SONDRA GAIR*

This discussion was broadcast by radio station WBEZ-FM, Chicago, in January 1984, on the occasion of the publication of the artist's memoir, A Not-So-Still Life. *It is published courtesy WBEZ-FM, Chicago.*

SONDRA GAIR Paul Klee changed his diapers, Jean Arp gave him piggyback rides. Jimmy Ernst has always been immersed in the artists' world. He was brought up with people like Piet Mondrian, Salvador Dalí, Paul Eluard, Man Ray, Marcel Duchamp, I could go on and on. It's like a jewel box overrunning with gems, it's overwhelming. The people you grew up with and have in your life still—was it ever or is it ever intimidating? Certainly as a child. I imagine it isn't now as an adult, when you are a successful painter on your own.

JIMMY ERNST No, it wasn't intimidating as a child. Children have a marvelous way of being very discriminate in their judgment—or, rather, very precise in their judgments. They react very directly. It was a problem as a young painter when I started out, when I began to realize that I had certain privileges in the art world. I probably showed my own work too early because people knew who I was. It was a problem in a different way. The intimidation really had to do with the fact that I was a child of all of these people, and as a young painter I really admired them as the great innovators that they were. I had a slight conflict when I had to judge them as human beings, and they were not always very perfect. In fact some of them, I believe, would be judged to be monsters by ordinary standards.

SG In your book, *A Not-So-Still Life,* when you write about being the child of all these people, in a way, Jimmy, it's very sad. From reading the book I feel that possibly the real reason for a lot of your confusion is because you really were not taken care of properly by your father, Max Ernst. Though your mother was more responsible, she too after the divorce was quite erratic. Your father was a fascinating man, yet as you wrote, "It was the gorgons and the strange creatures that were his real friends and lovers."

JE In retrospect, really, I think it was the best thing that could have happened to me.

SG Why?

JE I don't know what I would have grown up to be if I had been dependent on fatherly love or whatever. I think there was respect, there was caring. But those days, those times, did not allow for most of these people, whom we now call giants, to have any normal lives, to have any normal affections. And I see this as a painter. I mean, I resolved early not to be that way.

SG Why wasn't it normal? Why couldn't they? I know that your father was very well known as a womanizer. He was very detached from most people, or from all people. But why was it impossible to have a so-called normal life?

JE These artists and these intellectuals, unlike the artists of my time who are part of a star system and are socially acceptable across all kinds of class lines, these were very embattled minorities. Their circle of friends was very small. They were fervent believers in what they were doing. In their struggle—their aesthetic struggle, not their struggle for recognition, the struggle to make their ideas come to life—there simply was no time, there was no space in their bodies, in their minds, for what we pride ourselves in—devotion to someone we love or to our children and all that. I understand it without condoning it.

SG Your first seventeen years were spent rejecting art, but *Guernica* changed your attitude. How did that happen?

JE Well, I was living most of the time in Nazi Germany, though not by choice. I just could not go anywhere except to visit my mother and my father separately in Paris. And I didn't know what was happening in the Spanish Civil War. I had rejected art as some luxury, some caprice. And when I heard about Guernica I was horrified because it was like science fiction, it was like our dropping a bomb on Hiroshima. It was that out-of-the-world kind of thing. And then when I saw *Guernica*, the Picasso mural, at the Paris World's Fair in 1937, it made such an impact on me that it changed my life. I realized that painting was not a caprice, it was not something light or amusing or for a well-to-do elite. This was a painting for humanity. And I realized that my father really did the same thing. I mean, he changed the way we look at things.

SG He was affected by *Guernica* as well?

JE Oh certainly.

SG Jimmy, you were always very generous as far as the many women your father brought into your life. But I found it fascinating that his affair with Gala Eluard, who later became Dalí's wife, really disrupted the unstable marriage of your parents, didn't it? And you write about the fact that as you encountered her over these past years, you really did not like her at all and tried to stay away from her. Was Gala really an instrument for your father's change? In other words, he was detached and really rejected all people. Was this an instrument for his own transition? Did he use her not only to get out of the marriage, but to leave Germany and perhaps to change his painting?

JE I don't think he consciously used anyone, he was not that sort of man. But he used women in a far more deplorable way, I would say. By our thinking today, he certainly was a chauvinist, as were most of these men. I mean, this was Europe just emerging from the dicta of a very conservative middle class that confined the woman to very limited roles. The men were interested in their own sexual satisfaction. I did not like Gala simply because of her personality; it had nothing to do with—I don't think—the fact that she broke up the marriage between my parents.

SG You decided to emigrate to America, I think it was in 1938.

JE Yes.

SG And you had always until that time considered yourself as something of an outcast. What were you looking forward to in America, and what did you expect to find, and what did you find?

JE Well, I found everything I had not dreamed about, in other words had not dared to dream about. I found openness, which I did not have as a child, I mean in terms of living in Europe. I was amazed by the lack of class distinctions, the easy way in which people moved about—even some of the vulgarity, you know, the neon lights, all kinds of things. There was something very much alive, and I kept finding things that I had not even dared dream about in America, including its faults, which I find marvelous in the sense that America allows faults to be dealt with and to be criticized. I love the idea of America not being the child of its government. It is the other way around. We don't call America the Fatherland or *la patrie*, or anything like this. This is our child and we chastise it. All of these things were in contrast to what I had grown up with and had not dared to hope for. Here it all opened up, and really in a very ordinary way without flag waving or anything like that.

SG It is fascinating to me too that after a while your father, Max Ernst, reentered your life. He came to America with Peggy Guggenheim and then married her eventually. But your mother—and I should say, we did not mention this before, that you came from a mixed marriage. Your mother was Jewish and stayed in Germany, and your father was from a Catholic background but went to Paris very early. Your mother, why did she stay in Germany?

JE She stayed in Germany only until the onset of Hitler. She was professionally active as a journalist in Germany, but when Hitler took over she also went to Paris. She was actually arrested by the French on the say-so of the Germans.

SG And she was exterminated.

JE Well, she was on the next-to-last train from Paris to Auschwitz. The Americans were already halfway to Paris when that happened.

SG Jimmy, what do you think about your father's work?

JE I think it's the greatest magic in my life. There are some other painters too. But this is one of the great, great innovators of our time.

SG What legacy did your mother leave you?

JE I always had this inner feeling about it, but I discovered when this book was finished that suddenly there was my mother taking the book away, if that is possible, from my father as a positive influence. I like to think of myself as a total humanist, if there is such a thing. I think my ethical behavior is based on what she instilled in me—none of that was done consciously, it was just her presence and her intellect and her liberalism in terms of humanism and her feeling for human beings. The one thing about that book, apart from talking about that period—the political and social and aesthetic upheaval—is my discovery of my mother all over again.

JIMMY ERNST

POEMS

SEA OF GRASS *FOR JIMMY ERNST BY LOUIS SIMPSON*

If you're a Jew and want to know
which transport your mother was on,
the French railroads have a list.
Jimmy showed me the name of his:
"Lou Straus-Ernst…Transport 76."

One of those who made the journey
and survived, gave an account:
"Seventy would be put in a boxcar.
There would be a long wait
while the train was boarded up.
Then three days' travel east…
paper mattresses on the floor
for the sick, bare boards for the rest.
Many did not survive."

·

At Auschwitz shortly before the end
one had seen her: "A woman totally exhausted,
half lying, half leaning against a wall,
warming herself in the last rays of a dying sun."
And still we believe in loving-kindness…
some even believe there's a God.
This is a mystery, *ein Rätsel*
God himself could not explain.

·

A few minutes' walk from the house
where I live, there's a beach,
a brown strip of sand
lined with tide-wrack and litter…
boards, plastic bottles
and, at the water's edge, green reeds.

"Sea of Grass" Jimmy called it.
Every time I come here I think of him
and his painting.

 "Work!
God wants you to," said Flaubert.

There they are every summer
just as he painted them,
growing up again…a hedge
of stems and leaves standing motionless.

Blue water, and a harbor's mouth
opening into the sky.

From *In the Room We Share*
(New York: Paragon House, 1990)

ON A PAINTING BY JIMMY ERNST BY LOUIS SIMPSON

A line of masked dancers
facing you, their eyes are slits…
holding rattles in their hands,
the sky behind them on fire…
Max Ernst and Paul Eluard,
Giacometti, Man Ray, Miró,
Soupault…all the Surrealists
lighting up the sky of Paris…
all the Kachina Indians!

From *In the Room We Share*
(New York: Paragon House, 1990)

REMEMBERING A FACELESS WORLD *BY JIMMY ERNST*

The sounds of the ever silent screams
Follow me with the winds of bitter memory
For those whose faces I failed to see
I dare not remember the dark and wet streets
Without night there was day and blind light
The well-ordered marching of unnumbered feet
scraping the innermost pain of endless time
I weep as I flee from the edge back to life
The tears of my freedom will not dry
We must remember each other without eyes
For I saw you long ago when the color was brown
Now it is blood red on lifeless grey grave stone
The streets and towers move silently past petrified men
A carnivorous dove devours each sight and all thought

(May 14, 1961, one hour after leaving
Moscow by air for Copenhagen)

JIMMY ERNST

STATEMENT

FREEDOM OF EXPRESSION IN THE ARTS II *BY JIMMY ERNST*

This essay was published in Art Journal *25, 1 (fall 1965): 46–47. Reprinted with permission of the College Art Association.*

IN THE YEAR OF 1870, the great French artist Gustave Courbet wrote in a letter to the French Minister of Fine Arts the following:

> The state is incompetent in matters of art. When it undertakes to reward, it usurps the public taste. Its intervention is altogether demoralizing, disastrous to the artist, whom it deceives concerning his own merit; disastrous to art, which it encloses within official rules, and condemns to the most sterile mediocrity; it would be wisdom for it to abstain. The day the state leaves us free, it will have done its duty toward us.[1]

It would seem that the kind of states or regimes of which Courbet spoke are still with us in some parts of the world. Their existence today and their characteristics in relation to the artist, and indeed to the individual generally, are contrasted sharply by the far more enlightened attitude that many of today's governments take toward the arts. It seems clear that those societies, in which the individual citizen is the initial as well as final source of his government's power, have learned that the arts are a harvest which is of benefit to the community only when there is no interference with the seeding or planting of it. A government which honors the belief that it is not invested with the right to administer men's souls or spirit is of far more assistance to its cultural climate than those who use general subsidization in an attempt to dominate, and thereby corrupt, every creative individual. The role of the artist in a society, such as the United Sates, which honors diversity within its own borders, becomes symbolic of that nation as a respecter and guardian of diversity everywhere.

The idea of individual freedom of expression is not merely to be tolerated but considered to be mandatory as one of the foundations for a healthy society. It is this basic, humanistic idea that places the creative individual in the role as citizen of the world as well as a valued participant in his own nation's affairs. Art is indeed a means of communication which knows no borders and is above the barrier of linguistics. But before art can communicate anything, it has to come into being without the hindrance or superimposition of any outside influences. The creative act is finally a mystery. Such a mystery needs no explanation or defense because it is by its very nature its own defense against profanation. The artist's initial absorption has to do with the miracle of self-transcendence, conceived in individual thought and idea, born in a dialogue between man and work, growing out into the world by the force of a single man's universality. It is only in this manner that the artist can be of service to his society. If society expects from its artists a truthful view of man's existence, it must allow him his freely chosen ways for such contemplation. It must also be prepared to get its answer from the artist in language which at first may seem strange and, at times, even unintelligible. Society will find, however, that its initial lack of comprehension was due to the fact that new views and ideas usually have to resort to new or unexpected imagery. It is the artist's individual duty and responsibility to advance the adventure of the human spirit by forever curiously testing new opinions

and courting new impressions. The proof of his success or failure is not dependent upon contemporary criticism or praise but rather in how the stones he has thus formed fit into the structure of the house which he shares with all of humanity.

Today, art is no longer the peculiar property of any one nation even though there are graves, in some parts of the world, of men who died with the denunciations of their governments still ringing in their ears because they dared to speak as artists of a world rather than as tools of some narrow chauvinistic point of view. To some regimes, the artist is indeed a potentially dangerous individual. The true artist must reject the anti-humanistic concept that culture is a mere servant or tool of political or social aims. Social or political evolution is the result, rather than the cause, of an intellectually honest civilization. Regimes which have trampled on a people's culture to effect social and political changes ground themselves with bloodstained hands. The seeds of aesthetic and social aspirations of any people have always been anticipated, sensed and discovered by its philosophers, poets and artists. More often than not, theirs has been a lonely task, in a hostile climate, to nourish the fragile plant with their words and images.

No society or state has even been able to hide its own shortcomings behind the screen of a carefully nurtured and directed culture. Those states that have succeeded, through a variety of means, in proscribing the mode of expression and subject matter for its creative individuals have invariably found themselves not only defending faulty political concepts but state-supported mediocrity as well. While it may be possible to restrict an artist's or a poet's activities, history shows that the mind and spirit of the individual, thus violated, cannot be curbed. The names and works of those who defied this kind of chauvinism continue to haunt the perpetrators of this repression. Art as a cohesive core of culture is at all times the open enemy of political or intellectual intolerance. Since art is not of static substance but always ahead of its own time, it will perish where it is forced to propagandize ideas that demand absolute conformity from all individuals. Yet it will not remain dormant long enough to allow negative forces to achieve respectability in the eyes of the world. Art may be stifled but even in its temporary silence it remains an incorruptible witness for the future of what is repressed in the present. In October of 1963, the late President Kennedy gave voice to the attitude of the United States on this universal question when he said:

When power leads man toward arrogance, poetry reminds him of his limitations. When power narrows the area of man's concern, poetry reminds him of the richness and diversity of his existence. When power corrupts, poetry cleanses. For art establishes basic human truths which must serve as the touchstones of our judgment. The artist, however faithful to his personal vision of reality, becomes the last champion of the individual mind and sensibility against an intrusive society and officious State.

It is indeed not enough for a society to pay lip service to great men and noble things while, at the same time, attempting to dominate and corrupt its most valuable asset, namely the men of thought and ideas. Such a society, fearing the immense expansive forces of individual liberty, is in fact at war with itself. A state that fears and represses its own intellectual minority can ill afford to stand before the world as a champion of international peace. Freedom of expression for all individuals, as symbolized by the artist's freedom of expression, is the mortal enemy of war. The artist's revulsion against war, murder and injustice is expressed not merely in his protests against this inhumanity but also in his affirmation of all visible and invisible aspects of life. The great contributions of art to humanity have occurred when the reality of everyday life became enriched through the revelation of things and ideas that had remained hitherto intangible or invisible. In times of maximum danger, it is not for the State to say what form the artist's protest against death should be. Any affirmation of the life-force must be found by the creative individual in his own free way. Any state which thus endows the artist or the poet with the precious gift of trust will find the response to have been based on the highest sense of individual responsibility. Those who cannot summon the strength to act on this responsibility would be poor servants, indeed, of any idea, political or intellectual. It is important that free artists everywhere express this position because of the knowledge that the international community is still deprived of the full participation, in all of its aesthetic deliberations and explorations, by many of its contemporaries. Many a fine creative mind is kept apart from his natural world under the pretext that his voice belongs to his nation alone. More often than not, he is forced to serve a "revolution" which was lost long ago to those who fear the open mind and find comfort only in the various practices of anti-

intellectualism. It is from these very quarters that we hear the loudest demand that the arts be used for the promotion of a multitude of slogans. The arts, as an international force, will be of little value if they are to serve sectional interests only. The bluff of sloganeering should be called once and for all. By all means, let the artist talk about "the use of literature and art in the struggle against preparations for a new war"; let him oppose "the spread of ideas of hate among peoples"; let him openly advocate humanistic attitudes toward the many other problems that are being drowned and perverted in a sea of slogans. But before any of this can reach a speaker's podium or conference, the question of the "Freedom of Expression in the Arts" must be allowed to clear the air of any possible hypocrisy. This problem must be led out of the semantic jungle into which a variety of purely sectional considerations have placed it. The arts can indeed serve as the conscience of the international community but not as long as they are denied freedom of expression in any part of the world. In order to achieve this freedom, and also the competence to discuss problems which are dependent on this freedom, a series of international conferences under the auspices of UNESCO would indeed be useful. Under the main heading of "FREEDOM OF EXPRESSION IN THE ARTS" the following considerations could guide this agenda:

(a) Rejection of state-dictated theories and tendencies in art and literature.
(b) Recognition of the arts as an international community.
(c) Humanism and the open mind as the primary weapon against war and oppression.
(d) The artist's independence from sectional geopolitical tendencies.
(e) The achievement of international cultural freedom through the recognition of the artist's need to be initiator, rather than mirror, of ideas.

International programs consisting of traveling exhibitions and free exchanges of publications concerned with the arts and aesthetics should not be burdened with sectional limitations concerning styles, subject matter or means of expression.

Of undoubted usefulness would be an active program, sponsored by UNESCO, enabling artists and scholars to assist and encourage similar individuals in the newly emerging member states of the United Nations.

In conclusion, it should be stated that artists all over the world have a far stronger bond among themselves than has yet been negotiated between the various nations of the world. The spirit of the Universal Declaration of Human Rights is in evidence in the earliest pages of art history and the community at large would do well to look with new eyes on the ideas which flow so generously from its gifted minority.

NOTE
1. Robert Goldwater and Marco Treves, eds., *Artists on Art* (New York: Pantheon, 1945), 297.

CHRONOLOGY

CHRONOLOGY

This chronology is based on the compilation by Helen A. Harrison on the occasion of the career survey exhibition presented by the Guild Hall Museum in 1985; updates and additions have been made by Douglas Dreishpoon (1994).

1920

Jimmy Ernst is born Hans-Ulrich Ernst in an apartment on the Kaiser-Wilhelm-Ring, Cologne, Germany, on June 24. His father is the prominent Dada/Surrealist artist Max Ernst, his mother, Louise ("Lou") Straus-Ernst, an art historian and journalist. Max nicknames him "Jimmy" after the British soldiers then occupying the Rhineland. Spends childhood in the company of many of the foremost figures in the European avant-garde art world, among them Hans and Sophie Taüber Arp, Jankel Adler, Paul Klee, Gala and Paul Eluard, Tristan Tzara, André Breton, Theodor Baargeld, and Lyonel Feininger.

1922

His parents separate, Max traveling to Paris and Lou staying in Cologne with their son.

1925

Spends part of the year in the country with the family of his devoted nanny, Maja Aretz; attends Roman Catholic Church services there. After resolving the legitimacy of his presence in France, Max makes the first in a series of visits to his wife and child in Cologne and finalizes divorce.

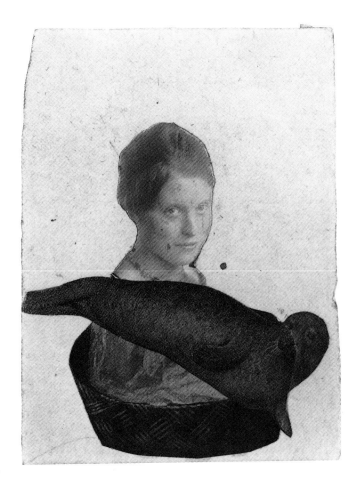

Max Ernst
*Portrait of Rosa Bonheur
(Lou Straus-Ernst)*, 1920
Collage of cutout printed
reproductions and photographs
with pencil on paper, 4½ × 3¼ inches
Jimmy Ernst Family Collection

1926

Enters public school in Cologne, where early Nazi activities attract his attention. Despite a stubborn indifference to painting, is taken by his mother to museums and galleries and on visits to artists' studios.

1927

Max brings his new French wife, Marie-Berthe Aurenche, to meet Jimmy and Lou.

1928

Lou and Jimmy move to a modern apartment on Emma Strasse in the Cologne suburb of Sülz. Attends a "dissident" school, one of a system of public institutions that co-existed with state-supported parochial schools during the Weimar Republic.

1930

Spends his spring school vacation in Paris with Max and Marie-Berthe. Meets a cross section of Parisian intellectual and political figures and many of the Surrealists, including Alberto Giacometti, Man Ray, Victor Brauner, Joan Miró, Jacques Prévert, Louis Aragon, André Masson, René Clair, Marcel Jean, Roland Penrose, Philippe Soupault, Yves Tanguy, Salvador Dalí, and Louis Buñuel. Attends a private screening of the as yet unedited Buñuel *L'Age d'or*. Hears American jazz musicians, including "Bojangles" Robinson and Fats Waller, for the first time at a Paris music hall.

1932–36

Attends Lindenthal Real-Gymnasium, Cologne.

1933

Adolph Hitler is installed as chancellor of Germany on January 30. One month later, the SS searches the Ernst apartment (as a noted intellectual and a Jew, Lou is doubly suspect by the new regime). Late in May Jimmy goes to live with Lou's orthodox Jewish father, Jacob Straus, and step-grandmother and begins regular monthly weekend visits to Max's pious Catholic family in Brühl, near Cologne, while Lou moves to Paris to find work. Jimmy pays twice-a-year visits to Paris through 1938.

1935

Apprenticed as a typographer to the printing firm of J. J. Augustin in Glückstadt, founded in 1632, which was one of the primary printing plants for the German navy; it issued the only local newspaper and produced mail-order catalogues and textbooks, including the books and papers of many prominent American anthropologists for distribution in the United States. Studies graphic arts (typography, typesetting, printing) at the Altona School of Arts and Crafts in Altona, Germany, in connection with his work for J. J. Augustin. Sets type for editions of anthropological studies on Navajo sand painting; Zuni and Hopi kachinas, silverwork, and pottery; and a French translation of the poems of Rainer Maria Rilke.

Lou Straus-Ernst, Paul and Gala Eluard, Max Ernst holding Jimmy, and the Eluards' daughter in Tyrol, 1922

Lou Straus-Ernst as a journalist covering Paul von Hindenburg's visit to Coblenz, ca. 1930

Jimmy on semiannual visit to Lou in Paris, 1933

Jimmy working in the Museum of Modern Art Film Library, a still from *The March of Time*, 1939
Photograph courtesy of Alfred Kleiner

1937

In June, visits the Paris World's Fair with his mother's press pass and is unexpectedly riveted by Picasso's mural, *Guernica*, in the Spanish pavilion. Begins to develop more positive attitude toward painting when he discovers art can be a crucial vehicle of human expression. Returns to Germany, an alien in his own country because of increasingly intense activities of Nazis (including a traveling exhibition organized by the Ministry of Culture of "degenerate" art, featuring work by Max Ernst, among others). Members of the Augustin family work secretly to obtain an American visa for him through the firm's New York office (firm is threatened with loss of navy contracts if Jimmy, half-Jewish, is not fired). Attends American films in Hamburg to learn English. Spends Christmas in Paris and is notified that affidavits from Hans Augustin and the renowned anthropologists Franz Boas and Gladys Reichard had arrived at the American Consulate in Hamburg. Late in the year, obtains his visa.

1938

Departure from Germany precedes Kristallnacht by one week. Sails for America by way of Paris and Le Havre, on the S.S. *Manhattan*, arriving in New York on June 9. Begins work for the New York branch of J. J. Augustin Publishers. His mother and father both remain in France. In late June, travels by car with Hans Augustin to the Southwest, visiting Hopi and Navajo reservations in Arizona and Los Angeles before returning to New York. Visits the galleries of the temporary quarters of the Museum of Modern Art in the basement of the Time and Life Building and encounters a collage by Max Ernst and a watercolor by Klee that he remembers from his home in Cologne.

1939

After a succession of menial jobs, is hired by the Museum of Modern Art on the recommendation of art dealer Julien Levy, whose gallery he frequents. Works in the mailroom and Film Library and is featured in the popular newsreel *March of Time* in the process of wrapping program notes. Begins making art with poster paints on cardboard salvaged from book shipments coming into the mailroom. In the winter, begins to work in oils—free samples are given to him by Victor D'Amico, the head of the Department of Education at the Museum of Modern Art—and makes prints from linoleum tiles. On weekends paints in the sunny riverside apartment of coworker Jay Leyda. *Guernica* is installed in the museum and he visits it daily. Allied powers declare war against the Axis powers on September 3.

John La Touche in front of the mural painted by Jimmy Ernst
as his first commission, Minetta Lane, New York, 1940

1940

Expands friendship with members of the New York avant-garde and European artists in exile. Completes first mural commission, for bathroom of lyricist John La Touche's Greenwich Village duplex on Minetta Lane. Spends weekends painting and listening to jazz at the Upper West Side apartment of William and Ethel Baziotes. Spends summer vacation at Chalet Indien in Boyceville, in the Catskills, where he paints second mural, *La Deuxième Création du Monde*. Petitions the Emergency Rescue Committee (ERC) to help Max and Lou escape from France.

1941

Makes first trip to the east end of Long Island for a week's vacation in Amagansett. The Emergency Rescue Committee (ERC) succeeds in securing Max's release from internment. After the fall of France, Max arrives in New York with Peggy Guggenheim and her entourage on July 14 and is released from Ellis Island three days later, in the custody of Jimmy. Works as Peggy's secretary-assistant, record-keeping, cataloguing, and organizing her art collection. Attends Gordon Onslow-Ford's lectures on Surrealism at the New School. In the fall, travels with Max and Peggy to California, where Charles Everett ("Chick") Austin, director of the Wadsworth Atheneum, buys *Vagrant Fugue*, 1941, for the museum. On their return to New York, Max buys him better art materials and encourages his development as a painter. United States declares war on Japan, December 8; on Axis powers, December 11.

Jimmy welcoming his father, Max Ernst, to the United States, Ellis Island, July 14, 1941

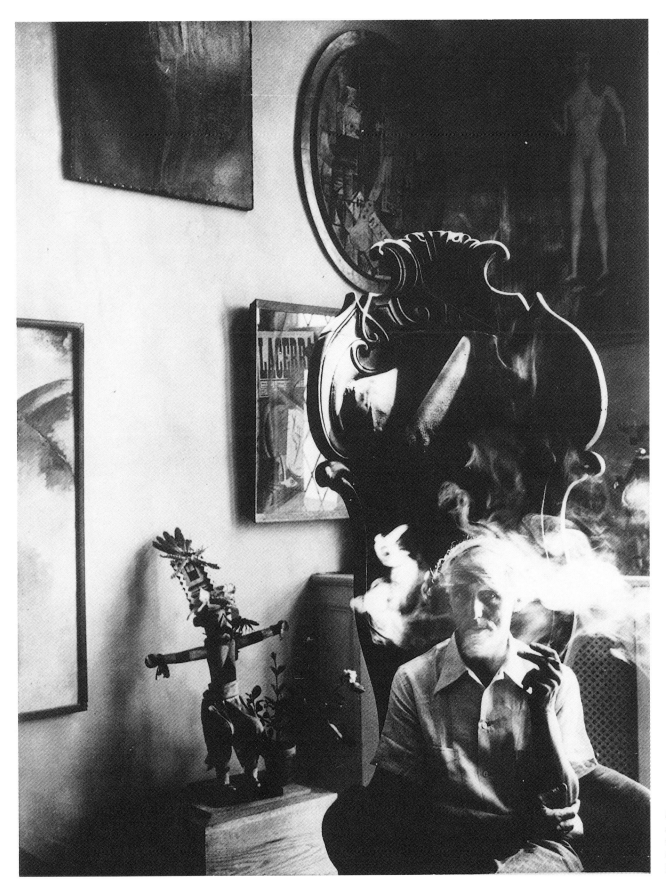

Max Ernst photographed by
Arnold Newman in the Fifty-first Street
triplex he shared with Peggy
Guggenheim in New York, 1941
Photo © Arnold Newman

Artists in exile group at the Ernst-Guggenheim triplex, New York, 1942
Left to right, first row: Stanley William Hayter, Leonora Carrington, Frederick Kiesler, Kurt Seligmann;
second row: Max Ernst, Amédée Ozenfant, André Breton, Fernand Léger, Berenice Abbott;
third row: Jimmy Ernst, Peggy Guggenheim, John Ferren, Marcel Duchamp, Piet Mondrian
Photo © Artists Rights Society. Philadelphia Museum of Art: Marcel Duchamp Archive,
Gift of Jacqueline, Peter, and Paul Matisse in memory of their mother, Alexina Duchamp.

1942

Exhibits a canvas, *The Flying Dutchman*, 1942 (page 37), at the Marian Willard Gallery, New York. Peggy Guggenheim's Art of This Century Gallery opens, October 20, with Jimmy as director. Attends sessions focusing on automatism in Matta's studio. German troops occupy Vichy France, further endangering his mother.

1943

Desire to serve in U.S. armed forces is thwarted when he is declared 4F in January. Leaves Art of This Century. Helps Elenor Lust organize and open experimental Norlyst Gallery on West Fifty-sixth Street in March. Has first one-person exhibition, *Reflections of the Inner Eye*, there, March 29–April 14, translating into art forms his generation's scientific inquiries into physics, botanical forms, and plant morphology. Museum of Modern Art purchases *The Flying Dutchman* from the show.

1944

Visits father and painter Dorothea Tanning on Long Island. Unknown to him, on June 30 his mother is transported on the next-to-last train to Auschwitz concentration camp from Drancy, a detention camp near Paris. She does not survive the war.

1945

Allied victory in Europe declared on May 9. After Jimmy learns about his mother's death, he spends a few days in early summer in Amagansett with Max and other Surrealists in exile. With the help of Gabor Peterdi, begins working as assistant to the art director in the advertising department of Warner Brothers.

1946

Wins Hattie Brooks Stevens Memorial purchase prize at the first Pasadena Art Institute annual. Max and Dorothea Tanning move to Sedona, Arizona, in the spring, and Jimmy sublets their Fifty-eighth Street apartment. Has first show at Norlyst Gallery of "jazz painting," in which Jimmy tries to transpose the basic principles of one art to the other.

1947

Marries Edith Dallas Bauman Brody, called Dallas, a talent scout for Warner Brothers, on January 3.

1948

Teaches evening classes in painting, Pratt Institute, Brooklyn (through 1950).

Jimmy and Dallas Ernst and *Dallas Blues* (page 45) in double exposure, 1947

Jimmy Ernst, New York, 1948

Young Painters in

Brooks	**1**	Wols
Cavallon	**2**	Coulon
de Kooning	**3**	Dubuffet
Ferren	**4**	Goebel
Ernst	**5**	Singier
Gatch	**6**	Palluty
Gorky	**7**	Matta

U.S. & France

Graves	**8**	Manessier
Kline	**9**	Soulages
Pollock	**10**	Lanskoy
Reinhardt	**11**	Nejad
Rothko	**12**	de Stael
Sterne	**13**	da Silva
Tobey	**14**	Bazaine
Tomlin	**15**	Ubac

Preview 4-6 Monday 23 October 1950
SIDNEY JANIS GALLERY . 15 E 57

Announcement card for the exhibition
Young Painters in U.S. & France, Sidney
Janis Gallery, New York, 1950

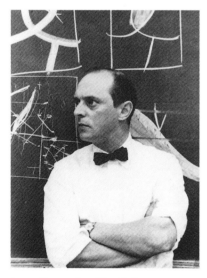

Jimmy Ernst at Brooklyn College,
early 1950s

1950

Joins fellow avant-garde artists (William Baziotes, Willem de Kooning, James Brooks, Adolph Gottlieb, Hans Hofmann, Ibram Lassaw, Robert Motherwell, Barnett Newman, Mark Rothko, David Smith, Bradley Walker Tomlin, and others) in three-day symposium, "Artists' Sessions at Studio 35," April 21–23. Joins so-called "Irascible Eighteen" in protesting the anti-abstractionist bias of the Metropolitan Museum of Art, New York. Museum of Modern Art purchases *A Time for Fear*, 1949 (page 48). Receives Juliana Force Memorial Award, a purchase prize for *Personal History*, 1949 (page 49), which enters the collection of the Whitney Museum of American Art, New York.

1951

Joins Grace Borgenicht Gallery, New York. Early affiliation with the burgeoning New York School is documented in the now famous photograph of the Irascible Eighteen published in *Life* magazine. Is invited by Robert Jay Wolff to join the art department of Brooklyn College as instructor of design. Leaves his job at Warner Brothers.

1952

Becomes U.S. citizen. Moves to South Norwalk, Connecticut. Toledo Museum of Art purchases *Cirque d'hiver*, 1952 (page 55).

1953

Metropolitan Museum of Art acquires the black-on-black painting *Almost Silence*, 1952 (page 56). Daughter, Amy Louise, born April 26.

1954

Receives Norman Weil Harris Prize (Bronze Medal), Art Institute of Chicago. Is visiting artist, University of Colorado, Boulder (also 1956). NBC television commissions a sculpture for the television show "Producer's Showcase."

ALCOPLEY • BOUCHE • BROOKS • BUSA • BRENSON • CAVALLON • CARONE • GREENBERG • DE KOONING • DE NIRO • DZUBAS • DONATI • J. ERNST • E. DE KOONING • FERREN • FERBER • FINE • FRANKENTHALER • GOODNOUGH • GRIPPE • GUSTON • HARTIGAN • HOFMANN • JACKSON • KAPPELL • KERKAM • KLINE • KOTIN • KRASSNER • LESLIE • LIPPOLD • LIPTON • MARGO • MCNEIL • MARCA-RELLI • J. MITCHELL • MOTHERWELL • NIVOLA • PORTER • POLLOCK • POUSSETTE-DART • PRICE • RESNICK • RICHENBERG • REINHARDT • ROSATI • RYAN • SANDERS • SCHNABEL • SEKULA • SHANKER • SMITH • STAMOS • STEFANELLI • STEPHAN • STEUBING • STUART • TOMLIN • TWORKOV • VICENTE • KNOOP •

COURTESY THE FOLLOWING GALLERIES: BORGENICHT, EAGAN, TIBOR DE NAGY, THE NEW, PARSONS, PERIDOT, WILLARD, HUGO

MAY 21ST TO JUNE 10TH, 1951
PREVIEW MONDAY, MAY 21ST, NINE P. M.
60 EAST 9TH ST., NEW YORK 3, N.Y.

EXHIBITION OF PAINTINGS AND SCULPTURE

Poster for the *9th Street Show*, New York, 1951

Life magazine photograph, January 1951, of artists who refused to participate in an American painting exhibition at the Metropolitan Museum of Art, New York. From left rear: Willem de Kooning, Adolph Gottlieb, Ad Reinhardt, Hedda Sterne; middle row: Richard Pousette-Dart, William Baziotes, Jackson Pollock, Clyfford Still, Robert Motherwell, Bradley Walker Tomlin; seated: Theodore Stamos, Jimmy Ernst, Barnett Newman, James Brooks, Mark Rothko. Nina Lee ©1951 Time, Inc.

1955

Is visiting artist, Yale University (summer). Publishes "The Artist—Technician or Humanist? One Artist's Answer," in *College Art Journal* (fall), a publication of the College Art Association of America. The Albright-Knox Art Gallery, Buffalo, acquires *The Chant*, 1955 (page 60).

1956

Wins competition for ninety-foot mural at new Continental National Bank Building in Lincoln, Nebraska. Is artist-in-residence at Museum of Fine Arts, Houston, which purchases *Audible Silence*, 1955. NBC television commissions a steel sculpture for the television show "Playwrights 56." Executes mural for the dining room of the S.S. *President Adams*, American President Lines. Son, Eric Max, born April 16.

1957

Is first recipient, with Stuart Davis, of the Brandeis University Creative Arts Award for painting.

1958

Across a Silent Bridge, 1957 (pages 66–67), is included in *17 Young American Painters*, U.S. Pavilion, Brussels World's Fair.

1959

Completes mural, *The Riches of Nebraska*, for Continental National Bank, Lincoln (later removed; now in storage, collection of the Nebraska Foundation for the Arts).

1960

Executes relief mural for the lobby of the Envoy Towers, New York.

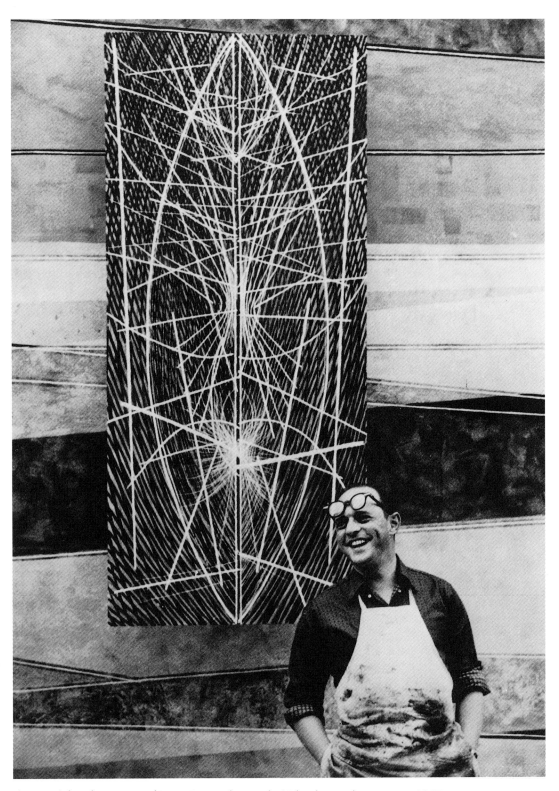

Photograph for *Life* magazine of Jimmy Ernst working on the Nebraska mural commission, 1957
Photo Stan Wayman/Life Magazine © Time, Inc.

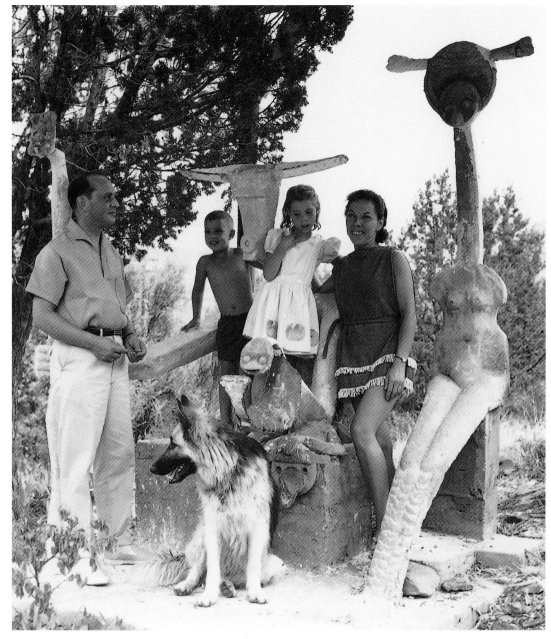

Jimmy and Dallas Ernst and their children, Eric and Amy, with the sculpture *Capricorn*, 1948, by Max Ernst in Sedona, Arizona, ca. 1960

1961

Receives John Simon Guggenheim Memorial Fellowship. Travels in Europe and returns to Germany for the first time. Visits his father in Hismes, France (Max had returned to France in 1953, leaving his Sedona property to Jimmy); also travels in the Soviet Union (with Rudy Pozzatti) as a visiting specialist in the U.S. Department of State's Cultural Exchange Program and develops friendships with Soviet artists and writers. Visits Moscow, Leningrad, and Tbilisi, Georgia. Publishes "A Letter to the Artists of the Soviet Union," *College Art Journal* (winter 1961–62). Moves to New Canaan, Connecticut.

1962

Corcoran Gallery of Art, Washington, D.C., acquires *Icarus*, 1962 (page 83). New York University acquires *Painting with a Secret Title*, 1957 (page 69).

1963

Travels in Germany under the aegis of the U.S. Department of State. Becomes full professor at Brooklyn College. Brooklyn Museum acquires *Narrative II*, 1956 (page 63).

1964

Whitney Museum of American Art acquires *Sooner or Later*, 1962 (page 85).

Jimmy Ernst and his family at his New Canaan, Connecticut, studio, 1964. Photo: John Vassos

Jimmy Ernst in his studio, with *Thoughts about W. B.* (page 97) on the easel, 1965. Photo: Fred McDarrah

1965

Is artist-in-residence at the Norton Gallery and School of Art, West Palm Beach, Florida. Norton Gallery acquires *Night Watch*, 1965.

1966

Is visiting artist at the Des Moines Art Center (summer).

1967

Under a grant from the Andrew Carnegie Foundation, begins a study and report for UNESCO on "Freedom of Expression in the Arts."

1968

Article, "The Artist Speaks: My Father, Max Ernst" (with Francine du Plessix), is published in *Art in America*, November. Sells the property in Sedona, Arizona.

1969

Moves to East Hampton, Long Island. National Collection of Fine Arts (now National Museum of American Art), Smithsonian Institution, acquires *Silence at Sharpeville*, 1962 (page 84), and *Nightnoon*, 1965 (page 96). Pennsylvania Academy of the Fine Arts, Philadelphia, acquires *Warning*, 1960 (page 77).

1970

Is elected to Board of Trustees of Guild Hall, East Hampton, New York.

Jimmy Ernst photographed by
Arnold Newman, 1970
Photo © Arnold Newman

1978

Spends first winter in Florida on Casey Key, Nokomis.

1980

Builds a winter home and studio in Nokomis and begins *Sea of Grass* series inspired by the primordial environments of the Florida Everglades.

1982

Receives an honorary doctorate from Southampton College of Long Island University.

1983

Is elected to membership in the American Academy and Institute of Arts and Letters, New York.

1984

His memoir, *A Not-So-Still Life*, dealing with his youth and early years in America, is published by St. Martin's Press/Marek, New York. Dies in New York on February 6. Memorial service is held at Guild Hall, East Hampton, February 10.

1985

"A Tribute to Jimmy Ernst" aired on the Charles Kuralt Show, CBS television.

1992

A Not-So-Still Life is reprinted by W. W. Norton, New York. French edition is published in Paris by Ballard, and German edition is published in Cologne by Kiepenheuer und Witsch.

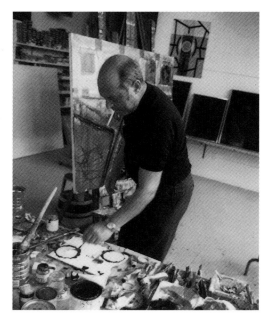

Jimmy Ernst in his studio, 1981

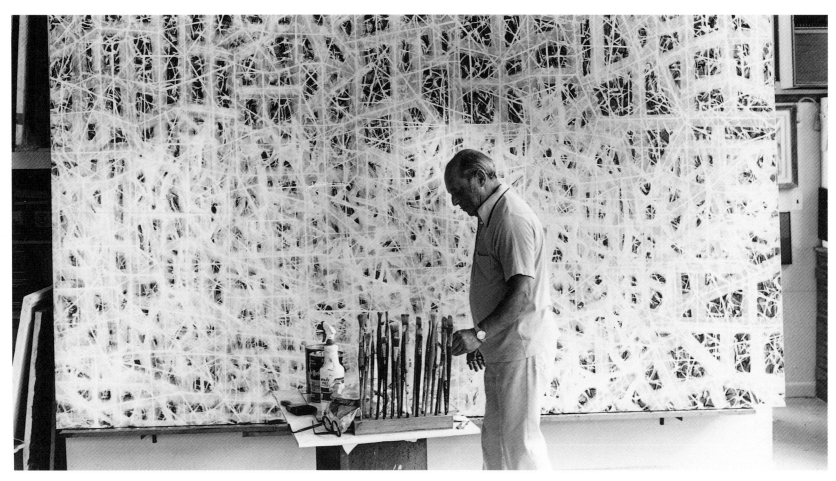

Jimmy Ernst in his East Hampton studio, 1982. Photo: John Reed

JIMMY ERNST

COLLECTIONS

EXHIBITION HISTORY

SELECTED BIBLIOGRAPHY

ACKNOWLEDGMENTS

INDEX

COLLECTIONS

EXHIBITIONS

1999
Sprengel Museum, Hanover, Germany

1998
The Sea of Grass Series and Beyond, Museum of Fine Arts, St. Petersburg, Florida

1997
Shadow to Light, Sordoni Art Gallery, Wilkes University, Wilkes-Barre, Pennsylvania

1994
Trials of Silence, Tampa Museum of Art, Florida
Philharmonic Center for the Arts, Naples, Florida

1990
Galerie 1900–2000/Marcel Fleiss, Paris

1988–90
University of Wisconsin, Oshkosh (traveled to McAllen International Museum, Texas; Community Gallery of Lancaster, Pennsylvania; and Muscatine Art Center, Iowa)

1988
The Forgotten Mural, Emily Lowe Gallery, Hofstra Museum, Hofstra University, Hempstead, New York

1987
Retrospective. Harmon-Meek Gallery, Naples, Florida (traveled to Butler Institute of American Art, Youngstown, Ohio)
Corbine Gallery, Sarasota, Florida

1986
Century Club, New York
Galerie am Schloss in Ausstellung der Stadt, Brühl, Germany

1985
Guild Hall Museum, East Hampton, New York

1984
Armstrong Gallery, New York

1981
Harmon Gallery, Naples, Florida

1976
Riva Yares Gallery, Scottsdale, Arizona

1974
Riva Yares Gallery, Scottsdale, Arizona

1972
Galerie Lucie Weill, Paris

1970
Guild Hall Museum, East Hampton, New York

1968–69
Arts Club of Chicago

1966
Des Moines Art Center

1965
Amerika Haus, Berlin, Germany
Pennsylvania Academy of the Fine Arts, Philadelphia
Norton Gallery and School of Art, West Palm Beach, Florida

1964
Städtisches Kunsthaus, Bielefeld, Germany

1963–64
Detroit Institute of Arts

1963
Kölnischer Kunstverein, Cologne, Germany

1962
Obelisk Gallery, Washington, D.C.

1957
Art on the Campus, Rabb Graduate Center, Brandeis University, Waltham, Massachusetts

1956
Museum of Fine Arts, Houston

1955
Silvermine Guild of Artists, Norwalk, Connecticut
Philadelphia Art Alliance

1954
Walker Art Center, Minneapolis

1953
Obelisk Gallery, Washington, D.C.

1951–72
Grace Borgenicht Gallery, New York

1950
Robert Carlens Gallery, Philadelphia

1948–50
Laurel Gallery, New York

1948
Philadelphia Art Alliance

1946
Black Music, Norlyst Gallery, New York

1944–45
Norlyst Gallery, New York

1943
Reflections of the Inner Eye, Norlyst Gallery, New York

1999
ACA Galleries, New York
The Linear Impulse, Michael Rosenfeld Gallery, New York

1998–2000
Surrealism in America during the 1930s and 1940s: Selections from the Penny and Elton Yasuna Collection, Salvador Dalí Museum, St. Petersburg, Florida (traveled to David and Alfred Smart Museum of Art, University of Chicago, and Cape Museum of Fine Arts, Dennis, Massachusetts)

1995–96
Art on Paper, Weatherspoon Art Gallery, University of North Carolina, Greensboro

1988
El surrealismo entre viejo y nuevo mundo, Centro Atlantico de Arte Moderno, Las Palmas, Canary Islands

1987–88
Visions of Inner Space, Wight Art Gallery, University of California, Los Angeles (traveled to National Gallery of Modern Art, New Delhi, India)

1980
Visitors to Arizona, Phoenix Art Museum

1977
Hathorn Gallery, Skidmore College, Saratoga, New York

1976
Salute to America's Foreign Born Artists, Heckscher Museum, Huntington, New York
Surrealism and American Art, 1931–1947, Rutgers University Art Gallery, New Brunswick, New Jersey

1974
E. B. Crocker Art Gallery, Sacramento, California

1973
Annual Exhibition of American Art, Whitney Museum of American Art, New York

1970
Annual Exhibition of American Art, Whitney Museum of American Art, New York

1969
Annual Exhibition of American Art, Whitney Museum of American Art, New York

1968
Signals in the Sixties, Honolulu Academy of Arts
Three American Painters: Ernst/Hartigan/ Sonnenberg, Grand Rapids Art Museum, Michigan

1967
Art in Science, Toledo Museum of Art

1966
Arts of the United States, Whitney Museum of American Art, New York
Mulvane Art Center, Topeka, Kansas
Annual Exhibition of American Art, Whitney Museum of American Art, New York

1965
Contemporary Painting, Sculpture, and Graphic Art, American Academy and Institute of Arts and Letters, New York
Biennial Exhibition of Contemporary American Painting, Corcoran Gallery of Art, Washington, D.C.
Annual Exhibition, Pennsylvania Academy of the Fine Arts, Philadelphia

1963
Biennial Exhibition of Contemporary American Painting, Corcoran Gallery of Art, Washington, D.C.
Annual Exhibition of American Art, Whitney Museum of American Art, New York

1961
Contemporary American Painting and Sculpture, Krannert Art Museum, University of Illinois, Champaign-Urbana
Annual Exhibition, Pennsylvania Academy of the Fine Arts, Philadelphia
American Abstract Expressionists and Imagists, Solomon R. Guggenheim Museum, New York
American Art of Our Century, Whitney Museum of American Art, New York

1960
American Academy and Institute of Arts and Letters, New York
Two Modern Americans, Art Institute of Chicago

1959–60
20th-Century American Painting from the Edward W. Root Collection, Smithsonian Institution Traveling Exhibition Service

1959
Annual Exhibition, Pennsylvania Academy of the Fine Arts, Philadelphia
Second Biennial of American Painting and Sculpture, Detroit Institute of Arts

1958
17 Young American Painters, Brussels World's Fair
Brussels Painters, Flint Institute of Art, Michigan
American Academy and Institute of Arts and Letters, New York

1957
Golden Years of American Drawings, Brooklyn Museum, New York
Contemporary American Painting and Sculpture, Krannert Art Museum, University of Illinois, Champaign-Urbana
Art on the Campus, Brandeis University, Waltham, Massachusetts

1956
American Pavilion, Venice Biennale
Pasadena Art Institute, California
Annual Exhibition of Contemporary Art, Nebraska Art Association, University of Nebraska, Lincoln
University of Colorado, Boulder

1955
Toledo Museum of Art
International Exhibition of Contemporary Painting, Carnegie Institute, Pittsburgh
American section, *International Art Exhibition*, Tokyo
The New Decade: 35 American Painters and Sculptors, Whitney Museum of American Art, New York
Annual Exhibition of Painting and Sculpture, Stable Gallery, New York

1954
University of Colorado, Boulder
Younger American Painters: A Selection, Solomon R. Guggenheim Museum, New York
100 Years of American Painting, Metropolitan Museum of Art, New York
Life Exhibition of Painters under Thirty-five, Metropolitan Museum of Art, New York
Young America: Artists under Forty, Shapiro Athletic Center, Brandeis University, Waltham, Massachusetts
Annual Exhibition of Contemporary American Paintings, Toledo Museum of Art
Art Gallery of Ontario, Toronto
Contemporary American drawings, sponsored by U.S. Embassy, Paris (traveled in France)
Annual Exhibition of Painting and Sculpture, Stable Gallery, New York

1953
University of Colorado, Boulder
Annual Exhibition of American Paintings, Toledo Museum of Art
Contemporary American Painting and Sculpture, University of Illinois, Champaign-Urbana
Contemporary Drawings from 12 Countries, Toledo Museum of Art

1952
Annual Exhibition of Contemporary American Painting, California Palace of the Legion of Honor, San Francisco
Annual Exhibition of Painting and Sculpture, Stable Gallery, New York
Abstract Painting in America, Toledo Museum of Art

1951
Abstract Painting and Sculpture in America, The Museum of Modern Art, New York
9th Street Show, 60 East Ninth Street, New York

1950
Annual Exhibition of American Art, Whitney Museum of American Art, New York
Young Painters in U.S. & France, Sidney Janis Gallery, New York
Annual Exhibition of Contemporary American Paintings, Toledo Museum of Art

1946
First Pasadena Annual, Pasadena Art Institute, California
Painting Prophecy 1950, David Porter Gallery, Washington, D.C.

1945
Annual Exhibition, Pennsylvania Academy of the Fine Arts, Philadelphia

1944
Abstract and Surrealist Art in the United States, organized by Sidney Janis for the San Francisco Museum of Art (traveled to Cincinnati Art Museum, Denver Art Museum, Seattle Art Museum, and Santa Barbara Museum of Art)

1943
Art of This Century, New York
Norlyst Gallery, New York

1942
The Collection, Art of This Century, New York (opening exhibition)
Marian Willard Gallery, New York
First Papers of Surrealism, Whitelaw-Reid Mansion, New York

1941
The New School for Social Research, New York

SELECTED BIBLIOGRAPHY

BOOKS

Baur, John I. H. *Evolution and Tradition in Modern American Art.* Cambridge: Harvard University Press, 1959.

Beekman, Aaron. *The Functional Line in Painting.* New York: Thomas Yoseloff, 1957.

Bethers, Ray. *Composition in Pictures.* New York: Pitman, 1962.

Blesh, Rudi. *Modern Art, USA: Men, Rebellion, and Conquest, 1900–1956.* New York: Alfred A. Knopf, 1956.

Canaday, John. *Mainstreams of Modern Art.* New York: Holt, Rinehart and Winston, 1961.

Ernst, Jimmy. *A Not-So-Still Life: A Memoir.* New York: St. Martin's/Marek, 1984. Reprint ed., New York: W. W. Norton, 1992.

Gemälde des 20 Jahrhunderts: Die jungeren Generationen. Cologne: Wallraf-Richartz Museum, 1976.

Janis, Harriet, and Rudi Blesh. *Collage: Personalities, Concepts, Techniques.* Philadelphia and New York: Chilton Company, 1962.

Janis, Sidney. *Abstract and Surrealist Art in America.* New York: Reynal & Hitchcock, 1944.

McCurdy, Charles, ed. *Modern Art: A Pictorial Anthology.* New York: Macmillan, 1958.

Mendelowitz, Daniel M. *A History of American Art.* New York: Holt, Rinehart and Winston, 1961.

Moore, Barbara. "Ernst." In *Art: USA: Now,* edited by Lee Nordness. 2 vols. New York: Viking Press, 1963.

Motherwell, Robert, and Ad Reinhardt, eds. *Modern Artists in America.* New York: Wittenborn, Schultz, 1951.

Porto, Gabriel Lawrence. "An Analysis of the Life and Works of Jimmy Ernst and His Father's Early Influence." Manuscript, 1969 [present archive unknown].

Pousette-Dart, Nathaniel, ed. *American Painting Today.* New York: Hastings House, 1956.

Read, Herbert. *Concise History of Modern Painting.* New York: Frederick A. Praeger, 1959.

Robertson, Jack S. *Twentieth-Century Artists on Art: An Index to Writings, Statements, and Interviews by Artists, Architects, and Designers.* 2d ed. New York: G. K. Hall, 1996.

Scordo, Hari. "Homage to Jimmy Ernst." Master's thesis, California State University, Los Angeles, 1980.

Seitz, William C. *Abstract Expressionist Painting in America.* Cambridge: Harvard University Press, 1983.

Ward, John C. *American Realist Painting, 1945–1980.* Ann Arbor: UMI Research Press, 1989.

EXHIBITION CATALOGUES

Arnason, H. H. *American Abstract Expressionists and Imagists.* New York: The Solomon R. Guggenheim Museum, 1961.

Baur, John I. H., ed. *The New Decade: 35 American Painters and Sculptors.* New York: The Whitney Museum of American Art, 1955.

Blesh, Rudi. *Black Music.* New York: Norlyst Gallery, 1946.

Getlein, Frank. *Jimmy Ernst: Black on Black,* New York: Grace Borgenicht Gallery, 1966.

———. *Jimmy Ernst Retrospective.* Naples, Fla.: Harmon-Meek Gallery, 1987.

Goodrich, Lloyd, and John I. H. Baur. *American Art of Our Century.* New York: Whitney Museum of American Art, 1961.

Guggenheim, Peggy, ed. *Art of This Century.* New York: Art of This Century, 1942.

Hardin, Jennifer. *Jimmy Ernst (1920–1984): The Sea of Grass Series and Beyond.* St. Petersburg, Fla.: Museum of Fine Arts, 1998.

Harrison, Helen A., ed. *Jimmy Ernst: A Survey, 1942–1983.* Introduction by Diane Waldman. Essay by Frank Getlein. East Hampton, N.Y.: Guild Hall Museum, 1985.

Jimmy Ernst. Paris: Galerie 1900–2000, 1990. Text by Edouard Jaguer, Irving Sandler, and Eric Max Ernst.

Jimmy Ernst: Shadow to Light, Paintings 1942–1982. Essays by Stanley I. Grand and Donald Kuspit. Wilkes-Barre, Pa.: Sordoni Art Gallery, Wilkes University, 1997.

Jimmy Ernst: Trials of Silence, Works 1942–1983. Essays by Douglas Dreishpoon and Martica Sawin. Tampa, Fla.: Tampa Museum of Art, 1994.

Kinsman, Robert D. *The Art of Jimmy Ernst.* Detroit: Detroit Institute of Arts, 1963.

Krempel, Ulrich. *Jimmy Ernst.* Hanover, Germany: Sprengel Museum, 1999.

Philadelphia Museum of Art. *Multiples: The First Decade.* Philadelphia: Boston Book and Art, 1971.

Raynor, Vivien. "Two in Stamford: Jimmy Ernst and Stairways and Chairs." *New York Times,* April 17, 1988, 34.

Recent Paintings by Jimmy Ernst. Chicago: The Arts Club of Chicago, 1968.

Ritchie, Andrew Carnduff. *Abstract Painting and Sculpture in America.* New York: The Museum of Modern Art, 1951.

Sweeney, James Johnson. *Jimmy Ernst.* Cologne, Germany: Kölnischer Kunstverein, 1963.

Wechsler, Jeffrey. *Surrealism and American Art, 1931–1947.* New Brunswick, N.J.: Rutgers University Art Gallery, 1976.

Younger American Painters: A Selection. New York: The Solomon R. Guggenheim Museum, 1954.

PERIODICALS

Art Now: New York (University Galleries, New York) 4, 1 (March 1972).

"At the Studio of Jimmy Ernst." *The Newspaper* (Southampton, N.Y.) 3, 4 (1979).

Bell, Jane. "A Sombre Memoir." *Art News,* December 1984, 29.

Berkson, Bill. "Review of Books: What Becomes a Legend." *Art in America,* October 1984, 23.

Braff, Phyllis. "Shedding Light on the 'Not so Still' Life of Jimmy Ernst." *New York Times,* February 5, 1984.

————. "The Art and Angst of Jimmy Ernst." *New York Times,* August 11, 1985.

Brenson, Michael. "Jimmy Ernst." *New York Times,* February 17, 1989.

Campbell, Lawrence. "Jimmy Ernst at Armstrong." *Art in America,* October 1984, 200.

Ernst, Jimmy. "The Artist—Technician or Humanist? One Artist's Answer." *College Art Journal* 15, 1 (fall 1955): 51–52.

————. "A Letter to the Artists of the Soviet Union." *College Art Journal* 21, 2 (winter 1961–62): 66–71.

————. "Freedom of Expression in the Arts II." *Art Journal* 25, 1 (fall 1965): 46–47.

Ernst, Jimmy, with Francine du Plessix. "The Artist Speaks: My Father, Max Ernst." *Art in America,* November 1968, 54–61.

Frank, Peter. "A Not-So-Still Life." *New York Times Book Review,* March 11, 1984.

Friedman, B. H. " 'The Irascibles': A Split Second in Art History." *Arts Magazine,* September 1978, 96–102.

Getlein, Frank. "Jimmy Ernst the Artist." *College Art Journal* 21, 2 (winter 1961–62): 60.

————. "The Younger Ernst." *The New Republic,* March 23, 1963, 35–36.

————. "Book Reviews: A Not-So-Still Life." *Smithsonian,* July 1984, 122.

Hadler, Mona. "Jazz and the Visual Arts." *Arts Magazine,* June 1983, 91–101.

Haggie, Helen. " 'Red' Poet Inspires 'Blue-Yellow' Antiworlds Painting for Bank." *Lincoln [Neb.] Sunday Journal and Star,* July 20, 1969.

Harrison, Helen. "Jimmy Ernst Mural Moved from House." *New York Times,* March 29, 1987.

"Jimmy Ernst about His Painting." *The East Hampton Star,* November 25, 1971, 8.

Russell, John. "Jimmy Ernst: A Survey, 1942–1983." *New York Times,* August 2, 1985.

"Samples of the Season." *Time,* December 11, 1944, 51.

Sirmans, James J. "Jimmy Ernst." *Art Scene,* December 1968–January 1969.

"Spiky Magic." *Time,* February 3, 1961, 58.

Vassos, John. "Jimmy Ernst: An Artist and His World." *County,* November 1967, 19–21.

Waldberg, Patrick. "Jimmy Ernst." *XXe Siècle* 38 (June 1972): 179.

Reviews of Jimmy Ernst's exhibitions, 1943–84, appeared in *Art Digest, Art News, Arts,* the *Magazine of Art,* and other American art periodicals.

ACKNOWLEDGMENTS

This book has been a project of passion and commitment for those closely involved. Special words of appreciation are due the artist's family, Dallas, Amy, and Eric Ernst, as well as Jeffrey and Dorian Bergen and the staff of ACA Galleries; the contributors to the chronology and various other listings, especially Helen A. Harrison; the photographers who have allowed their images to be used; the institutions and private collections holding works by Jimmy Ernst; and the dedicated staff at Hudson Hills Press.

—Phyllis Braff

The publisher would like to thank Phyllis Braff. Without her extraordinary help with an enormous amount of material, and the sensitive and intelligent choices she made, this book in its present form would not have been possible.